The Eurasian Face
ISBN 978-988-99799-9-7

Published by Blacksmith Books
5th Floor, 24 Hollywood Road, Central, Hong Kong
Tel: (+852) 2877 7899
www.blacksmithbooks.com

Designed by e5
Translations by Irene Oi-yan Lau

THE
EURASIAN
FACE

Kirsteen Zimmern

目錄

Eurasian: *adjective* **1** of Europe and Asia. **2** of mixed European and Asian parentage. *noun* a Eurasian person.

THANKS

The biggest thank you goes out to all the Eurasians who answered my impertinent questions and who put up with the indignity of having a camera thrust into their faces by a very average amateur photographer. You were good sports about it, I'll always be grateful. Thank you to the Eurasian Association in Singapore for all their assistance and hospitality with a special thank you to Yvonne Pereira. Thanks to Pete, my publisher who was always very patient and encouraging – it's been a long road! Just think, you've seen me through a wedding and two babies over the course of this project. And of course to Roy for his fabulous design work. Lastly, thanks and lots of love to my husband, children, parents and sister who all believed in me from the start.

鳴謝

首先，我希望向所有的歐亞裔受訪者，致以最深的感謝，多謝你們回答了所有莽撞的問題，並忍受了這位很一般的業餘攝影師，拿著鏡頭在胡亂拍攝你們的倩影。大家對本人的寬容，我永遠感激萬分。多謝新加坡的歐亞裔協會所有的友善協助，其中要特別感謝Yvonne Pereira。 也得要感謝我的出版商Pete，一直很耐心地鼓勵我，度過了漫長的道路——在本書的製作、出版的過程中，他看著我結婚、生孩子，直到現在完成全書。當然，也得多謝Roy在本書中絕佳的設計工作。最後，謝謝我至愛的丈夫、孩子、父母、姐姐，由此至終都對我置以信任。

THE EURASIAN FACE
歐亞面孔

Much of the glory in being Eurasian lies in being different, exotic even. Revelling in our uniqueness, we are nevertheless struck with anxiety over our identity and the human need to belong to an identifiable group of people.

It was partly this contradiction which compelled me to create this book. Through the photographs, I hope to show whilst each Eurasian is unique, we all share a 'look' that is distinctively Eurasian, a look that lends us an ethnic identity of our very own. The tell-tale signs of our mixed blood manifest themselves more strongly in some than others – some of us look more Caucasian, some of us more Asian. But in whatever measure, the signs are there. I cannot count the number of times that someone, upon discovering that I am Eurasian, has commented that I do not look Chinese. Why should I? I am not Chinese. I am not Caucasian. I am Eurasian.

The photographs demonstrate, very visually, the result when East meets West. A slanted eye here, a high-bridged nose there. Straight hair, wavy hair. Olive skin, pale, freckled skin. For many Eurasians it is a rare day when our appearance does not invite examination and comment. Our genetic legacy appears to be universally fascinating.

Many Eurasians who have contributed to this book have lent not only their image but also their thoughts, feelings and experiences. It is gratifying to see that we are no longer held back by stigma, ashamed to openly admit to our mixed blood. Younger generations of Eurasians happily do not share the burden of prejudice suffered by their older predecessors. It might be surprising to many of the Eurasians who have proudly taken part in this book that older Eurasians have flatly refused to be publicly labelled as such. One elderly gentleman in his eighties went so far as to comment that growing up as a Eurasian in Hong Kong was 'terrible' and hinted darkly that my attempts to write this book would be met with resistance. It is with relief I note that we now live in far more tolerant times and this project has been warmly received by Eurasians and non-Eurasians alike.

This book is dedicated to all the Eurasians out there. As individuals, we may feel at times that we do not know who we are or that we cannot reconcile our ethnicity with how we feel. We may be exhausted by attempts to explain our appearance, our cultural outlook, our way of living, our nationality. We may be frustrated by the fact that we do not fit neatly into either cultural stereotype. But perhaps in being brought together in this book, each of us may feel a sense of relief – we do not need to slot neatly into either the Caucasian or Asian camp, we are a group in our own right.

混血兒的榮耀大部份來自我們的與眾不同，甚至是誘人的異國情調。儘管我們自我陶醉於獨特的一面，卻同時對我們的身份認同感到憂慮，畢竟我們也有屬於某個群體、某個民族的需要。

就是這樣的矛盾，促成了部份創作此書的動力。透過圖像相片，我希望表達每名混血兒既是獨一無二，卻同時又有著相同但獨特的混血兒「外貌」，令我們在人群中分辨出來，這種獨特性給予我們獨立的種族身份。我們明顯的混血特徵，在某些人身上清晰的顯露出來，某些則不然——有些混血兒比較像白人，有些像亞洲人。但無論如何，那些特徵還在。我數不清有多少次，在別人發現我是名混血兒的時候，說我一點都不像中國人。爲什麼我要像中國人？我不是中國人，也不是白人，我就是歐亞裔混血兒。

這些相片，在視覺上演示了東西相遇交融的結果，微斜的鳳眼、高鼻樑、直髮、卷髮、橄欖褐色皮膚、白皙而有雀斑的皮膚。對很多混血兒來說，我們的外貌很少不會惹來別人的查問與談論，似乎我們的遺傳因子在到處都有吸引力。

很多參與此書的混血兒，不只借予他們的外貌形象，更和我們分享他們所思所感，以及他們的經歷。很高興看到我們已不再認爲自己的身份是恥辱，而羞於公開承認我們的混血血統。年輕一代的混血兒，活在開心快樂的時代，並未有如上一代的混血兒一樣，背負著被偏見的社會歧視的包袱。對很多自豪地參與此書的混血兒來說，他們或許覺得很奇怪，爲何老一輩的混血兒拒絕被公開標籤爲混血兒的身份。一名80多歲的老先生甚至表示，作爲混血兒在香港成長是件很「痛苦」的事，也悲觀地暗示我嘗試寫此書，將會遇到阻礙。令我鬆一口氣的是，我們現在生活在一個遠比以往包容的時代，而我的計劃也同樣受到混血兒和非混血兒的歡迎和接受。

此書謹獻給所有混血兒。作爲獨立個體，我們也許會有不知道自己是誰、感覺不到種族間的和諧的時候，或者會爲常常解釋我們的相貌、文化外表、生活方式、國籍民族而感到疲憊，可能會因爲不能完整地被納入任何一個文化模式而感到苦惱。但或許可以透過此書，將我們這群混血兒都連繫在一起，我們可以感到寬慰——我們不需要被納入白人或亞洲人的圈子，我們是自成一閣的民族。

Kirsteen Zimmern
Hong Kong, September 2010

I was born in Singapore. Both my parents were born in Singapore. I am not too sure, however, of my ethnic mix. My parents are Eurasian and my maiden name was Alberquerque, which is Portuguese. The Asian names in my family tree have been lost over the years; only the European names have survived. I believe my great-grandmother came from Malacca, Malaysia, a stronghold of the Portuguese Eurasians even today.

I was schooled, like many Eurasian children (especially of my generation), in a convent school. My school, St. Anthony's Convent, was right next to a Portuguese mission/church. Many Eurasians of Portuguese descent also attended that church. At school, we would learn to dance to music sent from Portugal. Eurasian cultural dance is heavily influenced by the Portuguese style – recent cultural exchanges with Portugal and Macau show that there is still a similarity in song and movement. Eurasians are generally well known for a love of dancing and music, and it forms a big part of our culture. I myself have always loved and been involved in dance and I am frustrated that as I get older I cannot do it any more. Nonetheless, I continue to be involved in various dance projects.

I do not think that being Eurasian brings with it any privileges in multicultural Singapore, where progress is based on merit, regardless of background. Having said that, I have to say I feel fortunate having grown up speaking English as a first language. Eurasians speak English with a distinctive accent, one that is markedly different from 'Singlish', what we Singaporeans call the English spoken in Singapore.

I also speak 'Kristang', which is the Creole-Portuguese patois spoken by many Eurasians of Portuguese descent. Kristang is still especially widely spoken among the Eurasians in Malacca. Kristang is a language that combines Portuguese, Bahasa, Chinese and Tamil. While native speakers of Portuguese would probably find it difficult to understand, they would definitely be able to pick out words here and there. Some words are the same in Kristang as in Portuguese. In other cases, the pronunciation of a Portuguese word has evolved.

Kristang was exclusively a spoken language. Recently, however, a friend and I compiled a Kristang/English dictionary, where we set out both the spelling of words and their phonetic pronunciation. We also incorporated some elements of Portuguese Eurasian culture. The dictionary has continued to sell. Compiling the dictionary took a very long time but it was a labour of love and the final product was well worth the effort. We worry that the language will die out as the young Eurasians may not use it. As it is, even in my youth many of us were not allowed to speak Kristang and encouraged instead to speak proper English. The survival of the language is at risk, but we hope that the dictionary will help keep it alive.

While Kristang may be spoken less today, 'Jingkli Nona' (a Kristang song meaning 'Fair Maiden') remains a very popular traditional Eurasian song. Even Eurasians who do not speak Kristang will get up and sing and dance to it. My son often provides the music for Eurasian events such as weddings or anniversaries, and will always ask me for the 'Jingkli Nona' tape! In some way, therefore, Kristang continues to run strong in our blood.

Like other racial groups in Singapore, Eurasians have our own customs and ways of life. These are very specific to our culture, and markedly different from other races. For example, breakfast is usually bread, and not porridge, noodles or rice. At 4 o'clock without fail, we have tea. We also tend to eat dinner a bit later, say around 7 o'clock in the evening. We have our own Eurasian cuisine which is a real mix of East and West. It would be as common to find a stew or roast on a Eurasian menu as a curry. There is also strong Western influence in many of our rituals, like weddings, christenings and Christmas. Objectively speaking, I would say our way of living appears more European than Asian. But really, it is neither. It is just Eurasian.

我和父母均在新加坡出生。然而，我不大清楚自己的國籍種族，我的父母都是混血兒，而我未婚前的姓氏是葡國姓 Alberquerque。經過那麼多年，我家族譜下的亞裔姓氏早已經不知所蹤，只剩下歐裔姓氏。我相信我的曾祖母來自馬來西亞的馬六甲，那裡至今仍是葡萄牙混血兒的大本營。

我好像其他混血兒孩子一樣（尤其是我那個年代）在修院學校唸書。我就讀的那家 St. Anthony's Convent 就正正在一葡萄牙教會／教堂旁邊，很多葡萄牙裔的混血兒後代，均是上這家教會的。在學校裡，我們會學習葡萄牙音樂的舞蹈。混血兒的民族舞深深地受葡萄牙音樂的影響——在最近的澳葡文化交流活動中，顯示了在歌曲及舞蹈動作上均有相似之處。混血兒普遍都以熱愛歌舞出名，這在混血兒文化中佔有很重要的部份。我自己就很喜歡舞蹈，從前常常跳舞，然而因為年紀越來越大而無法再像以往那樣跳舞，我是感到非常苦惱的。儘管是這樣，我仍然繼續參與舞蹈有關的項目。

在新加坡這種多元文化的城市中，我並不認為作為混血兒能帶來任何好處；在這裡，進步是基於個人成就，與背景和種族無關。雖說如此，我也很慶幸自己自小以英語為第一母語。混血兒的英語口語帶著獨特的口音，與一般的"新加坡式英語"(Singlish)大相逕庭。

我也會說葡萄牙文衍生語 Kristang，一種廣為葡裔混血兒使用的葡萄牙克里奧爾方言，尤其是在馬六甲的混血兒。Kristang 是一種混合葡萄牙語、印尼語、漢語及泰米爾語的語言。雖然以葡語為母語的人會難於理解Kristang，他們定可從片言隻字中，找到部份與葡文一樣的字詞，有另外一些字詞，則由葡語演變而來，只是讀法不一樣而已。

Kristang 純粹是一種口頭語言系統。然而，近來我與朋友編撰了一部Kristang ——英語字典，以拼寫及讀音兩方面來記錄，我們更加入了部份葡萄牙歐亞混血兒的文化；字典一直以來銷量不俗。編撰字典非常費時，但是那是因為愛，在見到成品時，就覺得辛苦是值得的。我們擔心當年青一代的混血兒都不用這套語言時，它會隨之而消逝。就是我年少時，很多同齡的混血兒都不給說Kristang，而被鼓勵說正統的英語。所以這語言是瀕臨消失的危機邊緣，但我們希望這字典可以令它歷久常新。

雖然 Kristang 語在今天已經越來越少應用，但那首歌曲'Jingkli Nona'（一首 Kristang 語歌曲，意謂'窈窕淑女'），卻仍然是很受歡迎的傳統混血兒調子。就是不會說Kristang的混血兒，也會高唱這首歌及跟著跳舞。我的兒子經常在混血兒的活動（如婚禮或周年紀念）中播放這首歌，而且常常問我拿'Jingkli Nona'的錄音帶！所以，Kristang 在某程度上繼續流在我們的血脈中。

一如新加坡的其他民族一樣，我們混血兒有自己一套習俗和生活方式，跟我們的獨特文化息息相關，與其他民族有顯著的分別。例如，我們的早餐通常都是麵包，而不是粥、粉、麵、飯。在下午準四時，我們會喝茶。我們傾向晚一點，大概七時左右才用晚膳。我們有自己的歐亞菜色，混合東西方的美食。在我們的菜單內，找到炖製或烤焗的咖哩食品，是很正常的事。我們很多的儀式，也反映了西方文化對我們的重大影響，如婚禮、受洗、聖誕等。客觀來說，我們的生活方式比較像歐洲人多於亞洲人。然而，那並非真正的歐式或亞式，我們就是混合式的文化。

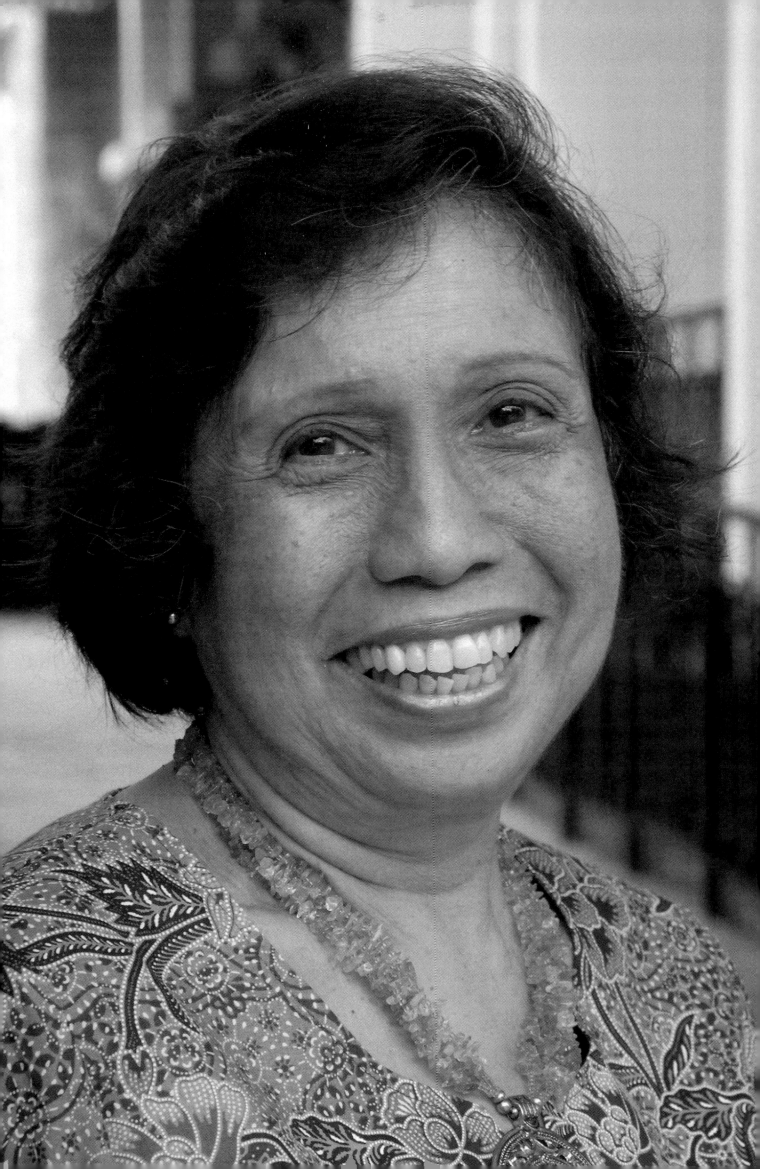

I was born in Hong Kong, my mother is British and met my Macanese Chinese father here when her family moved to Hong Kong.

As a child, being Eurasian had no real impact on me. I went to an international school and everyone was different. Now I am older, I appreciate the ambiguity of being Eurasian, I kind of like not belonging to any particular ethnicity. It's good to not be defined by any nationality and its accompanying stereotypes (although it has to be said that sometimes Eurasians have their own stereotype of being smart and good-looking!). Saying that, I think that this ambiguity is not the preserve of Eurasians alone. Being such a cosmopolitan place, people in Hong Kong generally have a choice to take what they want from each culture. Even if you belong to a nationality, it doesn't mean that you have to be immersed in that nationality. A lot of Asians identify with other countries, for example in following football, or being fans of different music.

I play and sing in a band and although sometimes it seems a bit weird to be playing English music to a mostly local crowd, I feel that music is truly international – it doesn't matter about language. Everyone knows who Michael Jackson is.

Being Eurasian has not really affected my music career. The only time it really comes up is during interviews when I'm always asked how I can look kind of Chinese and have lived here for 29 years and not speak Cantonese. The only answer I can give is that in the international school bubble, many, if not most of us couldn't speak Cantonese regardless of how long we'd been in Hong Kong or even if we had been born here.

When I meet other Eurasians, I don't necessarily connect with them. There are so many types of Eurasians. I don't like being labeled but I don't mind being labeled Eurasian – to me, Eurasian is opposite to a label because it is something so undefined.

Within all cultures and nationalities there are so many divides, so the divide within myself is not important. I'm just proud to be from Hong Kong, to have grown up freely in a multicultural city.

我出生於香港，母親是英國人，她在舉家移居香港時，認識了澳門籍的華裔父親。

在孩童時代，作為歐亞混血兒對來我說並沒有太大的感覺。那時候我在國際學校就讀，每個同學都長得跟一般人不同。到現在長大了，開始欣賞作為混血兒的混淆不清的身份，我似乎有點喜歡那不隸屬任何種族的感覺。不受任何一種國籍及其固定的形象所限是件好事（無可否認，混血兒有時也有自己的固定形象——就是長得漂亮和聰敏！）。雖然如此，我所說的混淆不清的身份，並非混血兒所獨有。在香港這個國際大都會，人們均可以在不同文化中選取所想。即使你是屬於某一個國籍，並不代表你須要浸淫在該國籍的文化中，很多亞洲人選擇跟隨他國文化，比如根據足球運動的喜好，或成為不同音樂的追隨者。

我在樂隊裡演奏及演唱，雖然在多數為本地人的圈子內表演英國音樂，看似有點古怪，我卻覺得音樂全然是國際化的——並無語言限制。人人都知道誰是米高·積遜。

作為混血兒並沒有影響我的音樂事業。只有一事，就是每當訪問時，總會有人問我，為什麼長得很像中國人，在這裡生活了29年，卻仍然可以不懂講廣東話。我只有唯一的回答：在國際學校長大的人，很多，或甚大部份都不懂說廣東話，不管我們在香港待了多久，或者是不是在這裡出生。

當我遇到其他混血兒時，我不一定會與他們聯繫，世上有太多不同種類的混血兒了。我不喜歡被標籤，但我不介意被標籤為"混血兒"——因為對我來說，混血兒正正是難以定義的身份，跟標籤是剛好相反的東西。

在云云眾多的文化與國籍種族中有那麼多的分水嶺，我只是其中一個身上流著不同文化的血液，所以這並不重要。我僅對於來自香港，並成長於一個多元文化的城市而感到自豪。

My father is Chinese from Malaysia and my mother is English. My father came to England in his early twenties. My mother first saw my father at a bus stop when she was just sixteen and they married when she was seventeen. My father used a whole year's salary to buy her an engagement ring and he has devoted his life to making her happy ever since.

We were the first Chinese family in Perivale. Although it was a very multi-cultural part of London, there were no other Chinese there. I was born in England and lived with my family in London until about six years ago. I never faced any discrimination or racism at school but there was one family on our street who were very jealous of us and they used to shout things like 'go back to China!'.

My dad is Buddhist and my mother an atheist. That's not the least of their differences but they've agreed to disagree! Only one of my dad's brothers took issue with their relationship and as Eurasians, my twin and I were well accepted by the family – especially by my grandmother with whom we would have dinner twice a week. When I was growing up, it was my dad who did the cooking so we always ate Chinese food. We also celebrated all the Chinese festivals and always had a close association with Asia, going to Malaysia three times a year.

Although I do have some family in Hong Kong, I actually came here for work. Because of my Chinese background, despite having lived all my life in London, I didn't experience any real culture shock. My outlook has always been quite Asian – I'm somewhat superstitious and believe in karma. It's interesting: although my twin sister was brought up in the same place, in the same way, I would say that I have always been more Chinese than she is.

When I was modelling a few years back, Eurasians were an extremely popular choice for their appearance. Saying that, people often cannot tell that I'm Eurasian. In New York they think I'm Hispanic, in London they think I'm Italian. In Hong Kong, it is rare that someone guesses that I'm half Chinese.

I love being Eurasian. In my mind, Eurasians are exotic and beautiful and can have an effect on places and people. I think we have a presence.

我的父親是來自馬來西亞的華人,而母親則是英國人。父親在20多歲時來到英國,母親在巴士站遇到父親時,年僅16歲,在17歲時就嫁了給他。當時父親用了一整年的人工,才買了定婚戒指給母親,從此以後,一輩子都盡力讓她活得快樂。

我們家是倫敦市中心以西近郊小鎮Perivale的首戶中國人。雖然那裡是倫敦一個多元文化區,但就是沒有其他中國人。我在英國出生、長大,直至六歲,在學校從來沒有受到種族歧視。只是在我們住的那條街上,有一戶人家特別嫉妒我們,常常對我們大叫「滾回中國去!」這類的話。

父親是佛教徒而母親是無神論者,那並非他們唯一的不同,但他們卻一直可以和而不同來相處!只有一名伯父反對他們的關係。作為混血兒,我和我的孿生姊姊普遍被家庭成員所接受,尤其是祖母和我們相當親密,我們每星期均與她吃兩頓晚餐。在成長期間,都是父親做菜,所以我們都吃中國菜長大。而且,我們都會過所有的中國節日,經常與亞洲保持親密的聯繫,每年會回馬來西亞三次之多。

雖然我在香港也有家人,但我只是為了工作而回來。因為我的中國人背景,雖然一輩子都住在倫敦,我在這裡並沒有經歷很大的文化衝擊。我的外表向來很像亞裔,某程度上我有點迷信,也相信命運和因果。有趣的是,雖然我的孿生姊姊在相同的地方和方式成長,我會說自小到大,我都比她更像中國人。

幾年前當我仍是模特兒的時候,混血兒在模特兒界相當吃香,因為我們獨特的外表。雖說如此,別人總是分不出我是名混血兒。在紐約,他們以為我是西班牙或葡萄牙裔;在倫敦,人家以為我是意大利人;而在香港,也很少有人知道我是半個中國人。

我喜歡做混血兒。我覺得混血兒是異常漂亮的,在不同的地方和民族、群眾,具有很大的影響力。

I was born in Singapore and both my parents were Eurasians. My father was a 'de Souza' which is a Portuguese Eurasian name.

My grandfather on my mother's side was British and he came to Singapore from England. He married my grandmother who was a German Eurasian and that changed everything. In those days, a child that was mixed could not take on his or her colonial father's nationality – one had to be pure to take on the colonial race. I suppose his decision to marry a Eurasian changed his family line forever – his brothers who stayed in England remained very much British.

Saying that, it never bothered me. There is nothing inferior about us! We mixed with everyone but had our own community. I had no complex about it.

We invite all races to our events – they love our cuisine. Likewise, we are often included in the festivals and events of other cultures. If there is a function, representatives from all the communities are invited. It is important to mix yet retain our own cultural identity. That is why Singapore gels.

We Eurasians have our own looks, food and lifestyle. We tend to be Catholics and follow our faith. In my mother's time, Eurasians were very conservative. As a docent, I act as a guide in the Asian Civilizations Museum. In learning about the ethics, religion and spiritualism of ancient civilizations and in broadening my knowledge, I have entered temples, mosques and other places of worship. Even now, many Eurasians are shocked when I do so.

We have always dressed in the Western style and I would say we are more prone towards a Western lifestyle. An Asian influence can be seen in our food, forming typical Eurasian dishes. At Christmas, a typical buffet would consist of 60 percent Western food and 40 percent Eurasian food.

In Singapore, people seem to be able to guess what I am. But overseas, I have been thought to be Spanish, Portuguese or South American.

Perhaps in some ways Eurasian culture is becoming more diluted these days. More and more Eurasians are marrying outside of the Eurasian community, and these days, children follow the father's race. A lot of Eurasians have also emigrated to Australia. However, we are beginning to see young first-generation Eurasians again with mixed Western and Asian couples becoming more and more common. In a way, we can replace the ones we've lost! I myself brought my children up in the Eurasian style, it was important to me to retain our culture.

Eurasians are moving forward with the times, we do not want to be left behind. The Eurasian Association has been key in keeping the community going. Education has been very important in this regard and the Association supports and helps needy families with educating their young. We have fixed community donations and our community spirit is very much alive – there is a sense of belonging.

我在新加坡出生，父母均是混血兒，父親姓'de Souza'，來自葡萄牙的混血兒姓氏。

我的外祖父是名英國人，從英國來到新加坡，娶了德裔混血兒外祖母，改變了一切事情。那年代，混血的孩子並不能承繼他或她父親的國籍——必須要是純正血統的，才可以取得殖民地的民族身份。我想外祖父當時要娶一名混血兒的決定，永遠地影響了他家族的血統世系——他在英國的兄弟直至現在也維持著英式的生活。

雖說如此，作爲混血兒對我來說從來都不是問題。我們並不是下等人！和其他人相處融洽之餘，卻有我們自己的社區和團體。對此我並沒有惡感。

在聚會時，我們會邀請不同的種族的朋友參加——他們都愛我們的菜色，同樣地，我們也會參加他們的節日和文化聚會。每當有活動時，所有民族社區的代表均會被邀請，保留自身的文化特質之餘，亦能和其他民族融合，對我們來說是很重要的，也是新加坡得以凝聚的原因。

我們混血兒有自己獨特的長相、食物和生活習慣。我們較傾向跟隨我們的信仰，成爲天主教徒。在母親年輕的年代，混血兒家庭是很保守的。我在亞洲文明博物館當導賞員，要了解古代文明的道德觀、宗教和精神靈魂學說，以及爲了增擴見聞，我常常進出廟宇、清真寺，以及其他崇拜之地。就是到現在，我到這些地方也會令很多保守的混血兒覺得吃驚。

我們的衣著像西方人，我會說我們的生活方式也較接近西方文化。亞洲文化對我們的影響，則反映在典型的混血兒菜色中。一般的聖誕自助餐，六成是西方的食物，四成是混血兒食物。

在新加坡，人們大多看得出我是名混血兒。但在海外，我常被認爲是西班牙人、葡萄牙人或南美洲人。

傳統的混血兒文化已經日漸式微，越來越多混血兒和其他民族通婚，而現在孩子都跟隨父親的種族籍貫，很多混血兒也移民到澳洲去。雖然如此，在西方人與亞洲人通婚越趨普遍的今天，我們卻開始見到新一代的年輕混血兒；在某程度上，這些第一代的新混血兒孩子，可以填補失去了的傳統混血兒！我讓自己的孩子在典型混血兒家庭及生活方式下成長，因爲我覺得保留我們的文化至爲重要。

混血兒群體與時並進，我們並不想落後於人。歐亞裔協會對社區的進步起著主要的作用；要維持進步，教育非常重要，協會支援及協助有需要的家庭，教導他們的孩子。我們都會固定捐款支持混血兒社區，因爲我們均很有歸屬感，社區間關係融洽，生氣盎然。

My mother is Thai and my father is a quarter Spanish, a quarter French and half Polish. He is American by nationality and was born and raised in the United States. I speak mainly English but am fluent in Thai and have passable French.

I was born in Singapore and lived there for the first two years of my life before moving to Japan. We were there for six-and-a-half years and moved on to Malaysia where we stayed for five years. My father worked for an oil company so much of my childhood was spent as an expatriate. After Malaysia, we moved to Houston and stayed there for 15 years.

In Japan, the Eurasian thing didn't really figure – a foreigner is a foreigner there, it didn't matter where I was from or what my mix was. I attended an international school so it was a non-issue. I did speak Japanese at the time but whilst I can still just about get by, I've lost a lot of it over the years. There was a larger foreign community in Malaysia and I made friends with people from all over the world. I met quite a few Malay Eurasians and admittedly felt easy with them but it was not the defining feature of my friendships.

It's funny, I remember when I was growing up in Asia that when people asked where I was from, I would say 'California' just because we had a house there… despite the fact that I had never lived there!

Houston was very different as it was predominantly Caucasian but any issues I had were more to do with being an expat kid than being Eurasian. Whilst many of the other children had grown up together, I had always moved around. In high school it's easy to find something to be insecure about and I used to feel sensitive about the fact that I hadn't had the same kind of upbringing that my classmates had. As I got older however, I realized that I was the sophisticated one and that I was extremely lucky to have travelled so extensively.

I feel close to my mother's side and have lots of cousins but whilst I am comfortable with my family there are times when I don't feel like a part of their culture. Even if I understand 90% of Thai culture, there will always be that 10% I don't understand because I didn't grow up there. My brother and I get a lot of allowances for being American!

Being Eurasian has been such an advantage. Being bilingual from the start has made learning other languages so much easier and with Thai being a tonal language, I've been picking up Cantonese really easily, much to the irritation of the other students in my class. The only sort of negative thing I've experienced is that with my mother being Thai and my father American, there is sometimes a sort of stigma, some insinuation about the manner in which they met (which, incidentally, was at work).

I'm generally presumed to be South American, especially when I used my maiden name. I sometimes get Italian or Spanish and am rarely seen as Asian.

I have been in Hong Kong just over six months now and am loving it. I felt comfortable here as soon as we arrived. It's almost as though the city is Eurasian, just like us!

我的母親是泰國人，父親有四分一西班牙、四分一法國和二分一波蘭血統。在國籍上他是名美國人，並在那兒長大。我以英語為主，但也操流利泰文，法語也算合格。

我在新加坡出生，至兩歲時移居日本。我們在那裡居住了六年半，再遷移到馬來西亞，再住了五年。父親在油公司工作，所以我兒時大部份時間，都是在遷居不同地方的外地人。在馬來西亞以後，我們再次移居，到了美國休斯頓，一住15年。

在日本，混血兒不是一回事——你是外地人，就是外地人，不管你身上流著多少個民族的血。我在國際學校讀書，所以更不成問題。當時我是會說日語的，雖然現在我的日文能力還算過得去，隨著時間流逝，很大部份都已經忘記了。在馬來西亞的外來人社區較龐大，我在那裡認識到來自世界各地的朋友，包括一些馬拉混血兒。無可否認，與他們相處融洽舒服，但那並不是我選擇朋友的特定模式。

很有趣地，我記得我在亞洲長大時，當人家問我來自甚麼地方時，因為我們有個房子在加利福尼亞州，縱使我從來沒有在那裡住過，我也會說我是來自"加州"！

休斯頓則是一個很不同的地方，那兒大部份都是白人；然而，我遇到的問題大多是與我是外地人有關，而非我是混血兒的問題。當其他孩子都在一起成長，我卻總是從城市到城市走來走去，定不下來。在高中時，我很容易覺得沒有安全感，我也對自己與其他人的成長背景不一樣這事實很敏感。但是，當我長大時，卻意識到自己比較老練和細故，而且能夠如此長期周遊列國，是件非常幸運的事。

我與母親那邊的家庭較為親密，也有很多表兄弟姊妹。雖然我與親戚和家人相處愉快，有時卻仍覺得不屬於他們的文化。就算我明白九成的泰國文化，總仍然有那麼一成是我不懂的，因為我不在這個地方長大。我的哥哥與我有很多空間成為美國人！

作為混血兒百利而無一害。自小已訓練雙語，令我們學習新的語言時容易多了。泰文是聲調語言，我因而很容易就學會了廣東話，惹惱不少班上其他同學。唯一負面經歷，是因為我的母親是泰國人，而父親是美國人，有時會有對於他們相識經過的暗諷和瑕疵（巧合地，他們果真是在工作中認識）。

我總是被人認為是南美人，尤其是在我用娘家姓的時間。偶爾也有人以為我是意大利或西班牙人，但甚少人猜我是亞裔。

我來了香港僅六個月，已經愛上這個城市。我們剛抵埗就覺得在這裡生活很自然、舒服，彷彿香港就是一個混血城市，像我們混血兒一樣！

我在新加坡出生，娘家姓 Bracken，我想那可能是源自 O'Bracken 這個愛爾蘭姓氏。我的父親擁有愛爾蘭、荷蘭、英國及錫蘭人等混血血統。我的母親姓艾爾斯肯(Erskine)，她為愛爾蘭、蘇格蘭及錫蘭後裔。她本來自馬來亞，但卻在新加坡與父親認識——那個時候，很多人都往新加坡找工作。

我有著典型混血兒的成長環境，我們居住的社區有很多其他的混血兒家庭，我們大多是來自羅馬天主教背景，會慶祝復活節、聖誕節等節日，並愛吃歐亞食品如魔鬼咖哩和蘇芝蛋糕。由於我是英裔混血兒，從小到大都我都是講英語的。我從來不會 Kristang 語，那是馬六甲混血兒間流行的方言。由於我的語言能力，從前常常當秘書的職位，一如其他混血兒女士一樣。很多混血男士則在不同政府部門內，當英國人的副手。

我嫁給另一名混血兒——Joseph Tessensohn，他的家族在新加坡的歷史上享負盛名。他的曾祖父 Edwin Tessensohn 在1922年受委任成為太平紳士，並於1923年獲提名為進入立法會，成為英屬新加坡的首位混血兒議員；他也於1900年代，在其安珀路住所成立了歐亞裔文化協會(Eurasian Literary Association)。

我育有兩名女兒，其中一名也是嫁給混血兒，並同樣以混血兒家族的方式帶大她的三名孩子。我認為將混血文化傳給孫兒後代是很重要的。

在新加坡人們大都憑我的外表知道我並非中國人，有時他們會叫我作紅毛(Ang-Moh)，即是歐洲人。其他混血兒卻總知道我是他們的一份子。

我覺得自己與其他混血兒比較相像，大家相處間都充滿暖意。我同時與新加坡的其他民族，如中國人、馬拉人、印度人等相處融洽，也參與他們部份的節日，如農曆新年、馬來西亞的開齋節(Hari Raya)、印度的光明節(Deeparvali)。

歐亞文化在我來說是很具體而活生生的，而在新加坡內也相當活躍。因為我們混血兒現在已經正式被認同為一個獨立的民族，某程度上歐亞文化對社會的影響比以往更強大及明顯，這在歐亞裔協會的影響力中可見一斑。

I was born in Singapore and my maiden name was Bracken. I think it might have been O'Bracken originally, which is Irish. My father was a mix of Irish, Dutch, English and Ceylonese. My mother was an Erskine and was of Irish, Scottish and Ceylonese stock. My mother was originally from Malaya but my parents met in Singapore – in the old days, a lot of people used to come to Singapore to find work.

I had a typical Eurasian upbringing. There were a lot of other Eurasian families in our locality and we mostly had a Roman Catholic background, celebrated Easter and Christmas and enjoyed Eurasian food such as Devil Curry and Sugee Cake. As I am a British Eurasian, I grew up speaking English. I never spoke Kristang, the dialect popular amongst Malaccan Eurasians. On account of my language skills, I used to work as a secretary as did many other Eurasian women. Many Eurasian men worked as second runners to the British in many of the government offices.

I married another Eurasian – Joseph Tessensohn. His family was very prominent and involved in the history of Singapore. His great-grandfather, Edwin Tessensohn, was made Justice of the Peace in 1922 and was nominated in 1923 to the Legislative Council as the first Eurasian member in British-ruled Singapore. He also started the Eurasian Literary Association which he founded at his own home address in Amber Road in the 1900s.

I have two daughters, one of whom is also married to a Eurasian and is bringing up her three children in the Eurasian style. I feel that it is important to pass on Eurasian culture to my grandchildren.

People in Singapore tend to know from my appearance that I am not Chinese. Sometimes they call me 'Ang-Moh' which means 'European'. Other Eurasians can always tell what I am though.

I identify more with other Eurasians and feel that I have more in common with them. There is much warmth between us. I also get on with the other ethnic groups we have in Singapore, for example, the Chinese, the Malays and the Indians. I also join in with some of their festivities, such as Chinese New Year, Malay Hari Raya and Deeparvali.

Eurasian culture is very alive to me and it is very active in Singapore. In some ways it is even stronger and more prominent now than it used to be, as we are officially recognised as a race today. The strength of the Eurasian Association is evidence of that.

I was born in Sydney and lived there until I was six. My Chinese father is a doctor and he met my mother, an English nurse in Australia. My parents gave my siblings and I hybrid names that would be the same in both Chinese and English – we all share the middle name 'Ming'.

My grandfather had three wives and my father was the ninth child, the only child of the third wife. My father's family all lived together in a large place in the Mid-levels made up of two flats knocked into one. Admirably, my mother moved into my father's family home when we came to Hong Kong and fully embraced his Chinese culture and way of living. I still live in that flat to this day. My mother says that my father was very Chinese when she met him but over the years has become more westernized.

When I first came to Hong Kong, I didn't like it much. I was used to Australia and it seemed so different here. I attended ESF schools and during the first few years always identified with other Australian students as opposed to the British or Chinese ones. In high school there were quite a few Eurasians. I realized that we had common ground not only with each other but also with other Asian students. By the time I returned to Australia for university, I soon become conscious that I no longer felt Australian and missed Hong Kong terribly. Now if people ask me where I am from, I'll say Hong Kong.

These days I feel more Asian and my mother has always said that I am quite like my father. I assimilate easily with local Chinese people, the only thing that holds me back is language – I can't speak Chinese and feel really terrible about it.

I have never had a bad experience on account of being Eurasian. In Sydney, people did not pay much attention to my ethnicity anyway, it being so much more diverse there. I do tend to get a lot more attention in Hong Kong – the ideal of beauty is different. Generally, people can tell that I am part Chinese and they try to speak to me in Cantonese all the time.

Being Eurasian has been such an advantage – I feel that people are more inclined to listen and they are more interested in me for being mixed. People do seem to genuinely want to hear my story.

我在悉尼出生，至六歲才離開。我的華裔父親是一名醫生，他在澳洲認識了英裔當護士的母親。父母為我及兄弟姊妹改了中英混合的名字，令名字在中文與英文中也相同，我們的中名均為「明」。

我的祖父娶了三名妻子，父親為三太太的獨子。父親一家人住在半山的大宅，由兩幢單位打通改建而成。當我們回到香港時，母親理想地一起搬進父親的大家族，並完全融入其中國文化及生活方式。我至今仍住在這個大宅內。

母親指父親在他們初認識時，是一名典型的中國人，但隨著年月過去，漸漸變得西化。非常傳統保守的祖父母，見到兒子娶了一名英裔媳婦並不太高興，只是母親付出了很大的努力，令父親的家人很快接受了她。

當我初來到香港時，並不大喜歡這個地方。我習慣了澳洲的生活，來到這裡甚麼都變不同了。我在英基學校上課，最初幾年，常常夥同其他澳洲來的孩子，被認為與英裔或華裔的同學不一樣。在高中時，學校裡有好幾名歐亞混血兒，那時我發現，我們之間不但有類似的地方，而我們更與亞裔的同學有相似之處。直至的回到澳洲升讀大學時，很快已發覺自己並不再覺得自己是一名澳洲人，反而很想念香港。現在如果有人問我來自那裡，我會說來自香港。

近來我覺得自己更像一名亞洲人，而母親也常說我像父親。我很容易與本地的中國人同化，唯一令我非常難過的是語言問題——我不會說中文。

作為一名歐亞混血兒，我從來沒有因此有任何不愉快的經歷。在悉尼這個多元文化之地，根本沒有人會留意我的種族。反而在香港，我會受到更多旁人注視的目光。總的來說，人們很容易看得出我有中國人血統，而他們總是嘗試跟我說廣東話。

對我來說，作為混血兒好處良多——我覺得別人傾向肯聽我的話，並因為我的混血兒身份，而對我更感興趣。他們倒像真心想聽我的故事。

因為我在香港的大部份朋友都是混血兒，所以我不覺得自己很特別。雖然在學校，我確是跟混血兒朋友比較親近一些，但我不覺得混血兒與非混血兒有很大差異。

我現在於澳洲悉尼上大學，在那裡很開心；我很討厭香港，我想我不會在短期內回來。在悉尼，我可以與任何人混得很熟，他們不會企圖詢問我的來歷，這才是一個真正多元文化的社會。

如真的有人問及有關我的民族問題，他們大概會猜我來自亞洲或太平洋島國。很多時候，別人都會正確地猜出我是混血兒。我也發現，人家對我的背景很感興趣。

在香港，我會覺得自己既是亞洲人，也是西方人；在悉尼，我覺得自己較像中國人。說到底我也是在香港長大，不像我的朋友，長大於悉尼。

我從來不覺得自己的民族認同是個問題，並對此很放鬆和適應，我就是我。

Most of my friends in Hong Kong are Eurasian so I don't really feel different or special in any way. Although I did feel closer to my Eurasian friends in school, I don't perceive any great divide between the Eurasians and the non-Eurasians.

I'm at university in Sydney at the moment and I'm happy there. I got sick of Hong Kong and I don't think I'll be coming back anytime soon. In Sydney, I'm able to mix with anyone and people do not tend to question me, it is such a multicultural society.

If people do ask my ethnicity, they tend to guess either Asian or Islander. Quite often, people will correctly identify the fact that I'm mixed. I do find that people are interested in my background.

I suppose in Hong Kong I feel both Asian and Western and in Sydney I feel that little bit more Chinese. At the end of the day, I did grow up in Hong Kong unlike my friends there.

I'm laid back and adaptable. I've never had an issue with identity, this is just me.

My ancestors on my father's side were Dutch in origin and arrived in Batavia (Jakarta) in 1730, six generations ago, and sailed around with the Dutch East Indies fleet before settling in Malacca in 1757. The third generation married outside of the Dutch community to a Portuguese girl. The Portuguese Malaccans were not 100 per cent Portuguese – many came from Goa, a Portuguese colony in India, and the mix was already there. My paternal grandmother's family name was 'Cropley', probably English in origin.

My maternal grandmother's family name was 'Scherder' (probably Dutch or German) while my maternal grandfather's family name was 'Clarke' whose ancestors were an Englishman married to a Chinese lady.

I have two daughters: one is married to a Caucasian American and the other to an American Filipino. They live in the USA and my six grandchildren have an even more exotic mix! My family can be found in five continents (including Australasia) and every four years we have an international reunion. So far, we have met in California, Singapore/Malacca & Australia with the next one in Canada in 2012.

My original birth certificate shows that I was born in 'Syonanto' – the Japanese name for Singapore – between 1942 and 1945 during the Japanese occupation. As a Eurasian, I was considered a British subject, as were all Eurasians at that time. My father avoided being interned as he worked for the Registry of Motor Vehicles, which was considered an essential job by the Japanese, so we were lucky.

There was a proliferation of Eurasians in the Straits Settlements – Penang, Malacca and Singapore. Historically, these Eurasians were Portuguese, Dutch and British. I suppose the ethnic basis for the Asian side was largely Malay, Chinese, Indian & Ceylonese.

In Singapore, the British Colonial Government actually created the Eurasian community. They needed us for many governmental and administrative jobs on account of our language skills and Westernised educated outlook, but at the same time they did not really want to mix with us. We weren't able to go into the Singapore Cricket Club, which was the preserve of the British, for example. This gave rise to the establishment of the Singapore Recreation Club (SRC), a sports and social club in around 1830. Eurasians who had a flair for sport were now able to practice and play in their own dedicated facilities. The Eurasians ended up beating the Brits at cricket, hockey and soccer!

The same people then established the Eurasian Association in 1919 to look after the educational and welfare needs of the growing community.

Generally, most Eurasians in Singapore are somehow related, and I grew up with a real mix of people so I have never really felt out of place. Having English as a first language has been a real advantage as the government has consciously evolved to make English an official language. It has also been an advantage in terms of getting overseas work postings.

I have found being Eurasian to be a real ice-breaker. My history has been explained on the backs of various napkins all over the world. My appearance is obviously different but I have never really thought about it. Can people tell me what I am? Well, they can tell me what I am not!

I have worked with Dutchmen overseas who, whilst knowing I was coming from Singapore, have looked at my name and expected another one of their number. It was always amusing to see their reactions when they saw me in person. Being Eurasian provides a lot of scope for interesting encounters with other people. I have got to say, I enjoy tickling them a little!

我父親的祖先均原籍荷蘭，並在六代以前約1730年移居到巴達維亞（今雅加達），再繞道荷屬東印度河域，最終於1757年在馬六甲定居。他們到第三代，開始與荷蘭籍以外民族通婚，一名子嗣與葡萄牙女子成婚。葡籍馬六甲人並非100%葡萄牙人——很多來自葡萄牙在印度的殖民地果阿，自那裡開始滲雜了混血兒的血統。我的祖母姓'Cropley'，祖籍可能源自英國。

我的外祖母姓'Scherder'（可能是荷蘭人或德國人），而外祖父則姓'Clarke'，祖先是英國人，與一名中國女子結婚。

我有兩名女兒：一個嫁了給一名美國白人，另一名嫁了美國菲律賓人。他們都在美國居住，而我的六名孫兒有更具異國味道的混血關係！我的家人分別住在五大洲不同地方（包括了大洋洲），每四年就會來個國際性的家族團聚。至今我們曾在加洲、新加坡/馬六甲、澳洲聚過，下一次將會是2012年在加拿大團聚。

我的出生證書上記載我出生於'昭南島'——那是日佔時期新加坡的日文名稱。作爲歐亞混血兒，誠如當時其他混血兒一樣，我被視爲英籍人士。因爲父親在車輛註冊管理局工作，被日軍視爲重要工作，所以幸免於被扣留，我們算是走運的了。

因爲英屬海峽殖民地（包括檳城、馬六甲和新加坡）的關係，混血兒有增生的趨勢。歷史上這些混血兒均爲葡萄牙裔、荷蘭裔和英裔。我相信在亞裔這半邊血統，則大多是來自馬拉人、中國人、印度人及錫蘭人。

在新加坡，其實是英國殖民政府建立了混血兒社區的，他們需要我們去填補不少政府及行政崗位，因爲我們優越的語言技巧，以及像個西方受過教育的一群；雖然如此，他們卻不是真的想和我們交流相處。例如我們並不可以到專爲英國上流社會而設的「新加坡板球俱樂部」，所以才導致在1830年成立了「新加坡休閒俱樂部」(SRC)，作爲本地人的體育和社交場所。混血兒才有自己的設施，發揮和鍛鍊體育運動方面的天賦，最終在板球、曲棍球及足球方面打敗了英國人！

同一班人也在1919年成立了「歐亞裔人士協會」，以照顧日益擴大的混血兒社區，在教育及福利上的需要。

一般來說，新加坡的混血兒都在某程度上有所關連，我就在一群混合各種不同民族的人之間長大，所以從不會覺得自己在這個地方格格不入。以英語爲母語真有益處；尤其當政府逐步推廣以英語作爲官方語言，此外，英語能力也對外派海外工作有利。

我覺得作爲混血兒真的能夠打破隔閡，我在世界各地發生的故事就可以證明這個說法。我的外表明顯地與衆不同，但我從來沒有認真的想過。別人可以說出我是誰嗎？嗯，他們只可以告訴我，我不是那個民族的人！

我曾與海外的荷蘭同事共事，他雖然知道我在新加坡，然而在電話簿見到我的名字時，總覺得應該是一個本地號碼。與他們踫面，他們見到我的長相時的反應總是很逗樂的。作爲混血兒給我很多機會與別人有不一樣的有趣的接觸。我不得不說，我很愛偶爾作弄一下他們！

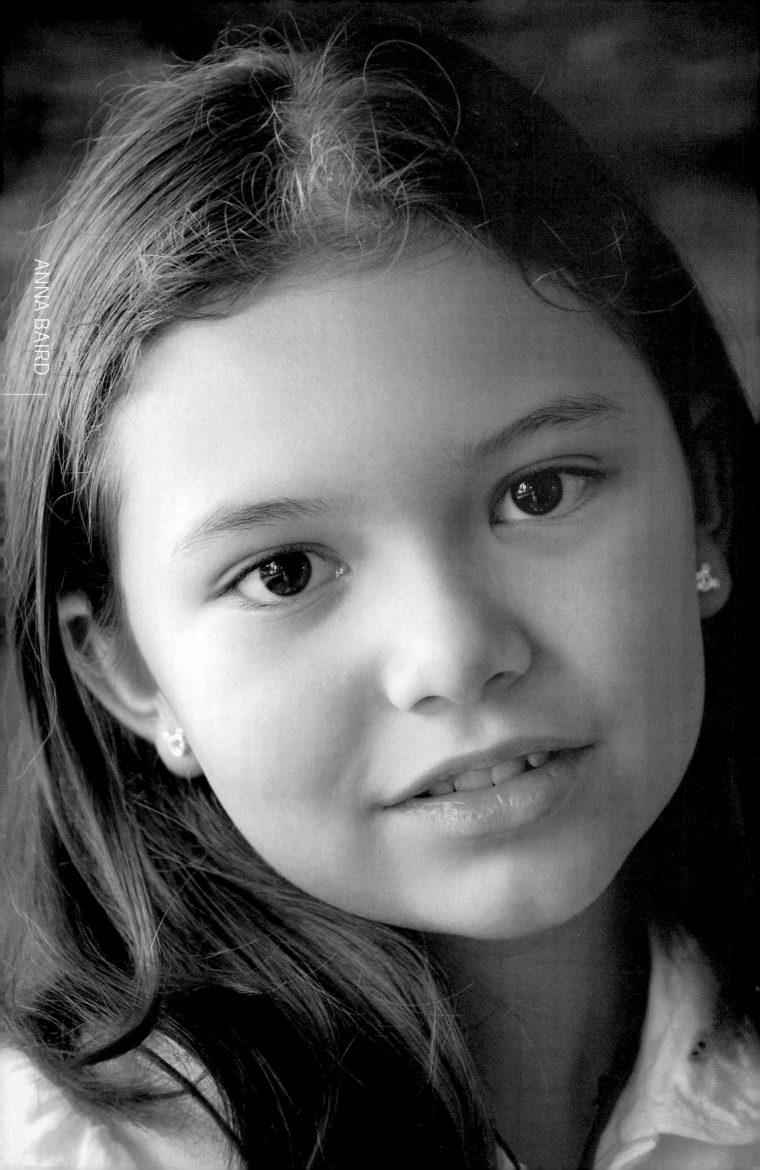

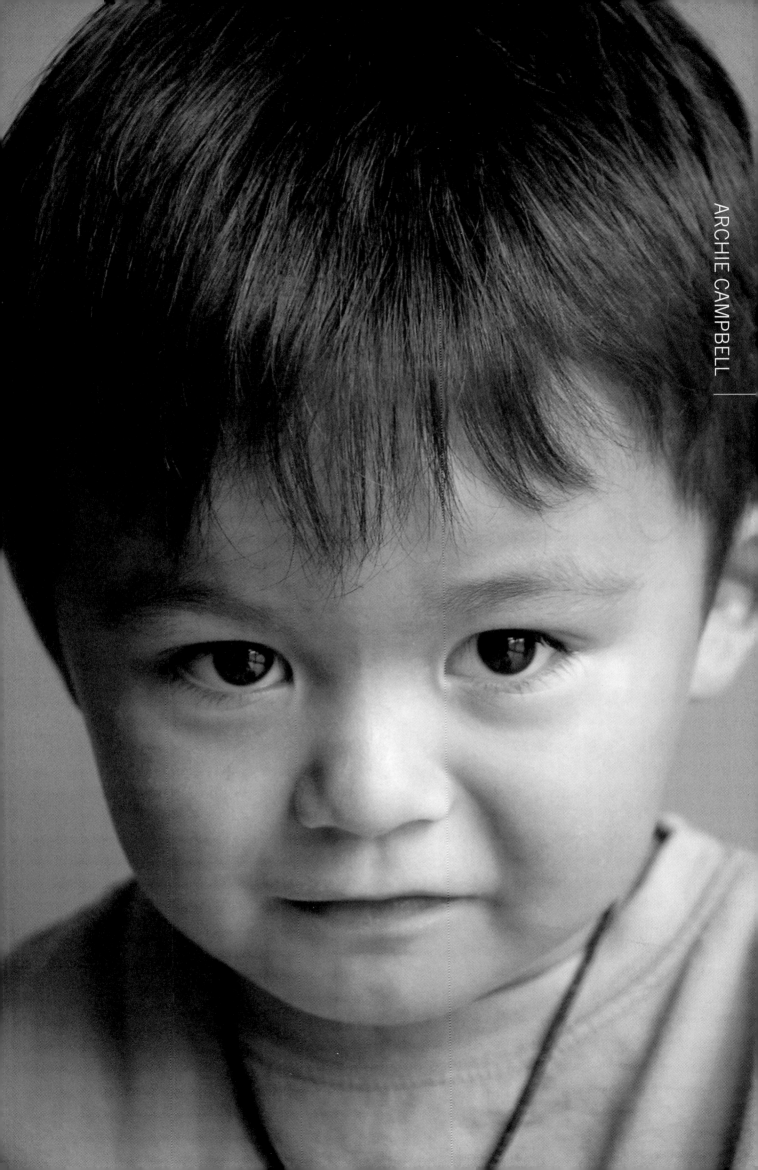

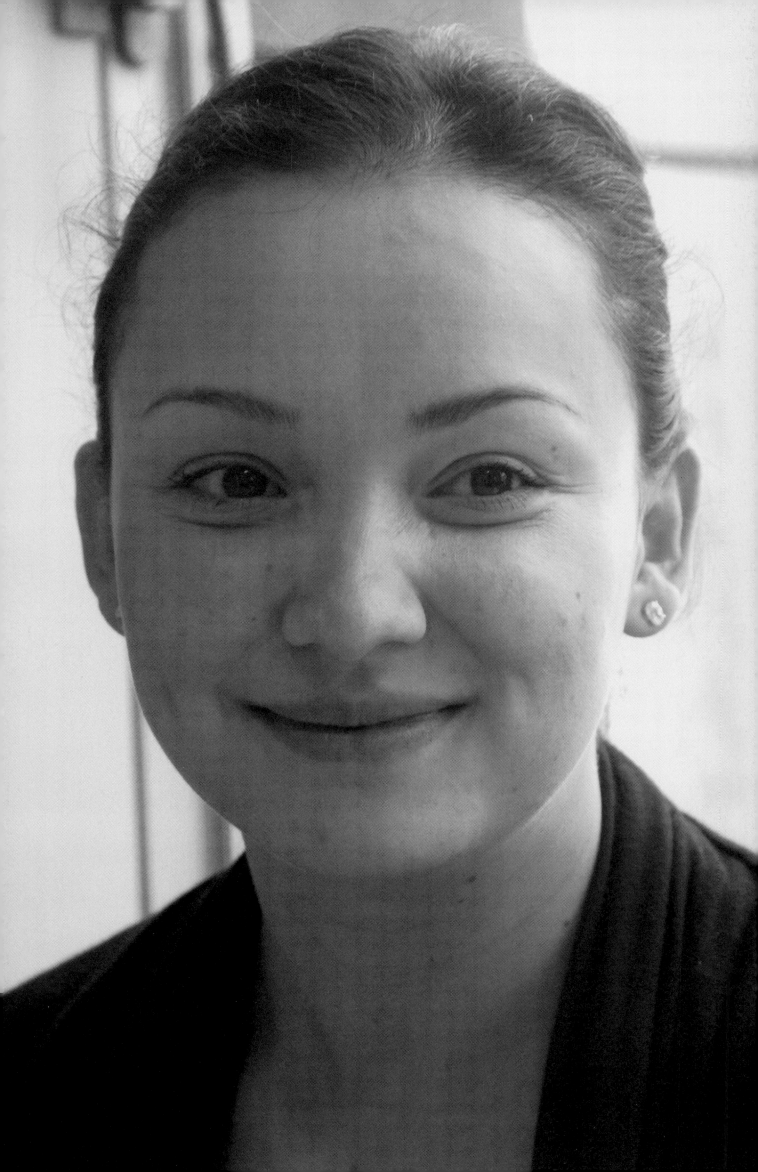

我的母親是中國人，而父親是英國人，他們在香港生了我。雖然我到處遊歷，但我從來沒有在其他地方居住過。在五歲以前，我的母語是廣東話，我開始入學是就讀於本地的中文學校。我知道我的同學們因爲我淺色的頭髮和不同的輪廓而對我另眼相看，而且對於我會說流利廣東話也顯得很困惑——他們對於我的背景應該是絕對好奇的。

無可否認，在我進了國際學校以後，身邊多了其他混血兒朋友，生活過得自在一些。但那不代表我背棄了我的中國人的一面，我的外祖母對我的早年成長有著重要的影響，所以我有部份亞洲人的價值觀仍舊存在。例如我在懷孕時，堅持依照中國人的分娩習慣。如果我不是混血兒，我很懷疑自己是不是還會理會這樣的傳統。

我在兩種文化間從沒有覺得爲難，反而覺得很自然，因爲自小已在這兩種文化薰陶下長大。在成長期間，父母親並不覺得需要幫我爲兩者協調，他們就順其自然讓我習慣不同文化，而我也從不覺得有問題。當我長大時，我才真正開始珍惜我的特殊背景，讓我可以得到兩個不同世界中最好的東西，從中選擇我想要的生活和習慣。

我在服務界工作，作爲混血兒從事相關工作是很有利的。我要和不同的人聯絡，作爲會說廣東話的混血兒，總是很容易打開話盒。本地人總會好奇爲什麼我會說這種語言，人們總會記得我是一名會說中文的「鬼妹」。

在亞洲有時候會有人誤以爲我是泰國人，不過大多數時間，別人都說得出我是混血兒來的。記得有一次，我以中國簽證過境時，被人問是否來自新疆省。

我見到其他混血兒時，絕對有股即時的感應和聯繫；那不是言語所能形容，我們就是和對方有一種不可言喻的共識。

My mother is Chinese and my father is English. I was born in Hong Kong and whilst I have travelled extensively, I have never lived anywhere else. Cantonese was my first language until the age of five and I began my education at a local Chinese school. I know that my fellow classmates viewed me differently on account of my lighter hair and were baffled by the fact that I could speak Cantonese – they were definitely curious about my background.

Admittedly, it was more comfortable for me when I moved to an international school where there were a number of other Eurasians. That is not to say that I left my Chinese side behind – my Chinese grandmother was very influential in my early upbringing so some of my values remained rather more Asian. For example, when I was pregnant, I was insistent on following the Chinese confinement practice. If I were not Eurasian, I doubt I would have followed this tradition at all.

I have never felt torn between the two cultures as I was brought up knowing both – that is my normality. My parents did not feel the need to help me reconcile the two sides when I was growing up, they just let me get on with it and I never felt it was a problem. However, as I get older I have begun to really value the fact that I have the best of both worlds. I can choose what I feel is right for me and I certainly appreciate having such an option.

I work in the hospitality industry so being Eurasian in this field has its advantages. I have to deal with different types of people so being Eurasian and being able to speak Cantonese is always a good conversation starter. It can draw attention when I speak Cantonese as locals are curious as to why I speak the language. People tend to remember me easily as the "gwei mui" who speaks Chinese.

Sometimes in Asia people think that I am Thai. Mostly people can tell that there is some sort of mix. On one occasion I was travelling on my Chinese permit in China and was asked if I was from Xinjiang province.

I absolutely do feel an instant bond with other Eurasians. It is an unspoken type of bond as if we all have this common understanding of each other.

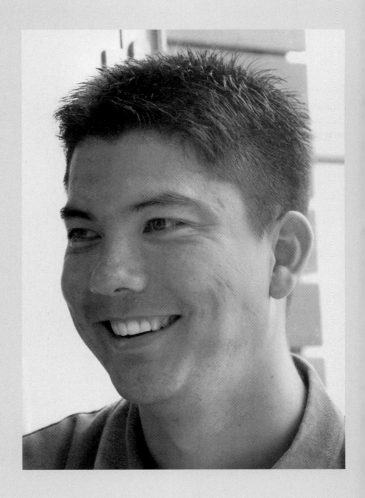

I am the same mix as my wife, half English and half Chinese. I was also born in Hong Kong and have lived here my whole life apart from university when I went to England.

If I had to say to which side I feel more inclined, I would say that I feel slightly more Western partly because I watch more English TV, speak English 80% of the time and think in English. However when I am with Western friends I can distinctly feel the Asian part of me.

I do not feel torn between my two cultures as I do not feel a need to comply with either, but instead make decisions based on what I think is best. However, the difficulty of reconciling my two sides can arise when dealing with parents – in my mind, the cultural pressure emanates from them as opposed to anything that I bring upon myself or is intrinsic in me. Going to Western schools and university I think it was a battle for my mum to keep the Chinese in me. Even growing up in Hong Kong it is easy to be totally Westernized, so the Western part was always there. My dad did not have to do too much with regards to that, but my mum was always trying to keep the Chinese side alive and at times it did feel like a battle!

I speak Cantonese and being able to understand both languages does make day-to-day life easier. Despite being born and bred in Hong Kong, many locals do not see me as local when I speak English. I have learned when to be a local and when to be a foreigner in terms of getting what I want – especially when dealing with customer services! I always cheer up locals when I speak Cantonese because it is not the language they expect to hear out of my mouth. People seem to find it very intriguing and are interested to know which mix I am and the languages I speak. It can certainly be an ice-breaker.

Being a pilot we must do things in English but perhaps being Eurasian has given me a competitive edge compared to locals in the interview process since my English is totally fluent.

Looking back, I would say growing up as a Eurasian was great! Although I admit that there were times at school when other kids would tease me for not being a 'thoroughbred', or having no home, I now see it as an absolute advantage. Having exposure to the best of both worlds is a great thing and especially as an adult I get to pick which bits I like and dislike about both sides and try to end up with all the good bits! There are no issues about belonging as I know I belong in the middle!

Strangely, I feel right at home with other Eurasians, even if I have only just met them. I guess it is like someone meeting a fellow countryman halfway around the world. There are not that many Eurasians so it is always nice meeting others!

我和太太有著相同的血統，就是半中半英，我也是在香港出生，在這裡生活了一輩子，除了在大學的幾年到了英國讀書。

如果要我說自己傾向那方面比較多，我會說是西方，可能因爲我較多看英語電視，八成時間都以英語溝通，和以英語思考。然而在我的西方朋友面前，卻立即可以感受到自己亞裔的一面。

我在兩種文化間同樣不覺得爲難，我也不認爲要作任何妥協，就以自己覺得最好的方式作決定就好了。然而，要協調父母間對於兩種文化的不同心態，有時卻存在困難。在他們倆所表現出對文化認同的壓力，遠遠大於我自己內在的或遇到的。例如我到西方的學校和大學讀書，母親就爲此鬥爭著，堅持要我保留中國文化的一面。即使在香港成長，你也很容易變成一個完全的西方人，所以我內在西方文化的一部份永遠都存在，父親也不用多做點甚麼來保留英國文化。反而母親卻常常要我保存中國文化的一面，有時候也真的像中西大戰！

我會說廣東話；能夠明白兩種語言，真的會令日常生活容易一些。雖然我在香港出生和成長，但當我說英語時，很多本地人並不把我看成土生土長的香港人。我已學會爲了想要達到目的，甚麼時候要做本地人，甚麼時候要做外國人，尤其是面對客戶服務的時候。我說廣東話的時候，常常可以取悅本地人，因爲他們認爲那不應該是出自我口中的語言。看起來他們覺得我很神秘而有趣，並想知道我是甚麼民族的混血兒，會甚麼語言等。這絕對是跟別人打破隔閡的好辦法。

作爲飛機師，我們的工作語言是英語。相比本地人，混血兒的身份可能成爲我在見工時的優勢，因爲我的英語是完全流利的。

回首過往，我覺得作爲混血兒，我們的成長經歷是很棒的！雖然有時候會給同學們取笑我非「純種」，或沒有家鄉，現在我覺得那是絕對有利的。吸收兩種文化最好的東西，長大後我會選擇適合自己和喜歡的部份，那將是更加完美。歸屬感並不是問題，因爲我知道自己其實是屬於兩種文化中間的！

很奇怪地，就是第一次見的混血兒，我也會覺得他們很熟識。我猜那就如同他鄉遇故知吧。世上實際沒有那麼多的混血兒，所以遇上他們是很難得和開心的事！

Debbie and Colin on their marriage

As a married Eurasian couple we feel that we can achieve a deeper understanding of each other as well as each other's families and backgrounds. This is especially helpful when it comes to celebrating and maintaining both English and Chinese customs and holidays. We understand the way both cultures think and how they can differ wildly.

We imagine that being married to a non-Eurasian would be very different, especially when it comes to food! We often joke that if we were not married and our partners were Western then we would not eat Shanghainese hairy crabs, or street stall food in Mong Kok, or chicken's feet at dim sum.

As we both speak English and Cantonese, when with friends we don't feel the need to keep to one language to keep the other person in the loop. We can be with a group of Chinese friends speaking Chinese or Western friends speaking English and no-one is left out of the conversation. When we're alone we speak mainly English but sometimes there are words which are better expressed in Cantonese. Also if certain things like dim sum names are known to us in Chinese then we use the Chinese name only.

I imagine that if we were married to Westerners it would be hard for our partners to accept some of the Chinese customs and ways of doing things. For example, when we got married we had a Western-style wedding yet had the Chinese tea ceremony as part of it. A Western spouse might not have appreciated that. Being half Chinese ourselves helps in accepting some of the more traditional Chinese ways which can be thrust upon us and which can go against the more modern Western way of thinking we use ourselves. Sometimes you just have to take a deep breath and accept it.

Being so close to another Eurasian has not really had the effect of drawing out either our Chinese or Western sides. In terms of

Katie Parker

'Eurasianness' we are pretty evenly matched and that makes life so much easier!

Without going into DNA and chromosomes, we would definitely say that our daughter is Eurasian. She certainly looks it! She will be brought up speaking both languages and be exposed to both cultures. However with both parents as Eurasians, she is not going to have either of us trying to force Western or Chinese values onto her as perhaps we experienced with our parents. We want our daughter to have the best of both worlds and be more open-minded and diverse, but we are not consciously raising her the Western way or Chinese way, just our own way. We will definitely teach her about both Western and Chinese festivals and traditions and encourage her to respect and understand both cultures – but at the end of the day, we will respect her choices as she grows up.

We would say that being Eurasian features in our lives every day, when we go out for meals, meet our families or friends. Even the way our flat is decorated is with contemporary Chinese furniture… Western-looking Chinese furniture if you like. That is like Eurasian furniture! We watch both English and Chinese TV at home and eat a good mix of both foods. None of that would be easy if we were not both Eurasian.

Debbie 和 Colin 結婚

作爲一對混血兒夫婦,我們覺得大家可以在對方本身、他的家庭和背景上,有更深了解。那對於慶祝中西文化的不同節日,以及保留他們的習俗和文化傳統,都非常有幫助。我們明白兩種文化的思維模式,以及兩者之間可以存在多大的分歧。

我們可以想像,如果與非混血兒結婚,生活將有很大的不同,尤其是在飲食文化方面!我們常常笑言,如果另一半是西方人,我們就不會吃上海毛蟹、旺角的街頭小吃、或點心裡的雞腳了。

因爲我們倆都會說英語和廣東話,和朋友聚會時,我們不需要刻意保持一種語言,而令對方跟得上對話內容。我們可以輕鬆地以中文和中國朋友圈交流,或以英文和西方朋友們傾談,雙語交流對我們兩個都不是問題。若只是單獨交談,我們會說英語,有些字我們卻覺得廣東話表達比較傳神,有些專有名詞如點心名,我們則只會用中文。

我想如果我們的結婚對象是西方人,對方很難接受一些中國人的習俗或做事方式。例如我們結婚時,在西式婚禮中,加插了中國奉茶的環節,西方的夫婦不一定欣賞這些禮節。作爲半個中國人,我們更能接受一些中國傳統習慣,雖然那可能與我們的現代西方思維背道而馳;有時或許需要一口氣把這些奇怪的習俗吞下去。

與另一個混血兒如此親密,並不代表我們會因而引發出我們中國或西方的一面。我們的「混血兒化」很平均和相配,所以我們的生活也因此而變得更輕鬆。

不用檢查DNA或染色體,我們也可以肯定女兒是混血兒,因爲她長得絕對像!以後她將成長在一個雙語及雙文化的環境下。她有一對同樣是混血兒的父母,則不會好像我們的父母對待我們那樣,受到他們將西方或中國的價值觀強加於兒女身上。我們希望女兒擁有兩個世界最好的東西,對待世界及新事物時,能夠心胸廣闊及不存偏見,保持多元化發展。同時,我們不會刻意以中國或西方形式撫育她成長,只會順其自然;當然我們會教導她兩種文化的節日及傳統,以及鼓勵她明白及尊重不同文化,然後待她在長大以後,自由選擇最適合自己的生活方式。

我們覺得混血兒的特徵充滿在我們的生活之中,不管是出外吃飯、見家人和朋友,就是家居裝飾,也用了當代中式傢俱———或者叫西式的中國傢俬吧,那就是混合文化的家居設計啊!我們在家會看中文和英語的電視節目,吃中西食品。如果我們不是夫婦兩人都同時混血兒,一切都不會來得那麼容易和自然。

JASMINE BOLTZ

STUDENT 學生

My mother is Chinese and my father was a Polish/Jewish refugee who fled to Shanghai during the war. They met in Hong Kong having escaped Communist China and I was born here. At that time, inter-racial marriages were rather looked down upon and the Chinese described Eurasians as 'Jaap jung' (which is comparable to being called a mongrel). My background is unusual, and not only on account of my father's Jewish background. My mother's family were all educated to university level – even the women. My father was Jewish, my mother Catholic and my maternal grandmother Buddhist, so the family relationship was not only inter-racial but inter-religious. As a result I am very fascinated by and embracing of all religions.

I was largely cared for by my maternal grandmother and I would say I was raised as Chinese. My father spoke several languages, including Chinese so the Western influence during my youth was somewhat weaker. There was never very much interaction with Europeans. I went to Maryknoll Convent School for primary and St Mary's Canossian College for secondary education; they were local schools and there were only two Eurasians in my entire year at primary school – I stuck out like a sore thumb! However, the other students treated me no differently. Although they teased me a little, calling me 'gwei mui', it was never malicious. I suppose at school I was considered exotic. The teachers always noticed me and I was often picked to stand at the front in photographs or to read poetry in front of the class. I suppose I was conscious of being different but it never really bothered me. As a result of attending a local school unlike many Eurasians who attended English schools, I can read and write Chinese, and speak Cantonese fluently. My mother, father and grandmother were also Putonghua speakers, so I learnt to speak Putonghua from listening to them converse with their friends.

Many of my friends are Chinese, although I am still 'gwei po' to a lot of them. Growing up, I was also very close to my extended Chinese family, especially my cousins. They never treated me differently for being mixed. I was dressed in Chinese style – my grandmother used to handmake my 'mein laap' (Chinese quilted jacket). Some of my neighbours were also Eurasians and to this day we are still in touch.

I ended up completing my education in Australia. I've spent about thirty years of my life in Hong Kong but have been living in Australia for the last three years and recently shifted to the USA. Although my morals and values are most definitely Chinese, I do have a mixed outlook. In terms of social intercourse I am definitely more typically Western – I am independent and outspoken; concepts of justice and fairness are very important to me. My mother always told me that I would never make a good, typical Chinese daughter-in-law! I have found it very difficult to meet a Chinese or Eurasian man who could match my temperament. I ended up marrying a New Zealander and have 3 sons. The question of culture really came into play when the issue of how we should raise our children arose. My Chinese values (especially with regard to education) became apparent and were at odds with my husband's more relaxed approach. I have tried to pass on some Chinese culture onto my children – I am proud to say that they also speak Chinese and value being able to do so – it is a real asset. I am so delighted they have all embraced Chinese language as part of their University curriculum.

In terms of appearance, I used to look much more Western as a child – quite Jewish in fact. As I grew older, my hair has darkened and my appearance has become much more Asian. I am a bit of a chameleon, everywhere I go in Asia people assume that I am local. That reflects how I feel really - I adapt to foreign surroundings very easily and have made friends all over the world. My background has made me a very 'international' person, someone who endeavours to understand and appreciate the cultural and religious backgrounds of others.

Although things have no doubt improved for Eurasians since I was a child, I am reluctant to say that the difficulties and challenges I faced affected me. I truly believe that my experiences added strength to my personality, they did not diminish me at all. I hope the Eurasian children of the present times will also learn to harness their uniqueness; perhaps the world will be a more peaceful place if growing up with a diverse background could help bridge some of the cultural and religious divides around us.

我的母親是中國人,而父親則是波蘭/猶太裔難民,在戰時逃亡到上海。父母親在逃離共產中國後,在香港認識,並生下了我。那時候異國婚姻被瞧不起,中國人稱混血兒爲"雜種"(即混血)。我的背景很特別,不單純因爲父親的猶太背景。母親全家均接受大學教育——就是女性也不例外。父親爲猶太裔,母親爲天主教徒,外祖母爲佛教徒,所以我的家人不只是跨民族,還是跨宗教。於是,我身邊都包圍著各個宗教,而我也著迷於這樣多元化的世界。

我主要由外祖母照顧帶大,我會說自己是成長在中國人的環境。父親會說多種語言,包括中文,所以在年少時西方文化對我有較少影響,從來都沒有很多機會接觸歐洲人。我在瑪莉諾修院學校就讀小學,並在嘉諾撒聖瑪利書院接受中學教育,兩家均爲本地學校,小學時整個年級只有兩名混血兒——我在班中顯得鶴立雞群!然而,其他同學對我並沒有兩樣。雖然,有時他們會取笑我是「鬼妹」,但從沒有惡意相待。我想我在學校算是異乎尋常的一個,老師總會留意到我,在拍照時也常被挑選出來站在前排,或被選出來在班上朗讀詩詞。我相信我當時是注意到自己與眾不同,但那對我並無任何影響。就因爲我就讀的是本地學校,可以讀寫中文,與其他就讀英語學校的混血兒不一樣。我的母親、父親及祖母均會說普通話,所以從他們及朋友間的對話裡,我也學會用普通話。

我很多朋友也是中國人,雖然對他們來說,我仍然是一名「鬼婆」。在成長的過程中,我與我的中國人大家族維持緊密的關係,尤其是我的堂表兄弟姐妹。他們對我這個混血兒親戚並沒有兩樣,那時我穿的是中式衣著,外祖母也常常爲我親製棉襖。有些鄰居同爲混血兒,而我們至今仍保持聯繫。

我最終在澳洲完成學業。在香港渡過了約三十個年頭,過去三年才遷居澳洲,直到最近才移居到美國。雖然我的道德和價值觀非常中國化,我的中西混合的外表卻不然。在社交層面上,我絕對是典型的西方人——獨立、敢言,相當重視正義與公平。母親常說,我永遠不會成爲一名傳統的典型好媳婦!我發覺很難跟得上跟我性急的脾氣相配合的中國或混血男友。最終我嫁予一名紐西蘭人,並養育三子。當我們要決定孩子成長方式及其教育時,文化差異所引起的問題,才真正出現。我內在中國人的價值觀(尤其教育問題上)漸漸明顯浮現,並與我丈夫那輕鬆自由的學習方式出現分歧。我嘗試在孩子身上灌輸中國文化——及後他們學會說中文及認同懂得中文是他們的寶貴的優點,我很以此爲榮。同時,我也很高興他們在大學裡,均曾修讀中國語文,作爲其大學課程的一部份。

在外型上,小時候的我看上去很像一個外國人,或者說是很像猶太裔。漸漸長大後,我的頭髮長得越來越黑,我的外表漸漸變得像亞裔。我像是變色龍一樣,在亞洲去到那裡都被認爲我是本地人。那也正正反映了我的感覺——我很容易適應異國環境,在世界各地都有朋友。我的背景令我成爲很「國際化」的人,竭力去了解並欣賞不同的文化及宗教背景。

雖然現在對混血兒來說,他們面對的生活環境比我小時候確實改善了很多,我並不想承認我曾被我所面對的困難和挑戰影響。我深深相信,我的經歷令我的性格更爲堅強,困難並不會令我低頭。我希望現今世代的混血兒,都一樣可以學會利用他們獨一無二的身份;假如在多元化的背景下長大,有助於不同的文化與宗教分歧間的互相溝通和了解,或許這世界會變得更和平。

My mother is Scottish and my father is Chinese, I was born in Hong Kong and live and work here presently.

Unlike many Eurasians in Hong Kong, I actually attended a Chinese kindergarten and a Chinese primary school until Primary 5 before attending an English-medium international school. Despite my appearance and mixed ethnicity in a school dominated by local Chinese, I was treated much like everyone else – I suppose the only difference was that I was expected to get 100% in English every time! I guess it could be considered unusual that I am able to read and write Chinese, I went to England at 16 for college and strangely, I was required to sit exams in English despite having attained 2 A's in English at GCSE. I adjusted to English life easily and had no problems blending in with the other kids. My ability to move between the two cultures came into sharp focus at college when house meetings were divided between 'locals' and 'foreigners'. Notwithstanding my mixed blood and the fact that I had lived on the other side of the world my entire life, I was deemed 'local'.

On the other hand, I have always maintained strong ties with my Asian side. I still go every Sunday to have dinner with my grandma in Tsuen Wan. It's so nice to have a real local family. Saying that, it used to get to me a little that whilst all my western friends got to go on nice holidays, I had to remain in Hong Kong to celebrate the various Chinese festivals. Still, it's really nice to have a local family and celebrate all the local customs.

Not many people know that I can speak Chinese. When people guess my ethnicity, they tend to say Hawaiian, Thai or Malay. Actually, when I travel around Asia, be it Philippines, Indonesia or wherever, people seem to assume I'm local and start talking to me in the local language!

I would say that whilst I live a largely western lifestyle, I most definitely have Chinese values. Being Eurasian is definitely the best of both worlds.

我的母親是蘇格蘭人，父親是中國人，我在香港出生、生活，並在此工作而今。

與香港的其他混血兒不一樣，我就讀於中文幼稚園、小學，直至小五才進入英文國際學校。雖然我的外表與混血種族和別人不一樣，在一所由華人學生主導的中文學校裡，我的待遇和其他同學都沒有兩樣——唯一不同的，是每次英文試卷，大家都期望我會取得滿分！我相信會讀寫中文這點對其他人來說是很特別的事。我在16歲那年來到英國升讀大學，雖然我已取得 GCSE 兩科英語A等成績，很奇怪地，我仍被要求參加英語測試。我很容易地融入英國人的生活，與當地的孩子相處亦全無問題。我在兩種文化間可以輕鬆融合相處的能力，在大學開會時，當與會者分成"本地生"和"外地生"兩派對立時，立時大派同場。儘管我是名混血兒，而且一直以來都在世界的另一端生活，我仍被視為「本地人」。

另一方面，我總是與我亞裔親人維持緊密的聯繫。每個星期日，我依然會到荃灣與我的祖母用晚餐；有一個真正的本地家庭，感覺很好。雖說如此，當我的西方朋友都在享受在旅遊渡假的時候，我則要留在香港慶祝各式各樣的中國節日時，我仍會覺得有點兒不好受。縱使我依然覺得有個本地家庭，並與他們一起並渡各本地節慶是件幸福的事。

沒有多少人知道我會講中文。當別人在猜我是那裡人的時間，他們傾向指我是夏威夷、泰國或馬來西亞人。事實上，當我在亞洲各地旅遊時，是菲律賓也好，印尼也好，去到那裡，當地的人都似乎當我是本地人，並會跟我說本地語言。

雖然我總的來說是過著西方的生活模式，但內在卻絕對有著中國人的價值觀。當一名混血兒真的可以擁有著兩個世界最好的東西。

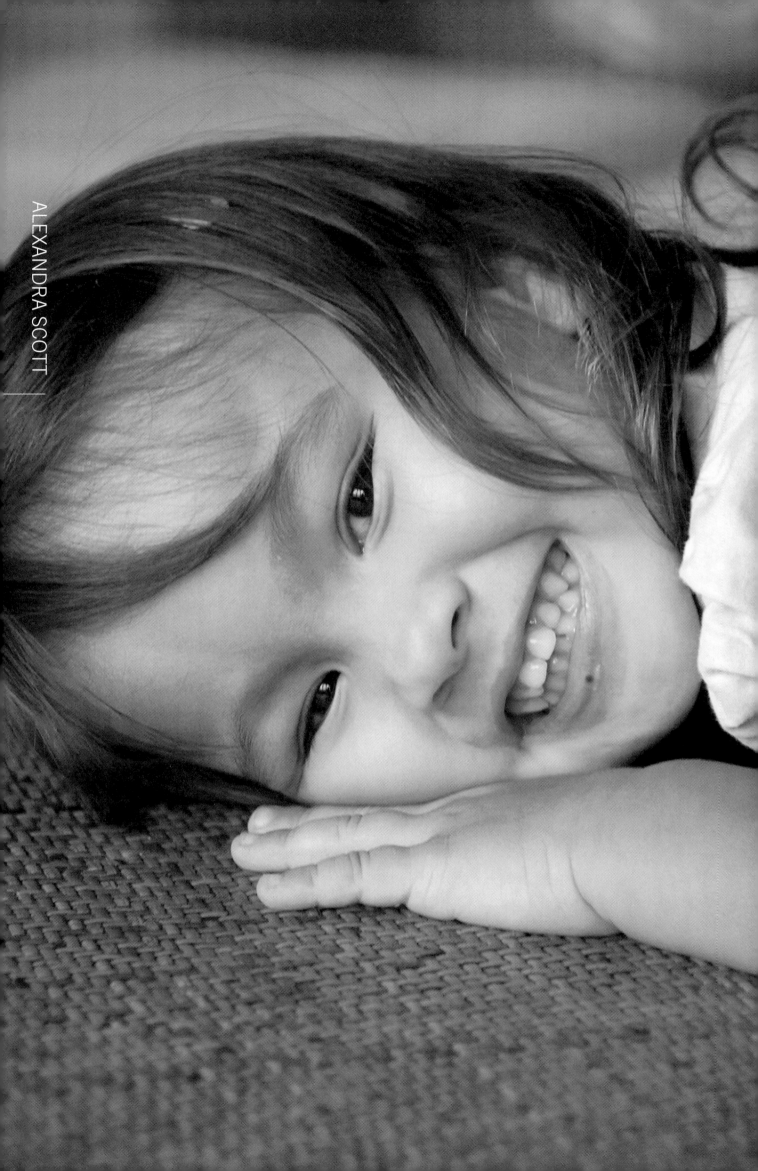

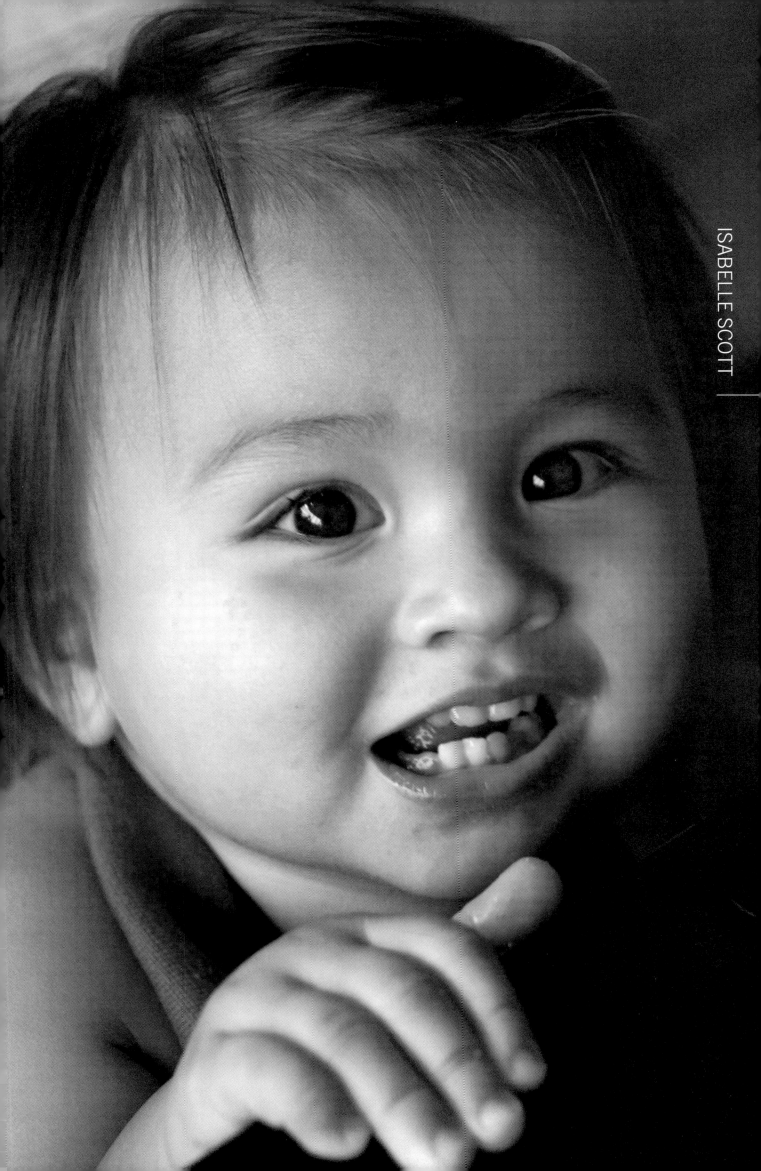

I was born in Kuala Lumpur, Malaysia, but I would define my nationality as British as I have lived in the UK for over 18 years. I live in Cardiff, South Wales and am half Welsh, a quarter Malay and a quarter Chinese.

I've heard people guess I'm from different countries such as New Zealand and South Africa but most people tend to think that I'm from China and might not even realise that I'm mixed. If there is some inkling that I might be mixed, I find that non-Eurasians in the UK usually try to identify me by my foreign ethnicity first. It is generally the Chinese part they get right. The Welsh part is almost secondary and they will rarely realise the Malay part. Perhaps it would be different in Hong Kong – or the same as the case may be – perhaps Chinese people would identify the Western side first! To be honest I don't feel much when people get it wrong, I usually just laugh at their guesses.

I find being Eurasian a positive experience because it's uncommon in the UK so it makes you different from others. I wouldn't say that there are any other advantages or disadvantages to being Eurasian. It's just good to be unique.

I have not been discriminated against for being Eurasian per se, but living in Wales with a Muslim name such as mine was quite difficult when I was in primary and secondary school in the sense that we were the minority. If I remember correctly, my brothers and I were the only children with Muslim names and amongst the few with foreign names. Teachers and class members found it difficult to learn our names. It doesn't help when you're a triplet and they have to try to tell you apart as well!

I only really suffered once because of my name – I was attacked by a group of kids in my year who were well known for fighting and causing trouble. This took place after school when I was walking through a park alone. It occurred after 9/11 and may or may not have been precipitated by that event, but having a Muslim name was the reason for the attack. I was called racist names and held down and beaten repeatedly. It was dealt with by the school and the police quickly though. Other than that I haven't had any real problems, although going through airports these days can be a bit of a trial.

I haven't really ever followed Islam but I was taught it when I was young on account of my mother respecting my father's wishes when they divorced. However, I was never told what religion I should follow. The only rule I can remember was not to eat pork. At the age of 13 we were given a choice to eat pork or not and I chose to eat pork. We were shown both the Muslim and Christian ways of living and nothing has ever been forced upon me. I am currently non-religious due to my views on religion itself.

Being Eurasian is not a common concept in Wales. Most people I have encountered do not understand what it means. I think though it's starting to become a common concept or will do soon.

As for when I am in KL with my Malay/Chinese family, names-wise I fit in perfectly. It's just that as the only Eurasians in the family, my siblings and I do stick out a bit for being different – in terms of our looks and our outlook on account of our views and the society that we have been brought up in. At the end of the day though, I still feel comfortable with them as they are family.

Unfortunately, I don't feel like I know enough about the Malay culture to pass it down to my children in the future. In any event, I would not personally influence my children with religion until they are old enough to understand what it is. If they wanted to learn about or follow Islam then I would support their learning as with any other religion that they might choose to learn about or follow.

When it becomes more commonplace it would be nice to think that 'Eurasian' could be considered a distinct ethnic group in its own right. There is definitely strength in numbers – as a Eurasian I felt more comfortable in Hong Kong, where Eurasians are very common. It's hard to explain why, when part of the appeal of being Eurasian is being different. Eurasians can usually spot other Eurasians; I can usually tell a fellow Eurasian. And thinking about it, I would say there is often an immediate bond between us.

我在馬來西亞的吉隆坡出生，但以國籍來說卻是名英國人，因爲我在英國住了超過18年。我住在南威爾斯的卡迪夫，有一半威爾斯、四分一馬拉和四分一中國人血統。

曾經聽過許多人猜錯我是紐西蘭及南非人，但有很多時候人家都覺得我是中國人，甚至不知道我是混血兒。我覺得在英國的非混血兒，會比較看得出我是外來人，但他們通常都只是說對了中國人的部份，其次就是發現威爾斯人的，很少人說得出我有馬來西亞人的血統。或許在香港會有點不同——也許情況是一樣的——可能中國人會先認得出我的西方人的一面吧！老實說，就是別人猜錯了我是哪裡人，我也不覺得是甚麼，通常我只會一笑置之。

我覺得作爲混血兒是正面的事情，可能因爲在英國混血兒並不常見，所以我們顯得與別不同。我並不認爲作爲混血兒的好處較多，或是壞處較多，但能夠成爲一個特別的人總是好事。

我不曾因爲本身的混血兒身份而受過歧視。然而居住在威爾斯，像我這樣擁有伊斯蘭名字的少數族裔，在上小學和中學時均曾遇過不少麻煩。如果我沒有記錯，我的兄弟和我是全校唯一持伊斯蘭名字的學生，老師和同學都覺得我們的名字很難唸；如果你們是三胞胎，而別人要把你們分辨出來，那問題則更大了！

我只爲了自己的名字受過一次苦——我曾被同年級的一群孩子毆打過，他們是出了名愛鬥和喜歡鬧事。其時我剛下課，正獨自途經公園。那次事件發生在911之後，或者與此有關，又或者不是，然而襲擊確是由我的伊斯蘭姓名而起。他們以歧視種族的稱呼叫我，然後就把我推倒及多番毆打。不過，學校和警方倒是很快處理這次的事件。除此之外，我再沒有遇過甚麼問題；除了現在經過機場的安全檢查時，會有點像過法庭審訊似的。

我其實沒有認真的依從過伊斯蘭教的生活，不過母親尊重父親在離婚時表示的意願，在我小時候曾教過我一點點相關的知識。但是我從沒有被要求過要飯依甚麼宗教，唯一記得要遵守的教條，就是不能吃豬肉。13歲那年，我們有機會選擇要不要吃豬肉，我選擇了前者要吃。伊斯蘭教和基督教的生活我們都接觸過，家人從不會迫使我們過怎樣的生活。現時我並無宗教信仰，那全是根據我自己的想法而決定。

在威爾斯，歐亞混血並不是普遍的事情。我遇過不少人，都不清楚歐亞混血兒是甚麼一回事。然而我相信混血兒這概念將越來越普遍。

當我在吉隆坡，和我的馬拉/中國家人在一起時，在名字上我們和家族相當融洽。作爲家中唯一的混血兒，我的兄弟和我與別人不同的地方，在於我們的外表，以及我們的世界觀和價值觀，以及成長背景的迥異。但始終他們和我們都是一家人，我總仍覺得和他們相處舒適。

然而不幸地，我認爲我對馬拉文化的認識並不深入，因而不足夠在日後承傳到下一代去。不管如何，將來有孩子的時候，我也不希望在孩子沒有長大和明白何謂宗教以前，以我的個人看法來影響他們對宗教和信仰的概念。如果他們希望認識伊斯蘭教，或飯依這個或任何其他宗教，我都會支持他們。

當混血兒變得越來越普遍時，「混血兒」本身可以成爲一種獨立的民族，將是一個不錯的概念。爲數多少絕對影響一個民族的影響力，在香港，因爲混血兒相當普遍，我在這裡生活也較爲輕鬆自在。很難解釋爲什麼作爲混血兒，其吸引力之一在於我們的與別不同。以我爲例，混血兒通常都可以分辨出其他混血兒；就這樣想，我會說我們之間是有種莫名的即時聯繫和凝聚存在的。

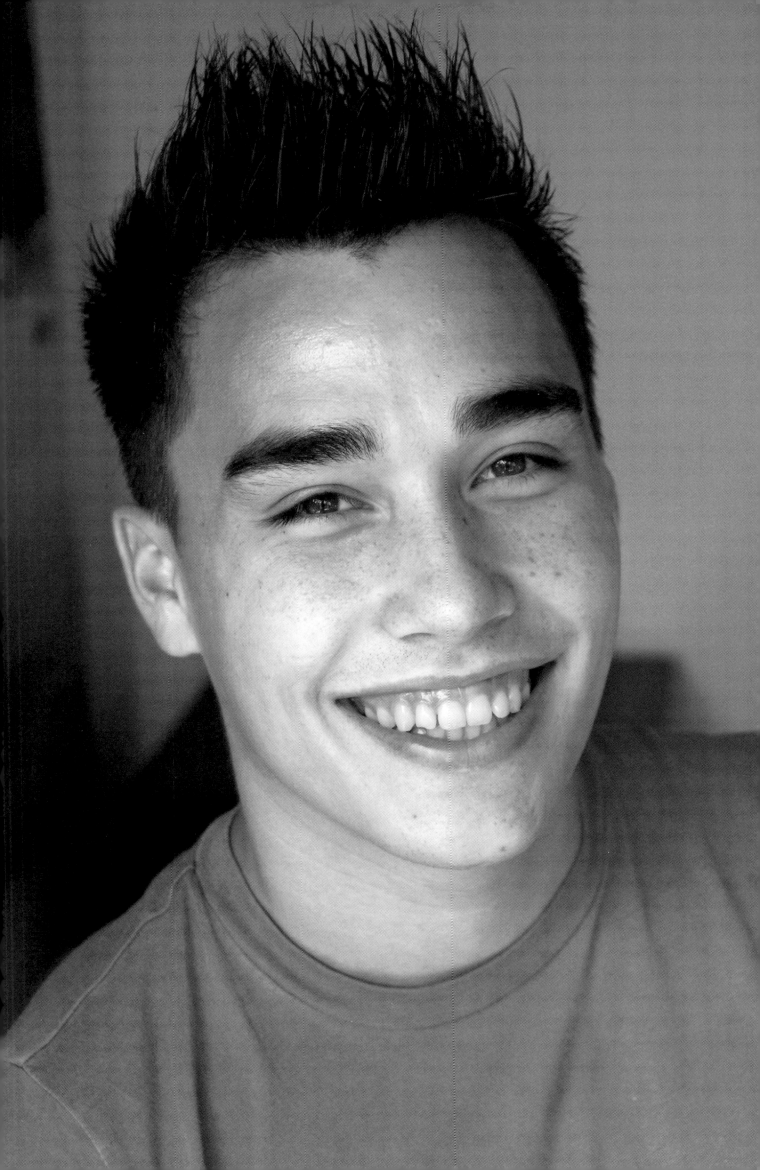

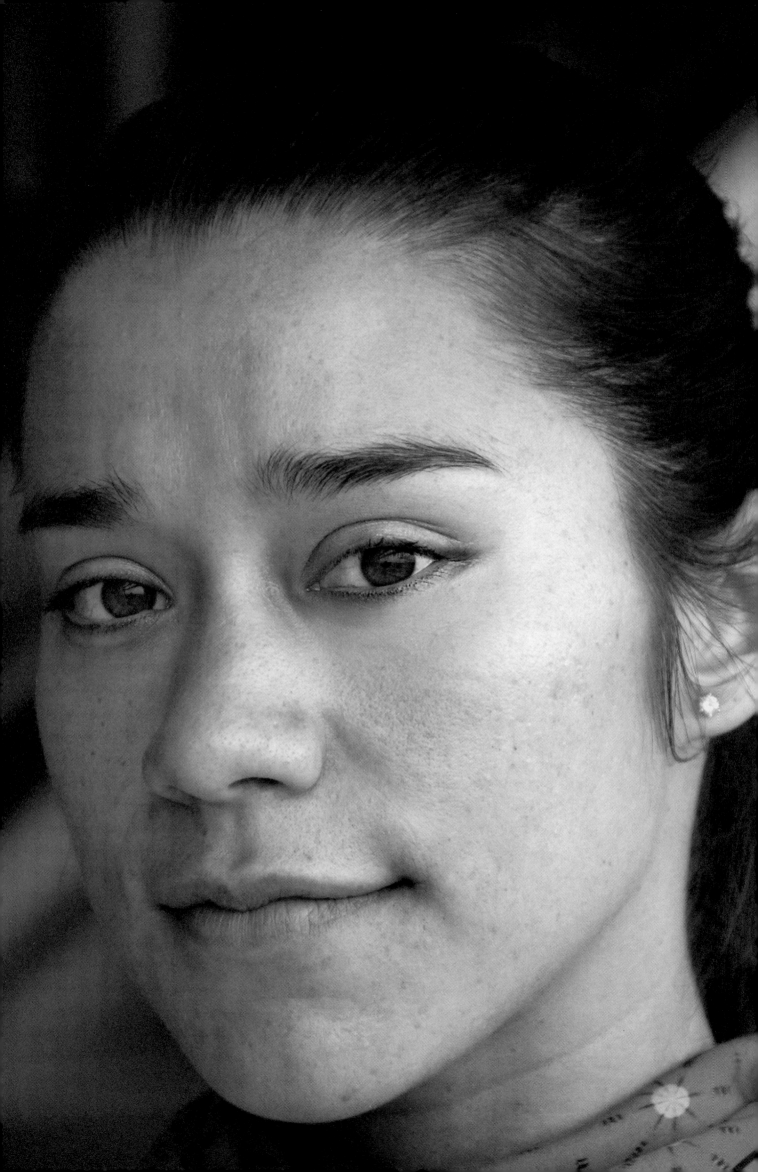

我們倆都在香港出生，但現居於倫敦。因為我們在此工作，居住和養寵物，在倫敦很有家的感覺。然而，每當我們回到香港去，也同樣會有家的感覺。

我們是¼英國人、½中國人和¼西班牙系猶太人，會說英語和廣東話。國籍上我們會告訴人家我們是歐亞混血兒，半歐半中。我們很愧疚自己真的不太會承認我們猶太的一面，那是因為一個很不幸的原因，祖父選擇與非猶太裔的祖母結婚，他被趕出家門，於是此後我們都沒有機會接觸我們的猶太親戚。我們在那麼遙遠的地方長大，令接觸的機會更為渺茫。

我們的姓氏很特殊，尤其對於我們生活過的地方來說。那是說我們的文化身份，總會與我們的姓氏扣上強烈的關係，那在希伯來文是「奇蹟」的意思。有時我們會想，我們對自己的猶太姓氏有這樣深的感受，卻不曾覺得自己是猶太人！

我們認為「混血兒」應該屬於一個獨特的民族，尤其是在填出入境表格的時候！我們常常要剔選「其他」一欄，作為混血兒，我們不只來自一個民族，僅選擇其中一欄，好像是我們在說謊一樣。

我們認同西方和東方兩個不同的世界。然而，由於我們來自家庭的經歷和觀念，我們的家庭觀絕對要來得中國化。

我[Rachael]長得更像西方人。當我第一次與別人見面，從來沒有人想過我有中國人血統，尤其是中國人。兒時在香港長大，母親帶我上街市，所有攤販都會問她是不是我的女傭。她會打趣地說她是名女傭，那會令我有點憤怒，結果是我站起來告訴那些人，她是我們的母親。他們會誇讚我很聰明，會說會聽廣東話。那對我是很好的訓練，他們很愛逗我玩，令我覺得開心之餘，更投入中國人的社區。

別人傾向以為我是歐洲人，當我曬黑皮膚時，他們會以為我是南美人，會問我是不是土耳其人、墨西哥人、秘魯人、愛斯基摩人等等，甚麼都會問，就是不會問中國人。我的妹妹Emma長得很像波利尼西亞人，像夏威夷人，甚至巴西人，但整體來說她長得比我像混血兒。我一點都不會惱怒別人猜不中我的民族，那不是他們的錯，是我沒

We were both born in Hong Kong but now live in London. Because we live and work here and have pets, London feels like home. However, whenever we come back to Hong Kong it still feels like home too.

We are ¼ English, ½ Chinese and ¼ Sephardic Jew and speak English and Cantonese. In terms of nationality, we just tell people that we're Eurasian – half European and half Chinese. It's a shame that we don't really identify ourselves with our Jewish side. That was the unfortunate consequence of my grandfather marrying a non-Jew – he was expelled from his family and as a result we haven't had much contact with our Jewish family. Growing up so far away from them made it even less possible.

Our surname is quite unusual, especially for the places we have lived in. It's meant that we have always strongly identified with our surname, which fortunately also means 'miracles' in Hebrew. It sometimes strikes us as odd that we feel so strongly about our Jewish surname, without actually feeling Jewish!

We do think that 'Eurasian' should be a distinct ethnic group, especially when filling out forms! We always have to tick the 'others' box. As Eurasians we're not from only one ethnic group, and ticking one box and not the other would feel like a lie.

We identify with both the Western and Eastern worlds. However, going from our own family experiences, our family values are definitely taken more from our Chinese side.

I [Rachael] look much more Western. When I first meet people, no one ever thinks I'm Chinese at all, especially Chinese people. When I was a child growing up in Hong Kong, our mum would take me to the wet market and all the traders would ask if she was my maid. She would joke that she was, and that would wind me up a bit and I'd end up standing up for her and telling them that she was our mother. They would always say how clever I was for understanding and speaking Cantonese. It was good practice for me as we would banter which it made it more fun and had the effect of making me feel more a part of the Chinese community.

People tend to think that I'm European or, when I have a tan, South American. So I get asked if I'm Turkish, Mexican, Peruvian, Eskimo and so on, anything but Chinese. My sister Emma looks very Polynesian; she looks Hawaiian or even Brazilian, but overall she looks more mixed than I do. It doesn't bother me at all when people get it wrong; it's not their fault I don't look like I'm from an obvious ethnic group. It's actually quite

有很明顯像那個民族而已。聽別人在猜，其實也挺有趣的，總在想他們下一個會猜那個地方。而努力說服他們相信我的來歷，也是一件很好玩的事。我想我國際化的口音，也會讓別人摸不著頭腦。每當我在倫敦買kebab烤肉串時（那是不常發生的哦），店員總是覺得我是土耳其人，是他們的一份子，而我更正他們時，他們卻堅信我是土耳其人，堅信到我覺得不好意思澄清我的身份。

作為混血兒真的是很棒的經驗！我們可以拿到兩個世界最好的東西，在每種文化中，我們取好的棄壞的。混血兒的好處是在不同民族的人中，我們都感到是他們的一份子，不單純是我們血統上的，其他民族亦然——或許我們更容易適應吧。我對自己會說母語和煮中國菜很感自豪，那是我的民族認同的重要一環，不管身處西方或亞洲世界。我們真的並不覺得作為混血兒有任何負面的感覺。

我並不記得有甚麼特別的歧視事件發生過，或仍然在影響我們。我想在香港或英國應該曾經有過一些小事發生吧，不過我完全記不起來，所以應該不是甚麼太讓人難過的事。我們算是幸運，我們長大的環境並沒有很嚴重的、惡意的、直接的種族歧視。最接近的，可能是因為大家來自五湖四海，大家互相取笑，都是孩子間沒有惡意的笑話。或許如此，令我們對自己的膚色和民族覺得更自然。

很多時候，我們覺得我容易認出其他混血兒，但我本身卻是一個很好的例子，證明混血兒並不都是很容易分辨出來吧。

我們不可以說我們與混血兒的聯繫較密切，我們這些在香港長大的混血兒朋友們，會說廣東話，相互間多一層共通點，其實這不僅存在混血兒群之間，也存在於我們西化了的中國朋友之間，他們也會說英語和廣東話，那稱之為「廣式英語」（夾雜兩種語言）。那既可用來開玩笑，也是我們之間的秘密語言——真是好玩！尤其混進西方和亞洲的不同幽默，則更有趣了。那只會發生在真實生活上，太難以筆墨來形容了！

這真是有趣——我們從來不曾認真的分析過這種現象。我只可以說，作為混血兒是我們安心立命的身份，我們為自己的背景而開心和自豪。我們覺得自己很幸運。

amusing hearing people guess, because I'm aware of it, I just wonder where they'll suggest I'm from next. I have fun convincing them what I really am. I guess my international accent throws people off as well. Whenever I buy a kebab in London (which isn't very often!) they always think I'm Turkish like them – in fact, they're so convinced that I almost feel bad for denying it!

Being Eurasian is such a positive experience! We can get the best of both worlds. We take what we like and disregard what we don't like from each culture. The advantages of being Eurasian are being able to feel a part of both ethnic groups, and even other groups – maybe we adjust more easily. I'm very proud of being able to speak my mother tongue and do Chinese home-cooking; it's a big part of my identity, regardless if I'm living in the Western or Asian world. We don't really feel there has been anything negative so far from being Eurasian.

In terms of discrimination, I don't recall anything in particular and no incident that has stayed with us. I think there were a few very minor incidents both in Hong Kong and the UK, but I can't really recall them, so they couldn't have been that bad. We're lucky; I don't think we grew up in an environment where there was much direct malicious racism, if anything there were so many people from so many different places that we just had fun teasing and joking about everything and anything as kids will – all harmless stuff. Perhaps that made us feel more comfortable in our own skins.

Most of the time, we find it easy to spot other Eurasians, but I am an example of one where it can be hard to tell.

We can't say that we feel more of a bond with our Eurasian friends than our non-Eurasian friends but the extra thing we get with our Eurasian friends (those who grew up in Hong Kong and speak some Cantonese) is also the same thing we get with our Chinese friends who have been westernized and who speak both English and Cantonese: namely, speaking 'Chinglish' (a mix of English and Cantonese). It makes for great banter and is like our secret language – it's fun! Especially when factored with the blend of Western and Asian humour. It's very hard to describe on paper – it just happens!

This exercise has been interesting – we hadn't really thought to analyse or even think too deeply about this topic before. All I can say is that being Eurasian is our identity and that we're happy and proud of it. We feel very lucky.

I was born in Malaysia to a Eurasian mother and a Philipino father. We came to Hong Kong when I was one and I've been here ever since. My father is from a famous family in the Philippines, they are all entertainers. My parents met in Malaysia when my father was performing. Every time anyone asks me where I'm from, I have to give a long story. At the beginning it was frustrating but after a while I got used to it. I don't really belong anywhere… we need our own country! Since we can't have that, I have to say that I feel that I'm from Hong Kong. I have a Malay passport but Malaysia doesn't hold much meaning for me and as for the Philipines, whilst I'm proud of that side and cheer for them in sports and all that, I only went there when I was a baby so don't have such a strong connection to there as I do Hong Kong.

When I was in school, there seemed to be a lot more Westerners. There were lots of kids from the UK or the US and I got on with everyone. Everyone was something different, so being Eurasian didn't really matter in that we weren't seen negatively in any way. The only time I had a bad experience was in England when someone called me a 'Chink' on the train. But that didn't bother me – it was more a reflection on the person who said it than me.

I've been playing in a band since I was 16, mostly to a local crowd. Whilst our scene is still pretty underground, we've really seen the local following grow in recent years. I don't think what we do will ever be commercial as cantopop is so dominant. As an international school kid, I was kind of immune to local culture for a long time. What I do now has brought me into closer proximity with local culture and I understand it better. The only thing I really regret is that I don't speak Cantonese. I have really good intentions about getting there one day though.

In Hong Kong, 'Eurasian' tends to typically be half English, half Chinese and I don't really fit that mold. In the past, people didn't question 'Eurasian' and what it meant. There was either a lack of interest or an assumption that everyone was the same combination. Now people are more global in their outlook and when I say Eurasian, they'll ask me 'what mix?'.

Being Eurasian has definitely had an impact of my personality… two such different cultures, best of the East, best of the West. Eurasians rock! I think Eurasians look unique and have a special aura. If this fusion didn't happen, we wouldn't have such good-looking people. Even in Hollywood now, so many stars are mixed. We are the future and represent what everyone will be like one day.

我在馬來西亞出生，母親是名混血兒，父親是菲律賓人。我一周歲時來到香港，就一直生活而今。父親出身自菲律賓有名氣的家族，他們一家都是娛樂家。父母在馬來西亞父親表演時認識。每次有人問我來自那裡，我也要大費唇舌解釋。最初開始時會覺得很煩，不過後來也習慣起來。我其實並不屬於任何地方⋯⋯我們需要有自己的國家！由於這是不可行的，我只有說我是來自香港。我擁有馬來西亞的護照，但這個國家對我沒有甚麼意義。至於菲律賓，雖然我為自己是半個菲律賓人而自豪，並很欣賞他們的運動等方面的才能，我卻只在嬰孩時代到過菲律賓，所以並沒有像香港那麼緊密的關係。

在求學時期，我覺得好像比現在有更多西方人，有很多來自英美的孩子，而我跟他們每一個都很合得來。每個人都有點不一樣，所以作為混血兒也沒甚麼關係，並沒有任何負面的感覺。唯一一次有不好的經歷是在英國，有人在火車些叫我做"Chink"（中國佬）。但我並不覺得怎樣，那個蔑視的稱呼更像是指那個說這話的人，而不是我。

我自16歲起就在樂隊裡表演，主要的觀眾是本地人。雖然我們還是地下音樂，近年卻確實看到越來越多本地人喜歡我們的音樂。我不認為我們做的音樂會有一天成為商業音樂，因為本地市場總被廣東流行音樂所支配。在國際學校長大的我，有很長的一段成長期，本地文化與我並無任何接觸。我現在的工作，卻令我更接近並了解本地的文化。唯一叫我後悔的，是我還不會說廣東話。只是，我真的希望有一天會改變這狀況。

在香港，「混血兒」一詞多指半英半中的血統，而我並非其中一員。以往人們並沒有對「混血兒」這詞的真正意義存在疑問，可能是沒有興趣了解，或假定每人都來自相同的血統組合。現在隨著社會越來越全球化，當我說自己是混血兒時，人們會問我是「那種組合的混血兒？」

作為混血兒當然有為我的性格帶來影響⋯⋯多麼不同的文化，集西方與東方最好的元素：混血兒萬歲！我覺得混血兒外貌獨特，而且有其特別的氣味。如果沒有我們這樣的文化融和，就沒有長得那麼漂亮的人種。現在即使是在荷里活，很多明星也是混血兒來的。我們就是未來，並代表了以後人們將會變成的模樣。

I was born in Kuala Lumpur and my father was English – his name was Christopher Williams Atkinson. My mother was Ceylonese. I came to Singapore when I got married in '62 and my youngest son was born here. We all became Singapore citizens.

In Kuala Lumpur when I was young, Eurasians were quite common. Soldiers came from abroad to help fight the Communists and Eurasian children were the result of their liaisons with local women. There were also many mixed families through colonization. Although these mixed relationships or even marriages were not uncommon, I would say that they were frowned upon. Up to the early '60's even, foreign private firms stipulated in their contracts that their employees were not allowed to marry locally. When I was a child, we were often called 'mixed devils' and the like. Many Eurasian children of that era emigrated to Australia in the end.

My father died during the war so I was brought up by my mother. As a result, I did not really feel the pull between the two cultures. My mother had been orphaned at 12 and attended convent school in Singapore which was full of Eurasian girls. As a result of their influence she raised me in the Eurasian way and cooked Eurasian dishes. I also attended convent school and had a fairly conservative upbringing. I remember having to wear my hair in pigtails until I was 16.

I remember becoming more proud of my Eurasian heritage after I got married and had children. My husband was also Eurasian and as he had a very dominant personality, I was influenced by him and drawn further in to Eurasian culture. I am slightly different to many other Eurasians as I am Anglican as opposed to Roman Catholic but that has not made much of a difference in terms of lifestyle.

Although I am a first generation Eurasian unlike many of the Eurasians in Singapore, I feel no different to the fourth generation Eurasians. Nor do I necessarily feel closer to other Eurasians simply by virtue of them being Eurasian. Maybe 40 years ago I would have, but now at 69, I just live a quiet life.

I have always been pale for someone who is half Ceylonese, especially considering my mother was very dark. Years ago when I had brown hair, people would think I was just English. Nowadays, with white hair, people tend to think I am Chinese – which is odd considering I don't have a drop of Chinese blood!

我出生於吉隆坡，父親是英國人，名叫Christopher Williams Atkinson；我的母親是錫蘭人。我在1962年結婚時來到新加坡，最小的兒子是在這裡出生的。我們一家都成為新加坡公民。

當我年少在吉隆坡的時候，混血兒可算很普遍。外國的士兵前來幫忙對抗共產黨，而混血兒孩子就是他們與本地婦女結合而生的下一代。而且，殖民地化也產生了不少混血的家庭。雖然這些混血的關係和婚姻很平常，然而人們卻不會對此表示贊同。甚至到了60年代，外資企業也會在僱用合約上聲明，不允許員工與本地人通婚。在孩童時代，我們常常被人稱為「混血魔童」之類的；很多那個年代的混血兒孩子，最後均移居到澳洲去。

由於父親在戰爭中陣亡，我是由母親帶大的；因此我並沒有真的感受過兩種不同文化的抗衡。我的母親本身在12歲時成為孤兒，並在新加坡一家滿是混血兒女生的修女書院就讀。因為那時的影響，母親以混血兒家庭的方式把我養大成人，也弄混血兒式的食物；我也在修女書院上學，在較為保守的環境下成長，我記得一直到16歲，我還是需要把頭髮束成馬尾辮子。

直至我結婚及生孩子以後，我更自豪於自己混血兒的身份和傳統。我的丈夫也是名混血兒，性格比較強勢，我受了他的影響而更投入於混血兒文化中。我與很多其他混血兒有一點點不同，就是我隸屬於英國聖公會教會，而非羅馬天主教徒，然而這對我們的生活方式並沒有帶來多少影響。

雖然我是第一代的混血兒，有別於一般新加坡混血兒是來自混血兒家庭，我覺得自己跟第四代混血兒並沒有差別。我也不會僅僅因為別人是混血兒，而覺得他們比較親切。可能在40年前我還會這樣想，只是現在已經69歲，我只想過一些平靜的生活。

相對其他半錫蘭人來說，尤其是我的母親膚色相當黝黑，我的皮膚算是相當白皙的。很多年前，當我擁有一頭啡髮時，人家都當我是英國人。現在的我長了白頭髮，別人會以為我是中國人——那是很奇怪的事，因為我身上一點中國人的血統都沒有！

I was born in Kuala Lumpur and came to Singapore when I was five years old, in May of '69 during the riots.

My mother is half English and half Ceylonese and my father was Italian, Vietnamese, French and a touch of Indian. They met in Kuala Lumpur where my father was working for the large department store, Robinsons, and moved back to Singapore when the Kuala Lumpur branch closed down.

I have always felt Eurasian. I spent the first ten years of my education at a mission school where there were lots of Eurasian boys, many of whom were the sons of my father's classmates. It was quite a sheltered existence, everyone knew everyone and being Eurasian was just so normal.

The only time I felt a little lost was when I went to the polytechnic. It was a culture shock, there were fewer Eurasians by far – a bit of a wake-up call really. I did feel different there but it did not affect my feelings about being Eurasian, nor did it have any lasting impact.

When I joined the army there were even fewer Eurasians. That is when people began to ask me what I was doing there. I was initially viewed with suspicion – people could not understand why a white person would join the Singaporean army. I think sometimes it is difficult because of my appearance for people to see me just as a Singaporean.

I feel that my generation of Eurasians are different to my father's generation of Eurasians. We have been encouraged by the government to achieve integration so that we are Singaporean first and Eurasian second. At the same time, we are encouraged and supported in our efforts to remember our heritage and run associations for that purpose. I really feel that we have moved towards that ideal – I am proud to be Singaporean first and Eurasian second. No regrets!

My wife is Chinese so I have been exposed to the Chinese way of life. Despite that, I do not really speak Chinese – I am too afraid that I will offend someone! In any event, from my appearance, people speak to me in English anyway. Without hearing me speak, most people tend to think I am European. But when they hear my local accent it always raises lots of questions.

My children have not really been raised as Eurasians. Out of necessity, they have been brought up with Chinese culture and speak Mandarin as a second language. I have tried to encourage the music and dance of Eurasians as I find that Eurasians are inclined to do well in the performing arts. Anyway, they are fifth-generation Singaporeans so they do not really need to explain where they are from, they were integrated into Singapore from the very beginning.

Being Eurasian has not helped my career as everything here is on merit. But being from a minority group has helped me to be aware of the world around me. I am always being asked to participate in events and I am deeply involved in community work at grassroots level. I feel that Eurasians often act as a bridge between the minority and the majority. In a way, we are the peacemakers.

我在吉隆坡出生，五歲時來到新加坡，當時正值1969年5月的暴動。

我的母親是半英國半錫蘭人，父親是意大利、越南、法國，加一點點印度的混血兒，他們在吉隆坡邂逅。其時父親在大型百貨公司Robinsons工作，直到吉隆坡分店關閉後，才舉家搬回新加坡。

我常常覺得自己是名徹頭徹尾的混血兒。在接受教育的首十年，我均在教會學校就讀，那裡有很多混血兒男孩，大都是我父親的同學的孩子；那裡像個庇護所，大家都知道大家是誰，混血兒在那裡顯得多麼的正常和理所當然。

唯一令我覺得有點迷失的時候，是在我上理工院校時，那裡只有很少混血兒，令我開始察覺到自己與別人不一樣，可算是個文化衝擊。不過那並不影響我對混血兒身份的看法，也沒有對我有太深遠的迴響。

在我加入軍隊後，隊伍內就更少混血兒了。當時開始有人問我為什麼會在哪，起初別人總是以懷疑的眼光看我——一個白人加入新加坡的軍隊是幹嘛的。我想，我的外表有時確實很難令人把我當成新加坡人看待。

我覺得我那一代的混血兒和父親的一代並不同，我們受政府教育要以融入新加坡社會為先，混血兒為次。與此同時，我們在同樣的鼓勵和支持下，努力為此保存我們的文化傳統，經營我們的協會。我真的認為我們已往那個理想邁進——我為作為新加坡人而自豪，而混血兒僅為次要，對此並沒有後悔！

我的妻子是中國人，所要我也接觸到中國人的生活方式。然而除此之外，我不大會說中文，我太害怕因而冒犯了別人！反正在任何情況下，別人單憑我的外表長相，都會跟我說英語的。在我沒有開口以前，大部分人都會以為我是歐洲人。但當他們聽到我的本地口音時，都會引發很多疑問。

因為生活所需，我的孩子的成長環境都是中國文化，並以普通話作為第二語言，有別於一般混血兒的成長方式。我曾嘗試在音樂和舞蹈等方面鼓勵他們，因為我發現，混血兒在表演藝術方面總是比較優秀。他們已經是第五代土生土長的新加坡人了，所以也不需要解釋他們祖先來自甚麼地方，他們在一開始，已經融入了新加坡的社會。

我並沒有因為是混血兒而幫助了我的事業，畢竟這裡是有能者居之的地方。但作為少數族裔，卻幫助我對世界大事有更敏銳的觸角。我常被邀參與不同活動，而我對草根階層的社區工作，也相當投入。我覺得混血兒常常成為了少數族群與社會大眾間的橋樑，在這層面上，我們協助締造和平。

I was born in Hong Kong and have lived here for 15 years; I consider it my home country. My mother is half English and half Irish, and my father is full Chinese. I can speak English, Cantonese and Mandarin, but I am most fluent in English.

I have a Chinese and a British passport, but I call myself British when it comes to nationality. Eurasian is becoming a more and more popular race so I think it should be an ethnic group in its own right. I believe that eventually everyone will be Eurasian, or at least mixed.

I feel more Western in general, although there are times when I feel more Asian, especially when I'm in England. I also prefer Asian food to Western food.

In terms of appearance, I think that I look more Western but that I also have some Asian features. I have been mistaken as Spanish or American, but usually people just assume that I'm English. They only really ask what nationality I am if they hear me speak Cantonese. To be honest, I don't mind when people get my ethnicity wrong, because then it gives me the opportunity to say "Oh no, I'm Chinese and English" and they say "Wow! That's amazing!"

I think being Eurasian is a positive experience; you could say I have the best of both worlds. An advantage of being Eurasian is that you have a chance to experience different cultures. Some people believe that mixed people are the superior race. It's original, and I like it. I'd say the only disadvantage of being Eurasian is that there isn't anywhere you are considered completely at home. But then again, by having more than one nationality, you have more places to fit in.

Living in Hong Kong, which is home to lots of Eurasians, I've never been discriminated against on account of my race. I can usually tell when someone is Eurasian, but then you can have so many types of different Eurasians with different mixes, it's easy to be mistaken. I wouldn't say I feel a bond with other Eurasians, I wouldn't consider race a factor in telling who I feel a bond with. I think that non-Eurasians view Eurasians as different, but not in a bad way, we are just like any other race, just with a bit more variety. I love being Eurasian.

我在香港出生，在這裡生活了15年，並以此為我的家鄉。我的母親是半英格蘭半愛爾蘭人，而父親則純是中國人。我會說英語、廣東話和普通話，不過最流利的是英語。

我分別有中國和英國的護照，但要我表示國籍時，我會說自己是英籍。混血兒變得越來越受歡迎，所以我認為應該可以自成一個民族。我相信最終所有人都會成為某程度上的混血兒。

我平常會覺得自己比較西化，然而有時候也會覺得自己較像亞洲人，尤其當我在英國的時候。同時，我也喜歡亞洲食品多於西方的。

在外表上我是長得比較像西方人的，但是也有部份亞洲人的輪廓。我曾被誤以為是西班牙或美國人，但人們一般假設我是英國人，他們只會在我講廣東話的時候，才會問我的真正國籍。老實說，我不介意別人猜錯我的國籍，因為那樣我才有機會說「啊，不是的，我是半中半英的混血兒啊！」他們就會說「嘩，那很棒呀！」

我認為作為混血兒是件正面的事，你可以說我擁有了兩個世界最好的東西。當混血兒的好處，是你有機會體驗不同的文化。有些人認為混血兒是個超級民族。我喜愛那原創性。作為混血兒唯一的壞處，就是你在那裡都不會有完完全全在家的感覺。但正因如此，作為多種族文化的人，你也可以有多些地方適合於安身立命。

在香港這個很多混血兒安家的地方，我從來沒有因為種族問題而受到歧視。我總可以說得上誰是混血兒，但有那麼多種不同的混血兒，很容易會看錯。我不會說自己與其他混血兒有特別的連繫，民族不會是我與別人建立連繫時的一個因素。非混血兒對混血兒的想法有點不同，但我想都是沒有惡意的，我們就如同所有其他民族一樣，只是比較多元化而已。我喜歡當混血兒。

I recall that when I was very young, I thought I was Chinese. Surrounded by my extended Chinese family in a Chinese village, the only European was my Scottish mother. Whilst we were always very close, the connection between her ethnicity and my own appearance was not made until much later and I remember clearly asking my grandmother to dye my brown hair black to correct what I perceived to be some sort of mistake. On another occasion, my uncle was compelled to remove me from a supermarket after I was found chanting 'Gwei lei ga, gwei lei ga!' (It's a ghost, it's a ghost) at a poor lone Caucasian in Yuen Long. At that point, I was truly bilingual, equally comfortable in English and Cantonese but perhaps culturally weighted towards my Chinese side under the influence of my many Chinese cousins with whom I would spend my days roaming rural Hong Kong.

School days brought with them a Western cultural bias which deepened with passing years and shaped my preferences in music, television, entertainment and to a certain extent, the company I kept. In my teens I preferred trying to get into the local pub to swapping Hello Kitty memorabilia. I listened to Radiohead, not Leon Lai. I dreamt about Johnny Depp, not Aaron Kwok. I laughed with my mouth wide-open as opposed to tittering behind my hand and I never, ever carried pocket tissues.

On the other hand, I also spent a good deal of time after school in noodle shops, did what my parents told me with very little question and was already resolute in my devotion to my family and their expectations of me. Buoyed by my mother's assurances that I could do whatever I wished with my life as long as I was happy, I nevertheless pursued the dreams of many a Chinese father and read law at university.

The issues that have arisen for me in terms of being Eurasian, whilst complex and difficult to explain, are not crisis-inducing. I have never agonized over my mixed ethnicity and wondered how it could have all been very different. Rather, it is the things other people say and do that bring certain thoughts into focus.

Being far more European than Asian in appearance, my spoken Cantonese is nearly always met with a double-take and a string of questions, the first one usually being 'Where are you from'? When I reply, quite simply, that I am from Hong Kong, the next question is invariably, 'But, I mean, where are you from'? Repeating my answer rarely garners any satisfaction for the questioner and I am drawn into explaining that I really am from Hong Kong having been born here but that my mother is Scottish and my father Chinese. This then invites the next inevitable comment, namely 'But you don't look Chinese'.

This tango occurs several times a day and mostly I just accept it as part of my day-to-day existence. People are genuinely excited, are probably unaware that I was asked the exact same things five minutes ago and it seems churlish, if not rude, to not answer their well-meant queries. There are times where I feel bored and weary of it all and other times where I feel downright indignant about having to justify my belonging to Hong Kong, and further yet, my ethnicity.

It is also strange to sometimes feel like a foreigner in the place I was born and bred and it can be disconcerting to be stared at, especially when I venture outside of the expat comfort zone or indulge in more 'local' pastimes such as munching on fishballs in the street. Jaws literally drop when I use my Chinese re-entry permit between Shenzhen and Hong Kong and people assume I am lost if I walk into a Chinese movie. This feeling of disconnectedness is probably experienced by many people who are born and raised in countries in which they do not constitute part of the ethnic majority… but the waters are muddied somewhat by the fact that I am Eurasian and half of me is part of the ethnic majority. Regardless of how I look, I still feel very much Chinese in many ways and being treated so differently on account of my outward appearance can be a little uncomfortable at times.

It is common for Eurasians to claim that they can move seamlessly between Western and Asian culture. But what does this really mean? For me, it is not simply a matter of speaking Cantonese. It is more than that. It is completely possible to speak Cantonese whilst engaged in a totally Western state of mind just as it is possible to speak English in a Chinese state of mind. What I mean by being able to move between two cultures is deeper than mere language. When I am with my expatriate friends, I am British. Not only is my body language, my sense of humour and my manner of speech British but I find myself alluding to a shared cultural heritage. In this company I will exalt the virtues of pork pies, make cracks about Scousers, Essex girls and Sloanes, bemoan the taste of any chocolate made outside of England, enthusiastically join in on the Marmite debate (I hate it but do kind of like Twiglets), shake my head over the woeful state of the Tube and reminisce

記得當我還是很小的時候，我以爲自己是中國人。在中國人聚居的鄉郊，包圍在身邊的都是我的中國大家庭，裡面唯一出現的歐洲人，就是我那蘇格蘭裔的母親。雖然我們母女倆很親暱，對於母親的民族以及我的外貌間的關係，我在很久以後才能聯繫起來。我清楚記得，曾經要祖母把我的一頭啡髮染成黑色，以改正我一直以爲的錯誤。有那麼的一次，我在元朗的超級市場曾對著一名可憐的白人喊叫「鬼嚟架，鬼嚟架！」，叔叔發現後被迫要帶我離開。那時候的我是真的雙語並用，對於英語或廣東話同樣自然，因爲受到很多中國表兄弟姊妹的影響，文化上也許比較靠近我的中國一面，那時我常常與他們一起在香港郊區漫遊。

在學的日子，把我帶到西方文化的環境，並漸漸形成了我現在對音樂、電視、娛樂，及在某程度上對擇偶的取向。在十來歲的時候，我愛到本地的酒吧，與別人交換Hello Kitty紀念品；我聽的是Radio-head樂隊的歌，而非黎明的；我魂牽夢縈的是Johnny Depp，而不是郭富城；我常常咧嘴而笑，而非中國人的笑不露齒或以手掩嘴；我也從不隨身攜帶包裝紙巾。

另一方面，我在課餘時也常在麵店流連，對父母的話言聽計從，堅決不負家人對我的期望。縱使母親鼓勵我只要活得開心，可以做任何喜歡做的事情，我還是選擇了追求很多中國爸爸的夢想，就是在大學裡修讀法律。

作爲混血兒，於我來說雖然是很複雜而難以解釋的事，卻並沒有爲我帶來過任何危機。我從來沒有對不同民族血統感到煩惱，沒有想過自己和別人有甚麼不一樣。反而是別人的說話和行爲，令我開始留意這些迥異。

由於外表像歐洲人遠多於亞洲人，我一口流利的廣東話，永遠惹來別人側目及引發連串問題；而第一個問題通常都是：「你來自那裡？」當我簡單地回應說自己來自香港時，下一個問題總是：「我指的是，你是源自那個地方？」再重複同一答案很少可以令發問的人滿意，那我就要詳細解釋我真的來自香港，但母親是蘇格蘭人而父親是中國人。這時候總會有人說：「但你一點都不像中國人呀！」

這樣的對答，一天大概也會發生好幾次，很多時候我會接受這是我生存每天要面對的事情之一。人們真的對此感很感興趣，或許他們並不在意我在剛剛五分鐘之前，才被問了同一個問題。如我不回答他們那麼認真的發問，會顯得很無禮。有時我會覺得很厭倦，有時甚至會覺得非常憤怒，爲什麼要去證明自己是香港人，或更進一步去解釋自己的種族。

有時會覺得很奇怪，爲何在自己土生土長的地方會被人當成外國人，尤其是當我不在令人自在的外國人圈子，很地道的在街上吃魚蛋之類的時候，被別人瞪著注視實在很窘。當我以回鄉證越過深圳香港關口時，人們總會大吃一驚；如我走進放映中文電影的戲院，人們總以爲我走錯路。那種疏離感，很多成長於異地的人可能都感受過，因爲他們並不屬於當地主流的多數族裔……然而我的情況更爲複雜一些，正因爲我是名混血兒，有一半中國人血統，理應有部分屬於本地的多數族裔。撇除我的長相，我仍然覺得自己在很多方面很中國化。僅僅因爲我的外表不同，而受到如此不同的待遇，有時真的有點令人難堪。

常聽混血兒說，他們可以自在地遊走於西方及亞洲文化之間，到底那是甚麼意思？對我來說，這不只是會說廣東話的問題。我們大可以西方思維方式去說廣東話，正如我們可以中國人的思維方式去說英語一樣。所以我說的遊走於兩個文化之間，是遠多於語言本身。當我與外地朋友在一起的時候，我是英國人。不只是我的身體語言、幽默感、語氣等都是英式的，我發現自己與他們暗中擁有共同的文化傳統。與這些人爲伴，我會讚揚英式的豬肉餡餅，諷刺利物浦人（Scousers）、艾塞克斯女生（Essex girls）、史隆族富家子弟（Sloanes），批評所有非英國製造的巧克力的味道，加入對Marmite 塗醬的熱烈辯論（我很討厭這醬料，但算喜歡Twiglets小吃），對倫敦地鐵可悲的情

bitterly about the Clarks shoes and itchy grey woollen tights (secured by two pairs of knickers) of my childhood. I also believe that something bad will happen if my children wear anything other than Marks & Spencers underwear.

When I go to visit my Chinese family, I am a different person entirely. On arrival, I loudly announce each of my relatives' titles in respect then sit down and read the paper whilst making occasional chitchat and helping myself to snacks. I feel no pressure to make conversation, update anyone on my news or ask anyone what they have been up to. It is a restful state and rather remarkable when one considers that my British self would be compelled, in utter panic, to comment on the weather after a four-and-a-half-second lull in conversation. Whenever I have brought Westerners back to the family home, they are utterly bemused by the fact that ten family members will be crammed into a room and that each person will be happily doing their own thing. Perhaps through necessity, the Chinese have learned how to be alone whilst surrounded by people. My Chinese self unthinkingly keeps conversation superficial, spits her bones onto the table, gives her grandma money, is not at all offended when it is loudly proclaimed that she has put on weight and does not ask personal questions (except those related to appearance, which are always fair game). I know my body language changes, my voice is higher but louder and that my sense of humour morphs from deadpan to slapstick and I never swear in Chinese. It is not like acting a role but more like being two completely different people. It is not choosing to behave one way or another, but automatically doing so.

It is also often said by Eurasians that our experiences make us more accepting of other people. To a certain extent I think that must be true. Growing up, parental influence is of no uncertain importance so when a child is confronted with two such different cultures, it is often inevitable that he or she learns to accept that there is more than one way of looking at the world. For example, when I was growing up, my mother always told me she loved me and was demonstrative in her affections. My father never told me he loved me and at best managed a pat on the head or a squeeze on the shoulder. This did not make me think that my mother loved me and that my father did not – I knew from a young age that he just showed it differently. In adulthood, this understanding that people behave differently and acceptance of the same has helped me in overcoming many obstacles in understanding other people and in accepting their cultures.

Many Eurasians will claim to have the best of both worlds. It is implied in that statement that they feel included in both cultures. Whilst I often feel that is the case, sometimes it can feel that I am included in neither. Despite feeling Chinese in many ways, the fact of the matter is that I have few local friends, I live an expatriate lifestyle, I am treated as an outsider and my only real exposure to real 'local' life is through my family and my work. But then, I am not, would never want to be and never could be an expatriate. A feeling of belonging to British culture does not translate into the feeling that I could ever be at home there. Whilst I take on attributes of both cultures, it could also be said that I am not totally comfortable in either.

I do feel that there is some uncertainty in being Eurasian, especially a Eurasian from Hong Kong. Hong Kong is a transient place at the best of times. Nothing ever feels really that permanent here. I remember when I was at university, it used to upset me when I came home from holidays to find the skyline changed yet again. The fact that my home moved so quickly without me was somehow unsettling and I found myself envious of my English friends who would return to the family homes in which they were born, in villages and towns that had barely changed in decades. A changing environment would perhaps be not so disconcerting if, for example, my parents had very strong links that I shared to their own birthplaces. Or if they were both from the same place or even if they were both born in Hong Kong as I was. It would be less disorientating, maybe, if I looked, felt and behaved more in line with the Chinese majority in Hong Kong without cycling between two personalities. But the fact of the matter is that all these things are at odds and it can be difficult to grasp any sense of belonging in these circumstances.

Despite some of the challenges of being Eurasian, I feel special and I am treated as such by both Westerners and Chinese. I have access to both cultures and I can retreat or advance into either camp at my convenience. Whilst it can feel that I do not belong to any one place, I am not tied down by my nationality or my ethnicity and there is freedom to be whatever I want to be. The rules of each culture bend to make allowances for my other half and I am generally met with tolerance if I step beyond the boundaries of what is usually expected.

For me, being Eurasian is incredibly positive. It is empowering, liberating and lends a rich dimension to my everyday existence. I honestly would not choose to be any other way.

況搖頭嘆息，以及回憶小時候的其樂鞋和令人發癢的灰色羊毛襪褲（以兩條短褲定位）。我也相信如果我的孩子不穿馬莎的內衣褲，會有惡運降臨。

當探望我的中國親戚的時候，我會完全成了另一個人。到達家門時，我會恭敬地大聲叫每一位在場親戚，然後坐下來看報紙，偶爾與他們聊一下，或吃點零食。我與他們對話、談及我最近的狀況、或問候他們等，都沒有感到任何壓力。那是很自然的休息狀態，有人會以為我的英國人那一半，會迫使我在大家沒有對話的時間，忍不住要談天氣，其實不然。每當我帶西方人回家時，他們都很困惑，奇怪為什麼十位家庭成員可以擠在一個房間內，而每人卻做著自己的事，竟也悠然自得。或許出於實際環境的需要，中國人已學習了如何在群體之中獨立自處。我的中國人那一半，會不加思考的說一些表面的話，在檯面上吐骨頭，塞錢給祖母，對於有人大聲的說我身材發福了也不會生氣，以及不會問私人問題（除了與外貌相關的，那是有來有往的）。我知道自己的身體語言轉變了，聲調提高了，由不動聲色的幽默，變化為鬧劇式的說笑，而且，我從不用中文說粗言穢語。那不是在飾演這個角色，而更像是兩個完全不同的人；也不是在選擇怎樣的行為模式，而是自動的轉變過來。

不少混血兒表示，我們的經驗令我們更容易接受別人，某程度上這是對的。在成長的過程中，父母對小孩的影響最為重要；當一個孩子在那南轅北轍的不同文化下成長，他/她不免學習到世界上其實有很多方法去看事物。譬如說，自小到大，母親常常告訴我她很愛我，而實際上也有很多親暱的舉動；而父親則從來沒有說過他愛我，最多是拍拍我的頭、捏一下我的膊肘。我並不會因此就以為只有母親愛我，而父親不然——我從小就知道，他只是對愛有不同的表達方式而已。長大以後，能了解和接受不同人有不同的行為和表達形式，助我克服不少困難，令我明白他人及接納他們的文化。

很多混血兒會說，他們擁有了兩個文化世界中最好的東西，那表示了他們覺得在兩種文化中均被接納。雖然很多時間我也會這樣覺得，但有時卻會感到在兩個文化中都不被接受。雖然我自覺自己在很多方面都很像中國人，事實上我只有很少本地朋友，我的生活方式是西化的，我在社會上被視為一名外來者；只有在工作上及家庭中，才可以接觸到真正的「本地」文化和生活。雖然如此，我並不是，也不想，而且永不會是一名外國人。感覺自己屬於英國文化，並不表示我可以視那裡為家。縱使我具有兩個文化的特徵，也可以說我在任何一方，均不會感到完全的舒適自在。

我覺得作為混血兒，總有些不穩定性，尤其是一名來自香港的混血兒。香港這地方，最好的東西都總是頃刻即逝；在這裡，甚麼都好像不太長久。我記得當我在大學時，每次放假回來，都發現香港建築物構成的城市輪廓線在改變，這使我很不開心。我不在香港的日子，家人常常搬家，這點令我很不安。我發現自己開始嫉妒我的英國同學，回家時可以回到自己出生的村莊、市鎮，這些地方幾十年不會變。如果說我父母的出生地與我有很強的聯繫，或他們來自同一個地方，又或者他們像我一樣出生於香港，那麼環境上的轉變，或許可以不會那麼讓人惶恐。又如果我和香港大部分中國人的長相、感受、行為都較相像，不用老是在兩種不同性格中徘徊，我可能不會如此迷惑。但當所有這些不一致的東西都湊在一起時，則很難在其中找到歸屬感。

除卻作為混血兒的一些挑戰，我覺得自己是特別的，而身旁的西方人和中國人也以這樣的方式與我相處。我可以接觸、並隨意出入兩種文化。雖說有時會覺得自己不屬於任何一個地方，我並不會被自己的民族、國籍而綁著，而擁有自由可以做自己想做的。其中一種文化的規則會對另一種文化下的我較為寬容，並通常容許我在文化的邊界上遊走。

對我來說，作為混血兒絕對是正面而具優勢的，在能力上如是、在自由上如是，並豐富了我每一天的生活。老實說，縱是可以，我也不會作另一選擇。

I was born in London and came to Hong Kong when I was seven years old. I moved back to London when I was 16 to go to boarding school and went on to study Art and Design in Wimbledon before going to Central St. Martins for Fashion Design.

My father is Chinese and my mother is Austrian. I do feel a strong connection to Austria as I spent my summers there growing up. After university I went to work in Vienna where I designed costumes for Burgtheatre. Later, I did costume design for opera productions in Salzburg. Through my mother and my education at the German Swiss International School in Hong Kong, I am fluent in German.

I also learned Mandarin at school and have basic restaurant/taxi Cantonese. I started learning Cantonese from last September but I think I'll focus on Mandarin, Cantonese is just so difficult!

People tend to guess that I'm Latin American, Hawaiian, Spanish or Italian. They don't tend to guess Eurasian but when I do tell them, it seems to click into place and make sense. Being different can be a bit of an issue in school, but when you grow up you realize it's a good thing. People are curious but never negative about it.

I have a number of siblings and we all look different. I find it fascinating to see how genetics work and how the two different races manifest themselves in an individual.

Being Eurasian in Hong Kong was never an issue and I never had any problems when I went to the UK – the only thing I had to be conscious of was the difference in lifestyle that I had enjoyed in Hong Kong compared to many students in the UK. I think that is something that many of us Hong Kong kids had to learn – Eurasian or not.

There is a feeling of sisterhood between Eurasians. I instantly feel some sort of silent connection with other Eurasians and can usually tell who they are.

I feel so lucky to be accepted into different cultures and likewise, to understand different cultures.

I will always feel half Austrian and half Chinese but there is no denying that I identify strongly with British culture and feel at home there. Sometimes I think I'm a London girl at heart, other times there is a part of me that feels that I don't quite belong.

I have never felt torn between my Chinese and Austrian side. Any difficulty I have is not with my ethnicity as such but more with the fact that I am not quite sure where home is – Hong Kong, London or Austria? I am going to stay in Hong Kong for now, it is hard to be in London when my family are all in Hong Kong. That doesn't mean that the pull of London is not always there though.

Being Eurasian can make you feel like you don't belong anywhere but belong everywhere.

我在倫敦出生，七歲的時候來到香港，16歲時回到英國就讀寄宿學校，後來在溫布頓唸藝術設計，再到中央聖馬丁藝術與設計學院攻讀時裝設計。

我的父親是中國人，而母親是奧地利人。我覺得自己跟奧地利關係非常密切，因爲在成長期間，我總是到奧地利過暑假。大學畢業後，我到了維也納工作，爲奧地利皇家劇院Burgtheatre設計服裝。隨後，我於薩爾斯堡爲歌劇劇作設計服裝。在母親及香港的德瑞國際學校的教育下，我能操非常流利的德文。

在學校時，我也學習了普通話，以及學會了可以應付酒樓吃飯 / 的士交通等的基本廣東話。在去年9月起，我已開始學習廣東話，但我想我應該會以普通話爲主，因爲廣東話實在是太難了！

別人總猜我是拉丁美洲人、夏威夷人、西班牙人或意大利人，不太會估到我是混血兒來的。但當我告訴他們的時候，則會好像恍然大悟似的。長得與別不同，在校匯生活或許會帶來一點問題，但當你漸漸長大，將會發現這是一個優點。人們會對你好奇，但永遠不會有負面的想法。

我有幾名兄弟姊妹，但每人都長得不一樣。我覺得遺傳真是很神奇的一回事，看著兩種不同文化血統如何在一個孩子身上顯現出來很奇妙。

在香港，作爲混血兒完全不是一個問題，我在英國亦然——唯一我須要注意的，是兩地學生擁有不一樣的生活方式而已。我相信這不僅限於混血兒，是所有我們這些香港孩子所需要學習的。

混血兒之間是有一種姊妹情，我會即時與其他混血兒有種不可言諭的聯繫，並總是可以把他們辨認出來。

我覺得自己很幸福，能被不同文化所接納融合，並明白這些不同文化。

我將永遠把自己看成是半奧半中的混血兒，而且不容否認，我與英國文化有很深的淵源，在那麼會有回家的感覺。在心底裡，我有時會認爲自己是名倫敦人，有時卻覺得自己並不完全屬於這個地方。

我從來不覺得內在的中國或奧地利文化在抗爭，我面對的問題，都不在於我的種族問題，而是我的根究竟在那裡——是香港、倫敦還是奧地利？現在我會一直待在香港，因爲當所有家人都在香港時，你很難一個人留在倫敦。但是，這不等於倫敦的吸引力已經不在。

作爲混血兒，可以令你覺得自己並不屬於任何一個地方，也可以是四海皆可爲家。

我在香港出生，母親是英國人（有愛爾蘭血統），而父親是中國人。由於我在本地學校就讀至小三，我能操流利廣東話，並會讀及寫一點點中文。雖然別的孩子常常會叫我做「金髮小子」（因為我的頭髮顏色較淺），但他們其實對我很好的。縱使我能很容易融入本地人的圈子，我想還是覺得自己跟別人不太一樣。

在香港，我覺得自己是偏向西化的，然而到了英國，我仍然覺得自己有點格格不入。英國人總會因為我的口音而以為我是美國人，由於校內有太多不同種族的同學，我是有點美語的鼻音的（有人還因為我的口音，而以為我是澳洲/紐西蘭人呢！）在外表方面，別人比較會猜我是巴西、意大利或西班牙人，有一次更以為我是印度人！

我喜歡作為一名混血兒——真的可以集兩個世界之所長。我會說混血兒們是與眾不同的⋯⋯但同時世界上有很多混血兒存在！我加入香港欖球總會的團隊比賽，裡面就有很多隊員是混血兒。

混血兒確實是世界上最棒的人！說笑而已⋯⋯我不是說我們混血兒是另類的新民族之類，只是有時能在不同的角度看世界，對我們來說是有利的事情。

我並不認為我曾經有被歧視過。曾經有人笑稱我是"麻種"（哈利波特故事裡指的麻瓜血統 Mudblood），然而這對我並非帶有攻擊性的冒犯，因為我向來以混血兒為榮。

總的來說，我覺得作為混血兒是有絕對的優勢，而我真的喜歡混血兒女孩，或深褐膚色的白人女子，哈哈。

I was born in Hong Kong and my mother is English (with a bit of Irish) and my father is Chinese. I am completely fluent in Cantonese as I went to a local school up to Primary Three and can read and write a little Chinese. Although the kids used to call me "Blondie" on account of my lighter-coloured hair, I was treated really well. Whilst I fitted in easily, I guess I still felt a little different.

In Hong Kong I do feel more Western but when I go to the UK, I still feel a bit out of place. People seem to think I'm American because of my accent – it has a slight American twang because of the mix of people at my school (someone thought I was Australian or Kiwi the other day because of it!). In terms of my appearance, people tend to guess Brazilian, Italian, Spanish and even Indian once!

I like being Eurasian, it really is the best of both worlds. I would say that it's different, that I feel unique… but there are so many of us out there! I play for the Hong Kong Academy rugby team and a lot of my team mates are Eurasian.

Eurasians are the best people in the world! Just kidding… it's not like we're another species or anything like that. It is an advantage being able to see things from different points of view however.

I don't think I've really been discriminated against as such. I've been called silly things like 'Mudblood' (from Harry Potter) but that's not very offensive to me as I am proud to be of mixed blood.

All in all, I feel that being a Eurasian is a definite advantage. And I really like Eurasian girls, or brunettes, haha!

My mother is Chinese and my father is English. I was born in Hong Kong and attended Kennedy School (when it was actually still on Kennedy Road!) and Island School. In those days there was only a handful of English schools. I went to the UK between the ages of 19 and 34. I ended up marrying an English/Irish classmate from Hong Kong after my return.

I was born in the 1950s and I would say that the mid-50s was the beginning of the Eurasian generation. There are older Eurasians of course but it was in the 50s and 60s that cross-cultural dating and marriage became more widespread. It still wasn't approved of, but it was becoming more common. Being from different cultures didn't seem to bother my parents, which was probably unusual – my father was always very independent and my mother adapted to Western culture very easily.

When I was young there was still a lot of prejudice against Eurasians, especially amongst the Chinese. They didn't like us and we were called 'jaap jung' – a derogatory term for being mixed. Locals could always tell I was mixed; even though as a child I looked very Asian I still stuck out like a sore thumb. The impression I got was not that the Chinese despised Westerners but that they didn't like the fact that we Eurasians were neither Chinese nor not Chinese. It was the mixed aspect that seemed to bother them.

That is not to say that there was no discrimination from the Westerners. I remember being kicked out of a well-known club as a young girl for being Eurasian as they had a 'no Chinese' policy in those days. It didn't really bother me though, I just accepted it. I've never had a chip on my shoulder about that sort of thing. Although I lacked confidence when I was young (I'm not sure whether it was on account of being Eurasian or not), I was always happy with my lot and who I was.

Unhappily, this was not shared by many of my Eurasian classmates who seemed to really suffer on account of their mixed blood. We were, of course, a minority in a predominantly European school and our Asian features would often become the target for nasty comments in the playground. Many of my Eurasian friends would compete over who had the roundest, and therefore least Chinese, eyes. I would say that most rejected their Eurasian identity completely and strived to become increasingly Westernized. In fact, all of those classmates except one have become completely Western over time. I could say that a lot of Eurasians of my generation were quite dysfunctional. Those were different times and many married men engaged in extra-marital affairs, often quite openly. It was widespread amongst all races but if I were to be honest, it seemed especially prevalent amongst mixed-race marriages. So perhaps that had something to do with why so many Eurasian children were so unhappy at the time. The Eurasians whose parents were not even married suffered the most, these relationships could be very unpleasant.

When I went to the UK in 1977, everyone was very kind to me. They were fascinated by my mixed blood and my appearance as well as the fact that I could speak fluent English. Even though I have been back in Hong Kong for quite some time I am tempted to say that I still feel more comfortable in England.

I feel culturally Chinese in many ways. I believe that I have intrinsically Chinese core values, for example, I feel very responsible towards my parents and have always respected my elders. I also have a very Chinese palate, I like nothing more than local home cooking. On the other hand, I have never really followed Chinese traditions or anything like that. Socially, I feel more Western.

Appearance-wise, people guess different things depending on where I am. Around Asia, in Vietnam, Indonesia, Malaysia etc., people always seem to assume that I'm local. In Hong Kong, when I pick up my children I have been mistaken for a Filipino helper.

I have three children and they all look very different. One looks more mixed than the other two and their colouring is varied. My children are extremely proud of their Eurasian side – it is interesting that they view 'Eurasian' in the same way as one would view 'Chinese' or 'English' – to them it is like a race in its own right. I have always brought them up to be proud of their mixed heritage.

I am reluctant to say that it is easier to be a Eurasian now than when I was young, as that would seem to suggest that it was really difficult. At the end of the day I have always been happy in myself and never had real problems with it all. But yes, I guess it was that bit harder then.

我的母親是中國人，而父親是英國人。我出生於香港，就讀於堅尼地小學（當然校址還在堅尼地道！）及港島中學，那時候全港僅有寥寥可數的英文學校。我在19至34歲間到了英國，結果在回來後，嫁了給從香港來的英國/愛爾蘭裔同學。

我在50年代出生，我會說50年代中葉是混血兒時代的開始。當然，在這之前也有上一代的混血兒，但就在50及60年代開始，跨文化的約會和婚姻漸趨普遍，雖然還是沒有被認可。我的父母似乎對他們倆來自不同文化並不以爲然，他們是很特殊的例子——父親向來是個獨立的人，而母親則很容易適應西方文化。

在我年輕時，人們（尤其是中國人）對混血兒存在很大的偏見。他們一點都不喜歡我們，並把我們稱爲「雜種」——那是對混血兒的貶稱。本地人總會覺得我是一名混血兒，儘管我兒時長得很像亞洲人，卻仍然顯得鶴立雞群。這現象給我的印象，並非中國人蔑視西方人，他們並不喜歡混血兒既非中國人，也並非不是中國人這事實，他們覺得混血這問題很困擾。

西方人也並非對混血兒全無歧視。我記得在年青時，就因爲是混血兒而給一家有名的俱樂部趕出來，原因是他們在當時有「中國人不得內進」的政策。那事件對我並沒有甚麼影響，我只是接受事實。我從來沒有因爲這種事情生氣過。雖然我年青時缺乏自信（我不知道這是否與我是混血兒有關），我從來都爲自己的命運和身份感到欣慰。

不幸地，我這個想法並不爲我很多混血兒朋友所認同，他們確實因爲混血兒的身份受了不少苦頭。我們在以歐洲人爲主的學校裡，當然屬於少數，而我們因爲擁有部份亞洲人輪廓，往往成爲了操場上被惡意取笑的對象。很多混血兒朋友都會比較誰的眼睛圓一些，傾向不像中國人。我會說他們大部份都完全抗拒其混血兒的身份，並爭取越趨西化的生活。實際上，所有同學都隨著時光流逝而完全全成了西方人，只有一個例外。可以說在我那世代，很多混血兒都有點不正常。那是不一樣的年代，當時很多已婚男士均公開地發展婚外情。雖然這情況在各種族都會發生，然而老實說這在異族通婚的情況下尤其普遍。這現象或許可以解釋當時的混血兒孩子爲何都很不開心，最受苦的是那些父母並沒有成婚而生下的混血兒，他們可能有非常不愉快的家庭關係。

當我在1977年到了英國，所有人對我都非常好。他們對我的混血血統、我的外表、以及流利的英語感到很驚訝。雖然我已回到香港好一段日子，我依然覺得在英國的時候的日子比較舒服和自在。

我覺得自己很多方面都很中國化，我相信自己本能上擁有中國人的核心價值，例如我對父母很有責任感，同時亦很尊重長輩。我也有很中國化的口味，最愛就是自製的本地住家菜。另一方面，我則從來沒有跟隨過任何中國傳統，在社交生活上，我覺得自己是挺西化的。

在外表方面，不同地方的人對我是來自何方有不同的猜測。在亞洲地區，如越南、印尼、馬來西亞等等，大家都以爲我是本地人。在香港，當我去帶孩子時，總給人誤以爲是菲律賓女傭。

我有三名孩子，每位長的不一樣。其中一個長得比另外兩名更像混血兒，他們三個的膚色都不同。我的孩子都以他們有混血兒的血統而非常驕傲——有趣的是，他們看「混血兒」就像是別人看「中國人」或「英國人」一樣，他們把混血兒看成一個獨立的民族。我總是教育孩子以自己擁有不同的文化爲榮。

我並不想說現在當混血兒比我年青的時代當混血兒容易多了，因爲那好像表示以前的日子相當難過。最後我總覺得自己是開心的，對於作爲混血兒完全沒有問題。但是我也真的認同，從前當混血兒，日子確是比較艱辛一點。

我在香港出生，也是兄弟姊妹中唯一沒有在英國出生的一個，所以也只有我可以取得往返中國的回鄉證。

我會說廣東話，而且會過所有中國的傳統節日及西方的節日。我的父親對風水學很有興趣，而我卻不大相信，尤其是因風水關係，我的姊姊可以擁有較大的房間；我只可以接受事實。我的父母的教子方法很不相同，父親對他認為是錯的事很嚴格，對其他很多事並無所謂；母親卻有較多的指導和規限。我覺得結合父母不同的管教方式，為我們帶來很大益處。

我想很多人因為我的外表而認為我很西化，但這無傷大雅。混血兒對我來說一點都不重要，我只是一名香港人。我在學校的所有朋友都來自不同的民族——對此我並沒有去細想。我與所有人都合得來，和本地中國人相處和聯絡亦全無問題，所有人都沒有分別。

我並不覺得作為混血兒令我有甚麼改變，我就是我。然而，我也喜歡作為一名混血兒；因為和別人有一點點不同，總是件好事。

I was born in Hong Kong and am the only one of my siblings who was not born in the UK. Because of that, I'm the only one out of us that can get a two-way permit to China.

I speak Cantonese and follow all the Chinese traditions as well as the Western ones. My dad is very interested in Fung Shui but I don't really believe it. Especially as it means my sister gets the biggest room. I just go along with it. My parents have different ways of parenting. My dad is really strict about things he thinks are wrong but doesn't mind about a lot of other things. My mum has more guidelines. I think the combination of parenting styles has been a real benefit to us.

I think other people think I'm more Western because of how I look, but it doesn't really matter. My mix has never been important to me, I'm just a Hongkonger. All my school friends are different races – I don't really think about it. I get on with everyone and have no problem relating to local Chinese, it's all the same.

I don't think being Eurasian has made me who I am, I just am. I do like being Eurasian though; it's good to look a little different.

My mother is English and my father is Chinese. I was born in England but came back home to Hong Kong when I was two weeks old and have lived here ever since. If someone asks me what my nationality is, I say 'mixed' – I don't think my passport matters. Despite my British passport, I don't feel much of a link to the UK. It's just somewhere I go to visit family.

I feel an exact split and celebrate all the festivals and traditions of both sides. My father is a big believer in Fung Shui and we all follow it as a family – it suits me… I have the master bedroom in our house! Living in Hong Kong fulfils my Chinese side and going to an English school brings out my English side. Whilst I am fluent in Cantonese, English was my first language. My school has made my more westernized; I imagine that if I went to a local school, I would be more Chinese. Schooling has a bigger effect than ethnicity. I do have local Chinese friends but sometimes I find it hard to relate to them.

A lot of people can tell that I'm Eurasian but generally, Chinese people think I'm Western and Western people think I'm Chinese. I don't necessarily identify more with Eurasians. There are so many different types of Eurasians with different ethnic backgrounds.

Being Eurasian does define a part of me but I don't think people should be solely defined by race. I see the world as a human nation, not individual nations.

我的母親是英國人,而父親是中國人。我在英國出生,但自兩周大已回來香港,並生活至現在。如果有人問我的國籍是甚麼,我會回答是「混合的」——我並不以爲護照代表甚麼。除了有個英國護照,我跟這個國家並沒有很大聯繫,這只是我去探親的地方而已。

我覺得自己內在清晰的分爲中英兩面,並慶祝雙方文化中的所有節日和傳統。我的父親非常相信風水學,我們都跟隨相信——這似乎很適合我.....因爲我被分配到家裡的主人房! 在香港居住適合我一半的中國血統,而在英語學校就讀,則帶出我另一半英國血統使然的性格。雖然我能說流利的廣東話,我的第一母語卻是英文。在學的日子令我變得更西化,可以想像如果我就讀的是中文學校,我將會更爲中國化。學校教育對成長的影響,比種族血統更大。我確有本地中國人朋友,然而有時我會覺得很難與他們聯繫。

很多人可以看得出我是混血兒,但一般來說,中國人會認爲我是西方人,西方人會覺得我是中國人;我並沒有特別長得像混血兒。這世上有太多不同類型及種族背景的混血兒了。

我確實有混血兒的個別特質,但我不認爲人們應僅僅被其所屬的民族而定型。我眼中的世界,是一個整體而由不同民族與個體匯集的人類聯合國,而並非由不同種族分割出來的很多個別國家。

I was born in Hong Kong and without a doubt, Hong Kong is my home. My father is half French and half Spanish and my mother is Chinese. Resultantly, I speak French, English, Cantonese and passable Mandarin.

I think that in the Hong Kong context, 'Eurasian' can properly be considered as a distinct group. Of course in reality, there are Eurasians whose lives essentially gravitate towards the Eastern side or Western side. Very few live in both communities at the same time.

Personally, I feel more Asian although my wife may think otherwise. When I was a kid I spent a lot of time at my maternal grandmother's place. I always wonder whether that is the reason I feel closer to my Chinese side.

People are always trying to guess my ethnicity. In Hong Kong about one third of the people I meet think I am definitely Caucasian and nothing else, one third definitely Chinese and nothing else, and the remainder will say "It's obvious you are Eurasian!" I myself can always tell another Eurasian immediately.

I am used to people getting it wrong. People in Hong Kong tend to be more up-front about asking other people's ethnicity. In London it's a bit of a sensitive topic. I prefer the Hong Kong way.

I think that perhaps before World War II, it would not have been a positive thing to be Eurasian in Hong Kong. Eurasians were clearly discriminated against socially. Although some did very well financially it does not amount to the same thing. Some people would say that under the old order we were not British enough and now we are not Chinese enough. I think that nowadays it is probably, by and large, not a bad thing provided you have the language skills. I think that we can sometimes act as a cultural bridge.

Nowadays, the principal advantage is that generally both groups tend to easily accept us socially and that if you are genuinely bicultural you get to enjoy more diversity. I feel happy that I can appreciate French comedy from Molière as well as a Stephen Chow Sing-chi 'mo lei tau' movie. On the down side, I think that after the handover there is a doubt as to whether Eurasians can rise above the glass ceiling in government or politics. I hope that anyone, including Eurasians, who 'love Hong Kong and love China' would be equally welcome in running Hong Kong.

I can sometimes feel more of a bond with other Eurasians but only when the fellow Eurasian is also bicultural. Sometimes Eurasians are only Eurasian physically – if in every other way they behave completely like a Westerner or Asian then for me at least, that particular bond disappears. In any event, I personally don't attach any meaningful importance to ethnicity as such. What draws people to one another are common values and a similar socio-cultural background. In that sense I would consider my wife (who is ethnic Chinese) also Eurasian as she can easily travel in both worlds.

我在香港出生，毫無疑問，香港是我的家。我的父親是半法國、半西班牙籍混血兒，而母親是中國人，結果我會說法語、英語、廣東話以及尚算合格的普通話。

在香港的環境下，"歐亞混血兒"可以算是獨立的一群。當然，在實際上混血兒須傾向東方或西方的生活，很少真的可以同時共存在兩個社區中。

個人覺得我是比較傾向亞裔的，雖然我的太太可能持相反意見。我還是小孩的時候，很多時都待在外祖母那兒，可能因此常常覺得與中國那邊血統比較親暱。

人家總愛猜我來自那個種族，在香港我遇到的三份一人都以為我僅只是高加索人而已，其他三份二人會說「很明顯你是名混血兒！」而我則總會即時分辨出誰是混血兒。

我已經習慣了別人弄錯我的身份。香港人比較誠實直接問及別人的種族，在倫敦這是個較為敏感的題目，我本人比較喜歡香港的方式。

我想可能是在二次大戰前，在香港作為混血兒並不好過，社會上顯然對混血兒有所歧視。雖然有個別混血兒很會賺錢，然而這對他們在社會上的地位並沒有幫助。有人會說，在從前我們不夠英國化，現在又不夠中國化。其實我相信現今當混血兒，只要你有相應的語言技巧及能力，大抵上都已經不是件壞事了。我們有時還可充當文化的橋樑。

現在，我們基本的優勢是兩種文化都很容易在社交上接受我們，而且如果你是真的擁有雙文化背景，你還可以享受這種多元化。我覺得自己可以一面欣賞法國莫理哀的喜劇，一方面欣賞周星馳的"無厘頭"電影。要數壞處，我覺得在回歸以後，大家都懷疑混血兒在政府內或政治上有沒有無形的玻璃牆，阻撓了我們向上爬的機會。我希望所有人，包括混血兒，只要都是"愛香港，愛中國"的話，都同樣歡迎來治理香港。

我有時與其他同樣是雙文化的混血兒好像有種無形的聯繫，有時某些混血兒只是虛有其表，內在與行為上則是完全的西方人或亞洲人，與這類型的混血兒我則沒有這樣的無形聯繫了。在任何情況下，我個人覺得種族本身沒有甚麼意義，能令人與人互相靠攏的，其實是大家共同的價值觀，以及類似的社交文化背景。在這個前提下，我會認為我的中國籍妻子是一名混血兒，因為她可以很容易地在兩個文化世界中遊走。

I was born in Hong Kong to a half-Spanish, half-French father and a Chinese mother. I was educated in the French section of the French International School and at home we speak French 95 percent of the time. The remainder is a combination of Cantonese and English. As my mother speaks French most of the time, I don't think I learned any Cantonese from her – I seem to have picked it up from watching Chinese television and from just being in Hong Kong. I guess you could say the same about my English – I just learned it along the way.

Although our family is scattered across the globe, I do have a number of Chinese relatives in Hong Kong with whom I celebrate all the typical Chinese festivals and traditions. I definitely feel that I have a Chinese attitude towards family and elders – for example, I would never have just left my parents when I turned 18, my family continues to be very important to me and in that sense I think I have quite Chinese values.

On the other hand, I still feel French although I've never actually lived there. When I go to France, I feel French and people think I am French. In many ways I blend in more easily there in terms of appearance and go largely unnoticed. In Hong Kong, I have to explain where I'm from whenever I speak Cantonese. I suppose I look foreign here. When I do explain that I'm from Hong Kong, I'm invariably asked 'But where are you really from?' It can be a little tedious.

I completed my medical degree in Dublin before going to London for my MA. I felt like a tourist in the UK, I really don't have any connection to that place. I always intended to come home to Hong Kong.

Whilst Eurasians in Hong Kong tend to be more commonly half English, half Chinese, there were quite a few French Eurasians in the French International School. With so many of us, I never felt like an outsider, it was normal really. I've never had any negative experiences on account of being Eurasian. I feel I have the best of both worlds… dim sum and foie gras! I feel fortunate in being able to enjoy both French and Chinese media and lifestyles.

I haven't found being Eurasian much of an advantage at work although my name can be a problem – for some of the patients who don't speak much English, I introduce myself as 'Dr Do' or 'Dr Mo' – I try to gauge the situation, being in hospital can be confusing enough!

I have friends of all types and can mix with all cultures quite easily. It can be difficult to mix with local Chinese unless they have been to an international school or have travelled a lot. It doesn't matter about their ethnicity, it's more about how they were brought up. All that said, I have to say that being Eurasian has definitely played a big part in my personality.

我生於香港，父親爲西班牙、法國混血兒，母親爲中國人。我就讀於法國國際學校法屬部，在家超過九成半的時間都以法文溝通，其餘的時間則夾雜廣東話及英語。由於母親經常使用法文，所以我的廣東話並不是從她那裡學回來的——我應該是在看中文電視和在香港生活中，學習廣東話的吧；相信英語亦然，也是在生活間點滴學回來的。

雖然我的家人散落在全球各地，我在香港也有部份華裔親戚，與我同渡傳統中國節日和活動。我覺得自己絕對是抱著中國人的態度，去面對我的長輩及家庭——例如我不會在18歲以後就立即離開父母，家庭對我來說仍然很重要，這點我認爲我持的是中國人的價值觀。

另一方面，我也覺得自己很像法國人，雖然我從未在法國生活過。當我到法國時，我覺得自己像個法國人，而當地人也這麼認爲。在很多方面，我在外表上更容易融入那個地方，就像一個本地人一樣。在香港，可能由於我看上去像個外國人，每當我說廣東話時，我也要解釋我來自那裡。當我解釋其實我是來自香港時，總是有人問我「其實你真正來自哪兒？」，這可以是很煩悶討厭的事情。

我在都柏林完成我的醫學學位課程，然後到倫敦修讀碩士。在英國，我覺得自己是個遊客，我真的跟這個地方完全沒有關係。我常常打算回香港的家。

香港的混血兒多是中英混血兒，在法國國際學校則仍有不少中法混血兒。在他們中間，我覺得自己跟他們一樣，從不覺得是個外來人。我也從沒有因爲混血兒的身份而有任何負面的經歷。我認爲自己擁有兩個文化世界最好的東西——點心與鵝肝！也覺得能夠同時欣賞到法國和中國的不同媒體和生活方式，是很幸運的事。

在工作中，我並沒有因爲我是名混血兒而有甚麼好處。反而我的名字有時會造成混亂——對有些不大會說英語的病人，我會自我介紹爲杜醫生(Dr. Do)或巫醫生(Dr. Mo)——我會嘗試去判斷不同的情況，有時在醫院也夠混亂的！

我有各式各樣的朋友，並很容易融入不同的文化。但卻很難融入本地中國人的圈子，除非他們曾經就讀國際學校，或經常出外旅遊。其實甚麼種族國籍並不是重點，重要的是他們如何成長和接受教育。說了那麼多，我得承認混血兒在我的性格中扮演著重要的角色。

作爲菲律賓籍母親及英國籍父親的兒子，我在香港長大及接受教育。我曾到英國就讀三年大學，但從來沒有長時間離開香港，因爲我常常會因爲欖球賽和訓練營而回來。

我在英國的日子很悠閒舒適，由於自小每個暑假我都會造訪英國，所以從來沒有像一些第一次到海外生活而產生的嚴重文化衝擊。混血兒的身份，並沒有爲我帶來任何相處的問題；我細小的身材，在欖球場上反而比其他球員更注目！讓我很容易被辨認，我也享受那一點點的臭名。

如果有人問我來自何方，而我說「香港」時，通常對方的反應都是「嘩，你的英文真好！」雖然英語是我的母語！別人都只是友善的開玩笑，從不會是惡意的，也不是因爲我是混血兒。有時人家會覺得我有點西班牙或南美裔人的長相，他們知道我不是完全的英國人，但卻搞不清楚我是那裡人。

作爲混血兒，我從來沒有任何負面的感覺；我喜歡自己是混血兒這事實，而且也以此自豪。成長的過程中，我和很多香港人一樣，擁有很多不同民族的朋友，所以我的種族從來不是問題，而我的友誼也大多建基於對體育的共同興趣。

我也沒有覺得兩個文化之間會有衝突之處，如果硬要我去選一個較親的文化，我會選英國。在成長期間我去英國的次數遠多於菲律賓，而不幸地我也沒有學會菲語。雖說如此，如果要我舉一個喜愛菲律賓的例子，那是他們對家庭的概念。我有36名菲籍表親，而英籍的卻一個都沒有！雖然我不是常與他們踫面，但當我們見面時，就彷彿從來沒有分開過一樣。

我就覺得自己是來自香港的，對英國或菲律賓都沒有很強的歸屬感...香港就是我的家。很多本地的混血兒朋友都是普遍的中／英混血兒，縱然我很自豪於我的兩個民族，有時也會希望自己身上有些中國人的血統，因爲我是屬於這個地方的。香港是東西交融之地，這就是我。

Born the son of a Filipino mother and an English father, I was brought up in Hong Kong where I completed my schooling. I went to University in the UK for three years but I was never away from home for too long as I was continually flown back for various rugby tournaments and training camps.

My time in England was pretty comfortable and as I had visited the UK nearly every summer during my childhood, I never experienced the big culture shock some people encounter when they first move abroad. I got no trouble from anyone for being Eurasian; indeed I was much more likely to be noticed for my diminutive stature on the rugby pitch amongst other players! It made me recognizable and I enjoyed some sort of infamy on account of it.

If people did ask me where I was from and I said 'Hong Kong', I got the usual "Wow, your English is so good", even though English is my first language! It was never malicious, just friendly banter and wasn't about me being Eurasian. Sometimes people would think I had some Spanish or South American in me – they could tell I wasn't fully English but they couldn't figure out what I was.

I never had any negative feelings on account of being Eurasian; I liked the fact that I was mixed and was proud of it. Growing up I had a very mixed group of friends, which is not uncommon in Hong Kong, so my ethnicity was never an issue and my friendships tended to be based on a common interest in sport.

I don't really feel a pull between my two cultures but if I had to say which side I felt closer to it would be my English side. Growing up I visited the Philippines far less frequently than the UK and unfortunately I wasn't taught to speak Filipino. In saying that though, if there was one thing I would say that I loved about my Filipino side, it would be the whole sense of family. I have 36 first cousins, compared to zero on my English side! Even though I don't see them very often, when I do it's like we haven't been apart.

I just see myself as from Hong Kong. I don't feel any strong ties to either England or to the Philippines… Hong Kong is home. Most of my Eurasian friends are of the more common English/Chinese mix and whilst I'm proud of my own mix, there have been times when I wish I had some Chinese too, probably because of my affinity with this place. Hong Kong is the place where East meets West, and that's me.

I am half Chinese, half English. I was born in Hong Kong and schooled here. Growing up, my brother and I reacted very differently to being Eurasian. When I was at school, the Chinese were looked down upon somewhat and I used to hide my Chinese side to the extent that I was almost happy if my mum didn't come to my school events.

This was at odds with the fact that I really didn't know my English family at all and was much more influenced by my Chinese family, taking on their culture, morals and values.

Now I am very proud to be Eurasian and regret the conflict that I used to feel. Maybe people were more racist then or perhaps I was just more sensitive, I'm not sure. I am very keen to pass on my Chinese culture to my children as it has given me many advantages. I am also determined that they will be able to read and write Chinese. Being mixed, we ought to be literate in both! I just love all the Chinese festivals and the family side of things. I believe in family values and having our elders live with us.

In Hong Kong, being bilingual has meant more job opportunities and has helped with my career. It has been especially useful in organizing live events. I MC live events in both English and Cantonese – it's great being able to include everyone. When I was in my most successful band, 'Sisters of Sharon', I wrote a song in Cantonese. I consider it to be one of my greatest achievements – it took nearly ten years as it is so difficult to write out lyrics in Cantonese without being able to read or write Chinese but it was worth it. The song, 'Will You?' was nominated for Best Alternative Song that year by C.A.S.H. (the Composers and Authors Society of Hong Kong) and lots of people told us it was an achievement for an indie band to be nominated. I still sing in Cantonese but I've given up writing songs in Chinese – it's just too difficult and takes too long!

It has also been an advantage not being restricted in my friendships on account of any language barriers. When I became a mum, it was nice to be able to make friends with Chinese mums as well as Western ones.

Being Eurasian has even played a part in my marriage. My husband is English and just before I met him, I had made a list of all the things I wanted in a partner. This included a Western outlook but with Chinese values. It transpired that he had made a similar list, also hoping for someone who was Western with Asian values. My being Eurasian made up a big part of the attraction for him. It was love at first sight, we married nine months after we met and have been together for 17 years.

It's so strange I look a lot like my Chinese mother even though I look so Western. I'm so white looking that people can never usually guess that I'm even Eurasian. People have thought me to be Greek, Australian and even South African. I think any impact that being Eurasian has had on me is more to do with the fact that I am a Eurasian who looks totally white than actually being Eurasian. It can be difficult when even my own Chinese family group me with Westerners as 'you people' as opposed to recognizing that I am half Chinese. I mean, do you have to be 100% Chinese to be Chinese?

Then there is the issue of being able to speak Cantonese. Strangers ask me, day in day out, why my Cantonese is so good. When I reply that I am half Chinese, they point-blank refuse to believe me. When I venture to explain that I grew up in Hong Kong, it is not accepted either! Hahahaha!

But as much as I bemoan people always asking me the same question, I've got to admit that it's a good conversation starter! Being Eurasian is all good.

我是名半中半英的混血兒，在香港出生及上學。在成長的過程中，我和弟弟對作為混血兒的反應很不一樣。在我仍在學的年代，中國人總有點被瞧不起，所以我總是習慣把我的中國人的一半藏起來，最喜歡母親不來參加我的學校活動。

然而這想法和我的生活其實互相違背，我對父親在英國的家庭全無認識，卻主要受到我的中國親戚影響，並接納了他們的文化、道德和價值觀。

現在我對自己的混血兒身份非常自豪，並對以往有關種族身份的矛盾感到懊悔。我不確定原因，或許以前的人都比較存有種族歧視，也可能是我從前比較敏感。我現在很喜歡將中國文化傳到我的孩子身上，因為它實在帶來太多的便利。我也同時堅持孩子們要懂得讀寫中文。作為混血兒，我們應該兩種文化皆要通曉！我對所有中國節日，以及中國人的家庭觀念都喜愛，並認同與長者同住和家庭價值觀。

在香港，能操雙語代表多些工作機會，而且也真對我的事業有幫助，尤其是主辦現場活動。我能當英語及廣東話的活動司儀——能讓不同文化的人均能參與真好。我還在我最成功的樂隊 'Sisters of Sharon'時，曾經寫過一首廣東歌。我以此為我其中一項最大的成就——因為我不會寫廣東話字，要以廣東話寫歌詞真的非常困難，足足花了我差不多十年的時間來完成，然而，這都是值得的。這首歌《會否》在當年被提名香港作曲家及作詞家協會(C.A.S.H.)的「最佳另類歌曲獎」；很多人告訴我們，以獨立樂隊的身份獲得提名是很了不起的成就。我現在還會以廣東話演唱，但已放棄再以中文寫歌——實在太難和太費時了！

此外，能夠不用受語言限制地交朋友，也是其中一個好處。當我自己成了母親時，能夠與中國和西方母親成為朋友，和他們交流，也是一件開心的事。

作為混血兒甚至對我的婚姻也有莫大影響。我的丈夫是名英國人，在認識他以前，我曾經列出理想配偶須具備的條件清單，包括了有西方人的外表，但具有中國人的價值觀。後來發現，他原來也列出了這條清單，同樣也希望未來太太是西方人，但擁有東方人的價值觀。於是我的混血兒身份深深地吸引到他。我們是一見鍾情，在認識九個月之後便結婚，已經在一起17年了。

雖然我有一副西方人的面孔，但很奇怪地，我跟我的中國母親卻長得很相像。我的皮膚白雪得別人不會猜到我是混血兒，他們或會以為我來自希臘、澳洲，甚至南非。混血兒對我的影響，只是在於我長得完全像一名白人。讓人難過的是，就是我的中國親戚，也把我與所有西方人混為一談，把我們說成是「你們這些人」，而不認為我擁有一半中國血統。難道真的必須為100%的中國人，才算得上是中國人嗎？

另外就是我懂廣東話這問題了；陌生人總從不間斷地問，為什麼我的廣東話會說的那麼好？我回答因為我是半個中國人，他們就直截了當地拒絕相信。當我試圖解釋我在香港長大時，他們同樣不接受這個答案！哈哈哈哈

縱使我常悲嘆人們常常問我相同的問題，我也得承認，這是個很好的開場白！作為混血兒真好。

I was born in the Cote d'Ivoire and lived there for a year. My father, who is an engineer, was one of only two Chinese men engaged in building dams there at the time. My mother is English/Scottish and my parents met in Scotland at a party after my father had taken a boat all the way from Hong Kong to the UK for university.

I moved to Hong Kong at the age of two and attended primary school here. When I was six, my mother, sister and I traveled to and from Nigeria where my father was stationed. At thirteen I went to boarding school in the UK but I always came back to Hong Kong during the school holidays. My mother ended up spending 26 years in Hong Kong despite longing for the UK and that our residence in Hong Kong was only ever supposed to be temporary. It was always the plan that we would return to the UK, back to the rolling green hills that my mother missed so much. That was one of the reasons I never learned to speak Cantonese.

On that note, my grandmother always regretted the fact that I had never learned the language and actually told my father that he had failed in his duty to teach me. Notwithstanding that, my father has always tried his utmost to instill in me a sense of Chinese culture and has even, in the past, criticised me for not embracing my Chinese side enough. I do appreciate the efforts he has made to perpetrate his culture in me and in my children. I definitely encourage the influence he has in that sphere. I have certain Chinese core values, such as respect for elders and emphasis on academic excellence that are very strong within me and I want to be passed to my own children. These values can be difficult to explain but my wife who is of Eastern European descent understands the dilemmas it sometimes puts me in. To this day, I cannot explain why I believe in these values, I don't remember learning them; it's just the way it is. It's funny, I remember resenting the fact that I had to have 'educational holidays' at the insistence of my father whilst my friends got to hang out at the beach, but now I have the urge to do the same to my kids!

As a child, our family mixed mostly with other local Chinese families – I think my father wanted their influence to rub off on us! The only problem was the language barrier, which could make things a little awkward, but I got on with them all pretty well. I am still able to mix with either Westerners or Asians. It's just a matter of going to the pub or going to karaoke! I've found that how I relate to local Chinese can depend on their own experiences, for example whether they've traveled a lot or been to university overseas for example.

When I first went to UK at 13, I was at a state school for a term. When people found out I was part Chinese they started with the predictable insults, but after a bit of rough and tumble in the playground it wasn't really a problem anymore. There were no other Eurasians at boarding school so it was fun to meet lots of mixed people at university. When you are Eurasian yourself you can always spot them! I identify with other Eurasians to the extent that if I would approach another Eurasian in a crowd even if I was on my own. I've got to say, I've never met an unpleasant or arrogant Eurasian.

I think I am more western looking than many Eurasians. People tend to guess that I am continental European. I've also had South American or Kiwi/Maori.

Being Eurasian has neither been a hindrance nor a benefit, I am happy with my ethnicity and I don't feel any real bias towards one side or another. When I am in Hong Kong, I don't think of what I am. I just am.

我在西非科特迪瓦（前意譯爲象牙海岸共和國）出生，在那裡生活了一年。我的工程師父親，當時在那裡建堤壩的工程人員中只有兩名中國人，父親就是其中之一。我的母親是英國／蘇格蘭人，兩人在蘇格蘭的一個派對中認識，那時我父親剛乘船由香港到英國讀大學。

我在兩歲那年移居香港，之後在此就讀小學。在最初的兩年，母親與我常常飛到尼日利亞，父親常駐的工作地去。在我13歲的時候，我到英國寄宿學校就讀，但在假期時常常回香港。我的母親結果在香港過了26個年頭，雖然她一直都非常討厭這個地方，而我們在香港的居所都總是暫時性的。我們總是計劃要回到英國去，母親非常掛念她青山綠草的故鄉。就是因爲這個原因，我從來沒有學會說廣東話。

這也是我祖母常常後悔的事，就是我沒有學會中文，她也曾對我父親說，他並沒有盡其父責來教導我。儘管如此，父親經常盡他最大的努力，要向我灌輸中國文化，以往也曾批評我沒有利用好我中國人的一面。我很欣賞他在教導我及我的孩子中國文化的努力，並絕對鼓勵他這方面的影響。我擁有某些中國文化的核心價值，如尊重長者，重視學業成績等，並希望把這些價值觀傳到我的孩子身上。這些價值觀很難向我的東歐裔妻子解釋；就是到了今天，我也不能解釋爲什麼我會有這些信念，我並不記得曾經學過這些觀念，但好像就是與生俱來一樣。有趣的是，以往我很痛恨父親堅持要我放「學習假期」，當我躲在家溫習的時候，同學們都到沙灘玩要去了；到現在，卻是我急著要我的孩子放「學習假期」！

在孩童時代，我們家常與其他本地中國人家庭聯繫交往——我想那是因爲父親希望藉此影響我們！那時唯一的問題是語言障礙，有時會導致棘手的場面，但除此之外，我與他們相處融洽。我現在也可以融入西方或亞洲人的圈子，只是去酒吧還是去卡啦OK的問題吧了！我發現，要如何與本地中國人相處交流，會基於他們自己的經歷，比方說有沒有常常去旅遊，或曾經在海外大學讀書等，這並不能輕易地概括出來。

當我13歲首次來到英國時，我在公立學校就讀了一個學期。當同學知道我是有中國人血統的混血兒，他們自然而然開始了各式的嘲弄，但經過了一輪難過的日子，我們的相處再也不是問題了。在寄宿學校裡，並沒有其他的混血兒，所以在大學裡遇見各式各樣不同的混血兒同學，我覺得非常有趣。當你自己是一名混血兒，你總會把其他混血兒都認出來！我們的相同之處，就是即使我是自己一人，也會在大夥兒中，和其他混血兒相認。我想我從來沒有遇見一個不禮貌或傲慢的混血兒。

我想我比其他混血兒長得像西方人。別人總猜我是來自歐洲大陸，或是南美或紐西蘭／毛利人。

作爲混血兒並沒有爲我帶來阻礙或方便，我對自己的種族很滿意，而沒有對任何一方存有偏見。當我在香港時，我沒有去想我是誰，我就是我。

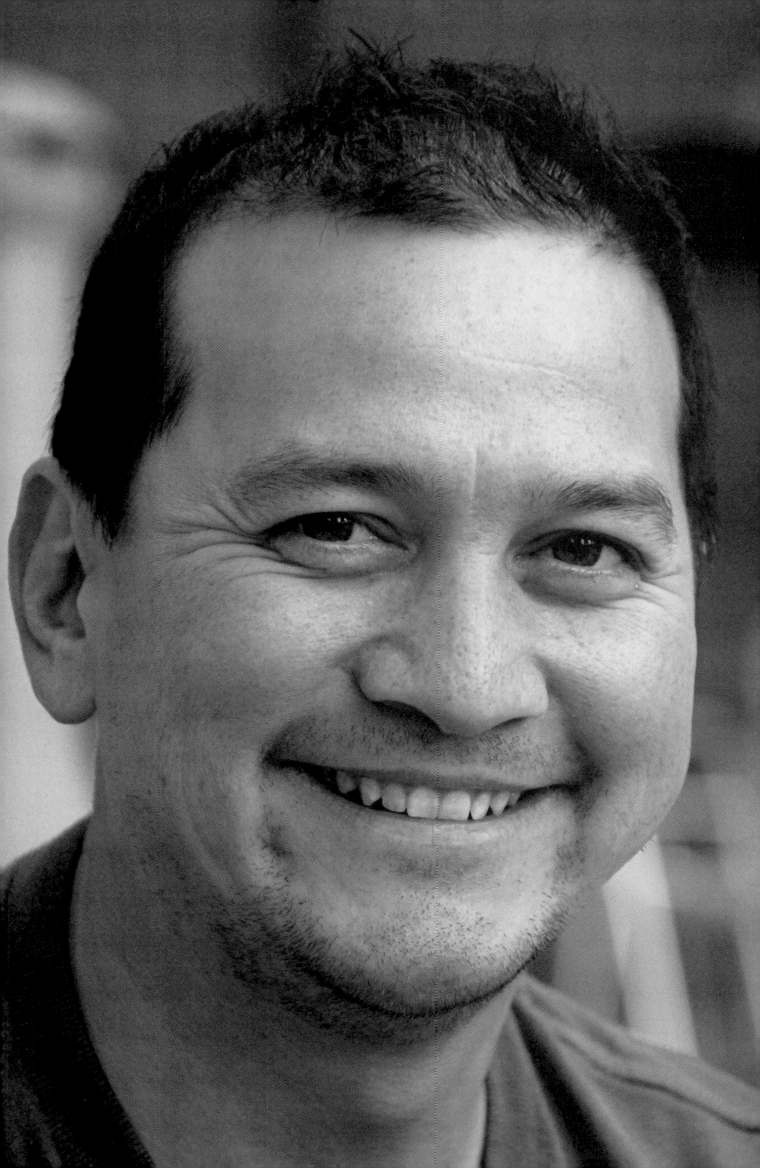

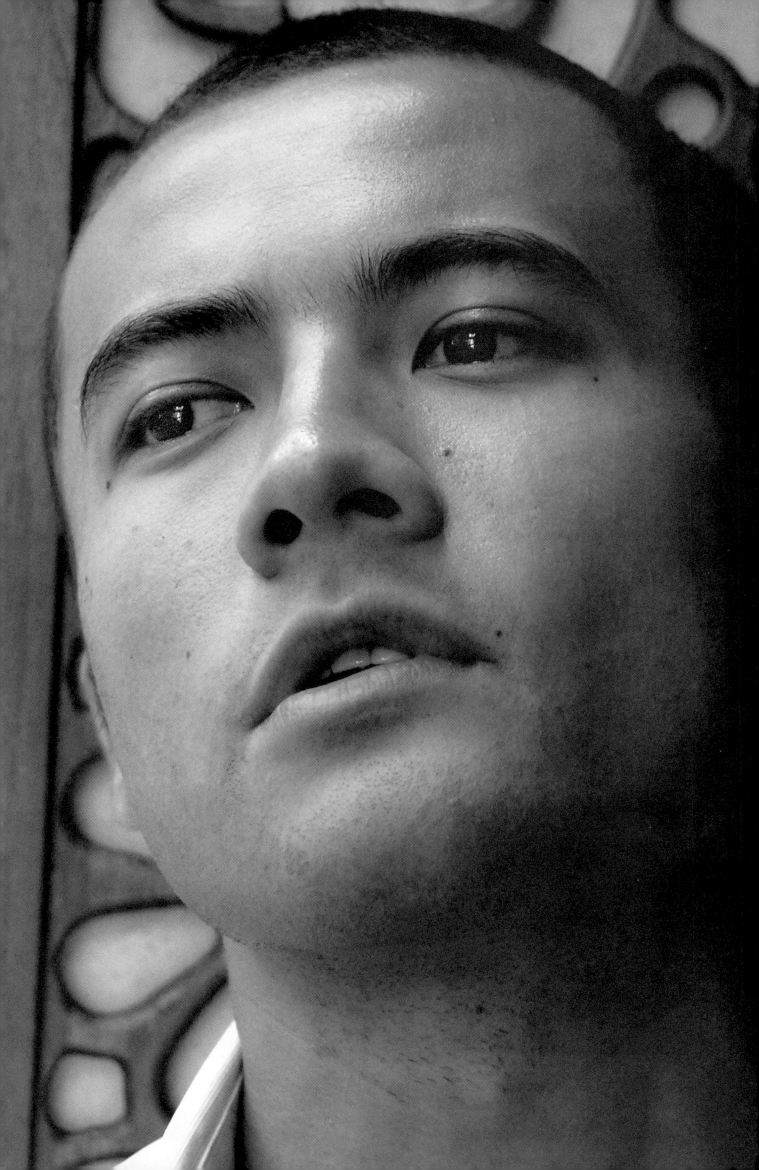

I was born in Hong Kong and apart from attending university in London and a short period working in Taiwan, I have always lived here and consider it to be home. My mother is Chinese and was a model, my father is English and an old China hand – he started out around Asia and in Hong Kong back in the seventies.

Despite my British passport, I used to define my nationality as 'Hong Kong' but Hong Kong has changed so much, even in the last five years that I'm not really sure any more. Whereas Hong Kong used to be so international, it feels so Chinese now.

I'd like to be able to say that I feel equally Western and Asian and have reached some sort of middle ground but to be honest, it depends on the situation. Sometimes I feel really Chinese – for example if I'm at a Chinese restaurant with Westerners. Sometimes it's not so much that I feel Chinese so much as I just don't feel English. At university, I didn't have any interest in their pub culture, their beer, the football or being a 'lad'. Having been brought up in Hong Kong, I felt that I had done all that when I was much younger and had a more sophisticated, mature and international outlook than the English students.

Likewise there are lots of Chinese things I cannot appreciate and it can be difficult to understand the Chinese mentality which is often so culturally insular and conservative. I feel fortunate as a Eurasian being able to appreciate all cultures and being able to blend in everywhere I go. For me, being Eurasian has been a positive experience as it allows me to interact with so many people. My ability to bridge the gap between East and West has helped me to understand different markets and has contributed significantly to my success in business.

Although I feel like I belong everywhere, I suppose I am often seen by others as an outsider. In England, people viewed me as Chinese. In Hong Kong, I am spoken to in English eighty percent of the time. The locals can easily see that I am not fully Chinese and I am always being asked why my Cantonese is so good. I probably looked more Western when my hair was longer – it's wavy! I have never suffered any discrimination for being Eurasian, only for being Asian. That said, nearly everyone can tell instantly that I am mixed.

Eurasians being recognized as an ethnic group in our own right is a nice idea but it would be difficult as there are so many different mixes. From a social point of view, I do feel as though we should have some sort of association though. I can always tell another Eurasian immediately – in fact, when I see another Eurasian, I always go up to them to find out their mix. Aside from being a great pickup line, I find it genuinely interesting. Although it's often unsaid, I think there is some jealousy from non-Eurasians… after all, Eurasians are widely known to be the best looking!

我在香港出生，除了在倫敦留學，及在台灣工作過一段短時間，我都是在香港居住，並以此爲家。我的母親是中國人，並曾經當過模特兒，我父親是英國人，並是一名中國通——他早在70年代已經來到亞洲地區及香港工作。

除了我擁有英國護照，我以往總習慣用「香港」作爲我的國籍，然而香港在過往——甚至是最近五年——也經歷很大變化，我再也不像從前那麼確定了。以往香港是那麼的國際化，現在則變得非常中國化了。

我也很希望自己真的是半西方半亞洲裔，然而老實說，要視乎情況而有所不同。如和西方人在中式酒樓的時候，我會覺得自己很中國化。我有時並非覺得自己特別像中國人，這感覺僅僅因爲我不覺得自己像英國人。在大學時，我對他們的流行文化、啤酒、足球、作爲他們口中的「小伙子」一點興趣都沒有，在香港長大的我，往往覺得以上這些事情我早就做過了，相比起英國學生，我看上去比較成熟、有深度和國際化。

同樣地，有很多中國的東西我不會欣賞，以及難以明白中國人的意識形態——文化上往往是那麼狹隘和保守。我很慶幸作爲混血兒，可以欣賞不同文化，及去到何地，均可融入那裡的文化。對來我來，作爲混血兒的經歷都是正面的，讓我可以與很多不同人溝通交流。可以跨越中西文化差異的能力，幫助我了解不同的市場，從而對我在生意上的成功貢獻良多。

雖然我覺得自己可以屬於任何地方，然而別人可能都覺得我是局外人。在英國，別人會以爲我是中國人。在香港，八成的時間人家也會跟我說英語。本地人很容易認得出我不是完全的中國人，而我也常被問及爲何我的廣東話會這麼流利。我大概在頭髮長得越長的時候，會越像西方人，因爲我有卷髮！作爲混血兒我從來沒有被歧視過，只有作爲亞洲人的時候有被歧視。雖說如此，幾乎所有人都立即看得出我是混血兒來的。

混血兒作爲獨立種族這提議是不錯的，但這可能有很大困難，因爲我們本身有那麼多不同種族的混血兒。在社交角度上，我是覺得我們混血兒需要有某些協會之類的組織的。我總可以立即分辨出其他的混血兒——事實上，我每當見到混血兒時，我總會上前詢問其來自那兩個不同的文化血統，這除了是很好的開場白以外，我是真的有興趣知道。雖然沒有明言，我覺得我們是會惹來非混血兒的妒忌……畢竟外界均認爲混血兒是全世界長相最好看的！

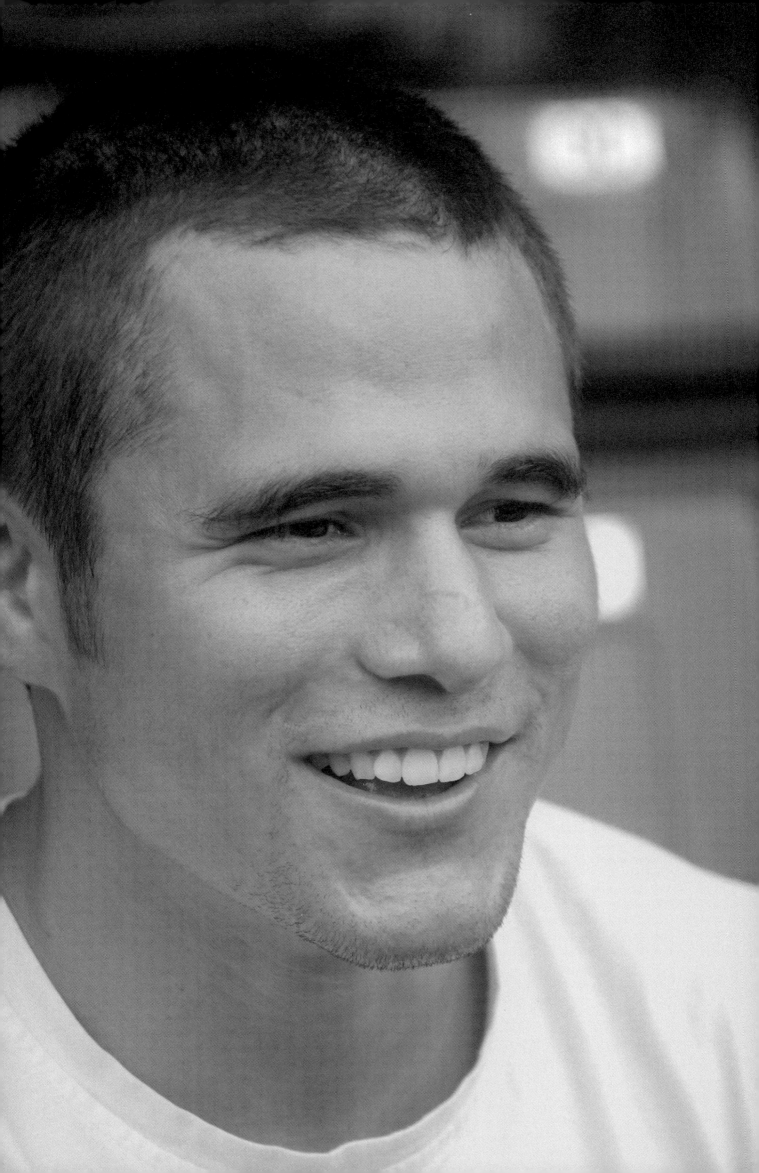

My mother is Macanese, her family (D'Almada Remedios) have been in Hong Kong and Macau as long as anyone can remember and the mix in her blood between Portuguese and Chinese could be anything by now. My father is English. I was born in the UK as my father was worried about getting me a British passport but we returned to Hong Kong when I was eight or nine days old. I lived in Hong Kong until I went to university in England.

I never really thought that much about being Eurasian when I was in primary school. There were few Western kids at my school, most being either Chinese or Eurasian. When I went to KGV secondary school there were far more Europeans on account of the catchment area and I suppose this made me more aware of the fact that I was Eurasian. I made a lot of Western friends from that point onwards and became increasingly Western in my outlook.

Although there were more Chinese students than Western ones at my primary school, Beacon Hill, it was still an ESF school at the end of the day so I didn't really get a taste of local Hong Kong schooling until I did the PCLL (a postgraduate professional legal course) at University of Hong Kong. I found it to be a completely different culture and completely at odds with my experiences of university in the UK. I was always called 'the white guy' there!

I speak a little Chinese but being half Macanese is a little different. Despite that, my mother was keen to get my sister and I involved in local culture. When we were children, she invested in a time-share in a little Chinese village in the New Territories and we would spend time there at the weekends. At the time we really hated it, everything was so primitive and we were made to find very basic ways to entertain ourselves. I appreciate the experience now though, we really learned a lot and had the benefit of spending quality time outdoors. I also had a Chinese 'Ah Ma' growing up instead of a domestic helper and she used to take us for congee in Sham Shui Po, we used to get some very strange looks!

I never felt English when I lived in the UK but oddly, it was only when I got there that it really hit me that I wasn't white… I was so much smaller than the English rugby players! There was quite a bit of good-natured banter and teasing about my ethnicity, I quite enjoyed it. People in the UK would know that I was not white, but seemed to have difficulty putting their finger on what exactly I was. I've had the usual guesses – Spanish, Italian, and then weirdly, South African.

The UK was a massive culture shock. I had only ever been there for holidays before university where it was a controlled environment. I liked the choice of media in the UK – the magazines, the television programs and aspects of popular culture. That aside, Hong Kong suits me much better. I feel as though everyone has an opinion or something to say in the UK and they're not shy about saying it. Hong Kong is more anonymous, people keep to themselves and I prefer that. Westerners in Hong Kong tend to live in a bubble which sometimes I feel I am a part of. But because of my mixed upbringing I sometimes find myself outside of that bubble, and I enjoy that. I really do not see myself as a typical 'gweilo' and am more immersed in local Hong Kong culture than most Westerners.

I play on the Hong Kong international team and have been playing professionally for the past year. There has been a big change in the Hong Kong team in the last few years. Previously, players were brought in from overseas to play for Hong Kong and they were mostly Caucasian. These days, there are a lot more local Chinese and Eurasians. The Union office keeps a breakdown of where players come from and Eurasians are up there. It's not surprising seeing as there are so many Eurasian children in Hong Kong schools now. I also found when I was at school that most of the best athletes were Eurasian. In terms of rugby, whilst Eurasians tend not to be huge, we do tend to have a bigger physique than many local Chinese players. This combined with the pressure to excel commonly exerted by Asian parents may also go some way to explaining the prevalence of Eurasians in the international Hong Kong rugby teams at all levels.

我的母親是澳門人，她的家族D' Almada Remedios在香港和澳門已經有相當久遠的日子，她血統內的中葡混血已經再也分不清了。我的父親是名英國人。因為父親忙我拿不到英國護照，所以我在英國出生，但在我八、九歲時，我們便回來香港居住，直至我去英國唸大學。

在小學時，我沒有為自己是混血兒一事而想太多。我的學校內有好些西方的孩子，但大部份都是中國人或混血兒。當我就讀英皇佐治五世學校時，多了很多歐洲同學，我才更在意原來自己是名混血兒。在那時起，我認識了很多西方朋友，在外表上亦越來越西化。

雖然我就讀的畢架山小學內，中國人學生比西方學生多，畢竟那也是英基學校協會下的小學，所以我一直沒有機會嘗過本地的香港教育，直至我在香港大學修讀法律碩士。我發現本地文化是徹頭徹尾的不一樣，與我在英國的大學經驗大相逕庭。我在那裡總是被稱為「那個白人」！

我會說一點中文，但作為半個澳門人是有點點不同的。除此之外，母親總是要我和妹妹涉足本地文化。在我們很小的時候，她在新界地區的一條中國小村落投資了分時度假，讓我們可以在那裡過周末。那時我們很痛恨那裡———一切都是那麼的原始，我們被迫要找方法自娛。然而現在卻懂得欣賞當時媽媽的苦心，那時的經歷，令我們得益不少，也渡過了很多健康的戶外時光。家裡沒有外地傭工，我卻由本地保姆帶大，她常帶我們去深水埗吃粥，經常給途人投以奇怪的目光！

住在英國的時候，我從來不覺得自己是本土人，但奇怪地，去到英國發現自己並不是白人，會覺得有點異樣……相比英國的欖球員，我長得多麼矮小啊！對於我的民族問題，朋友間也有不少善意的玩笑，我也很喜歡跟他們這樣子鬧。英國的人都知道我並非白人，但也分不出來我是來自那裡，總是那些正常的猜測——西班牙、意大利等，最離譜的是南非。

來到英國，給予我很大的文化衝擊。在大學以前，我僅來過這裡渡假，環境大概都是可以控制的範圍內。我喜歡英國媒體選擇的多樣性——雜誌、電視節目、流行文化等。除此之外，香港比較適合我。我覺得在英國，每人都有自由表達自己的意見，而他們也不會羞於啓齒。香港人比較喜歡用匿名，或都把話留在自己那裡，我比較喜歡這種模式。在香港的西方人，傾向於有自己的小圈子，我有時也覺得是這些小圈子的一份子。但因為我混合文化的長大環境，我有時卻覺得自己是在小圈子以外的。我很愛這樣的感覺，證明我不是典型的「鬼佬」，比大部份西方人更能融入本地的香港文化。

我是香港國際欖球隊的隊員，過去一年都在參與相關的職業賽。過去幾年，香港隊內有很大的改變。以前，港隊的成員都是海外來的白人，代表香港作賽。現在則多了很多本地的中國人和混血兒參與，聯會的辦公室有記錄隊員來自甚麼地方，混血兒也在此欄。香港的學校也多了很多混血兒學生，所以這並不出奇。就是我仍在學的年代，我也發現大部份最優秀的運動員都是混血兒。以欖球來說，雖然很多混血兒都長得不算非常高大，但相比很多本地中國運動員，卻仍然有身材上的優勢。加上來自亞裔父母普遍望子成龍的心態所造成對子女的壓力，或許在某程度上，可以解釋為何香港國際欖球隊充斥著混血兒隊員。

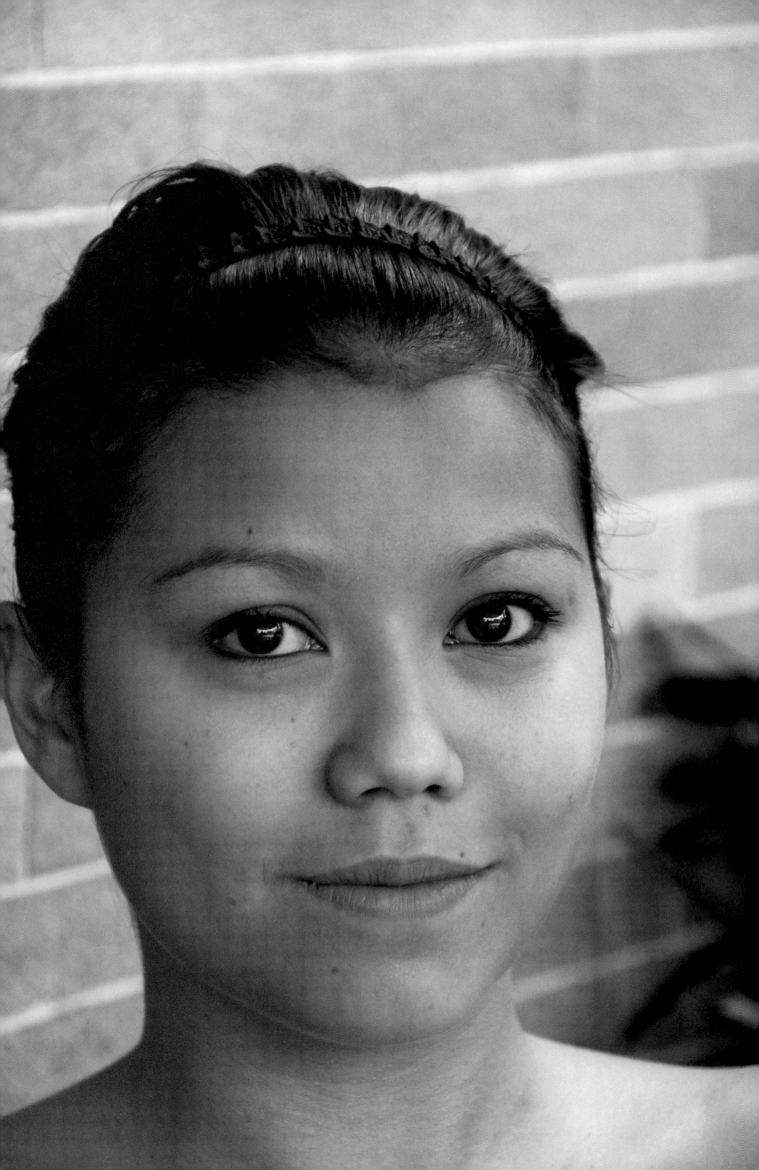

I was born in Hong Kong and have always felt Hong Kong to be home. Saying that, I would define my nationality as British. My father is Chinese and my mother is Scottish and whilst English is my mother tongue, I do speak some Cantonese as well.

I do think that "Eurasian" should be considered an ethnic group in its own right as there are more and more mixed people now than there were in previous generations.

In terms of whether I feel more Western or more Asian, the answer is that I feel a bit of both. I do feel though that I have been brought up to be more westernized despite having lived in Hong Kong my whole life. I think that going to an international English school played a large part in this and as my parents separated when I was young, I was brought up in a westernized household by my mother. But saying that, because I have a large Chinese side to my family and I am close to my father it's never forgotten that my roots are also Chinese. But overall I think I feel more Western.

I think my appearance is both Western and Asian. I have big round eyes that people say come from being Western. You get fairer-looking Eurasians who I think can look more Western but I'm lucky that I tan quickly and keep a tan easily and so this probably gives me more of the Asian look.

I get mixed reactions from people with regard to my ethnicity. Sometimes local Chinese people seem to just know that I'm mixed. Other times they may not know and will try talk to me in Cantonese and realize my Cantonese isn't very good. When I was living in England during my university years, a lot of people thought I was either Hawaiian or perhaps Thai. But I think that's just because they don't see many Eurasians so can't distinguish where exactly I am from. It doesn't bother me at all when people get it wrong. It is interesting to see what other people actually think.

When I tell a Westerner (not from Hong Kong) that I am half Scottish and half Chinese, they tend to ask how on earth my parents ever met, like it's really out of the ordinary.

Being Eurasian is definitely a positive experience because in coming from two complete different cultures and parts of the world we are able to blend in with both. I also think it is good to look different and more interesting than people from just one place. The disadvantages of being Eurasian is that you don't fall into a category of being from a certain place. I guess it's just where home feels. Also, if you don't speak fluent Cantonese or the language of your other half, it can create feelings of shame and guilt because of expectations in terms of family and work.

I find it interesting to see, as generations pass down, really mixed people. Or someone who is not just half and half, such as someone who is Eurasian who has a child with a Westerner. The child may be a quarter Asian and three quarters Western, or vice versa. It's really interesting to see the features that they have, their skin tones, eye colours, hair and so on.

I am able to tell a fellow Eurasian instantly unless a person is just a quarter mixed which makes it a little harder. In a weird way I guess I do feel a bond with other Eurasians.

我在香港出生，一直以來都以香港為家。雖說如此，我會把我的國籍界定為英國。父親是中國人，母親是蘇格蘭人，我的母語是英語，但我也會說一點廣東話。

我是認為「混血兒」應該自成一個民族，因為現在已經有超越了以往幾個世代那麼多的混血兒出現了。

要說我覺得自己比較西化還是中國化，我是認為自己兩面的文化都有一點點。我覺得自己的成長環境是比較西化的，雖然我一輩子都在香港生活。在英語國際學校長大，對我的影響很深遠。父母在我小時候離異，而我在母親的西方家庭下成長。雖說如此，由於我與父親保持密切的關係，而且有一個很龐大的中國人家庭，我從來沒有忘記自己有中國人的根源。雖然，總的來說，我是覺得自己比較像西方人。

我擁有融合西方人和東方人的外表，我的一雙又大又圓的眼睛，別人都說是來自西方血統的。我認為有些皮膚較白皙的混血兒，會長的更像西方人。然而我很幸運，我白皙的皮膚很容易曬成褐色，而且很容易保持著那種古銅色的肌膚，所以會變得更像東方人。

別人對有關我的種族的猜測，回應各異。有時本地中國人似乎知道我是混血兒，有些人可能不知道，並會嘗試用廣東話與我溝通，才發現我的廣東話不太流利。當我大學留學英國時，很多人以為我是夏威夷或是泰國人；但可能因為他們沒有見到太多混血兒，所以不會分我是從那裡來而已。我並不會懊惱別人的錯誤猜測，我反而覺得他們表達真正心裡所想的，是很有趣的事情。

當我告知西方人（並非來自香港）我是半蘇格蘭半中國人時，他們總會問我的父母究竟是如何認識的，好像是有違常理一樣。

作為混血兒絕對是優越的，因為來自兩個世界的不同文化，我們可以融入他們的不同圈子。我也認為，長得和別人不一樣，比來自同一地方的人來得有趣。作為混血兒的壞處，大概是你並不能隸屬任何一個地方；我想，就是那種家的感覺吧！再者，如果你不能說流利的廣東話，或你另一半血統的語言，你也可能因此辜負了家人和工作的期望，而感到愧疚。

我對混血兒世代相傳下來的真正混合的文化十分感興趣。有些人並不只是半混血的血統，如有些混血兒與西方人生育的孩子，將會是¼亞裔、¾歐裔；相反亦然。察看這些孩子的五官、膚色、眼睛顏色、頭髮等等，都非常有趣。

我幾乎可以一眼就把其他混血兒認出來，除非他只是¼名混血兒，或許會比較困難。我想自己可能與其他混血兒有某程度上奇怪的聯繫。

Until the age of eight, I grew up in a small town in the northern prairies of Manitoba. It was no more than a couple thousand people, with virtually everyone sharing a German migratory history, as well as the same German Baptist Church and lone grocery store. I remember cherishing automatic drive-thru carwashes in the big cities as much as I did Disneyland's Space Mountain, simply because they were novelties where I came from. Our theatre had one screen, playing outdated films, and the only fast food option to satisfy our childish desires was a Dairy Queen on what was pitifully termed Main Street.

Being half German and half Chinese was not so easy when growing up in such a racially unified and globally isolated place. At the time, prejudice against any race that wasn't white was commonplace and very much felt by me. Although the aboriginal people were targeted most openly, I couldn't evade feelings of embarrassment that my mother was Chinese and that our staple starch at home was rice. I was an adventurous tomboy growing up, never shying away from climbing the tallest tree or finding the perfect stalk in a forest of wild shrubs to convert into a peashooter. However, climbing onto the school bus every day to be taunted by the song, "Me Chinese, me so dumb, me stick chopsticks up my bum," never failed to put knots in my belly.

My father was finally convinced by the rest of the family to move to British Columbia's beautiful Okanagan Valley. The city of Kelowna was an enormous change for me, seeing as I had more access to people, media, and an overall perception that welcomed multiculturalism, not to mention the novelty of having McDonalds any time I wanted.

When I was 12, I moved with my mother and younger brother to Vancouver. In contrast to my early upbringing, I was surrounded by my mother's side of the family in a city that is known for its large Chinese population. As my mother was able to return to her roots, my ease with and pride in my Chinese side grew. My friend circle also diversified, and I began to tap into Vancouver's positive prejudice toward people with different ethnic backgrounds.

Today, I couldn't be more happy about my mixed blood. I feel as though living in such contrasting cultural environments has enriched my understanding of myself and lent credence to the notion of a colourless world. Externally speaking, I have also benefitted from my atypical appearance. Fashion clients across Asia are captivated by models who look Eurasian, and this intrigue has been permeating into the mainstream fashion world for years now. I've met way too many models to count who are either fully or completely not Asian and posing as a Eurasian for better work opportunities.

I've been studying in Canada and modelling across Asia for the past two years now, and am still amused when people assume that I am anything from Chinese to French or Portuguese. There seems to be an unquenchable desire for people to engage in the "guessing game" when it comes to Eurasians. I swear I get asked what my mix is more frequently than my name. However, the subject of my ethnicity is becoming rather old news for me, as I'm sure it is for other Eurasians. Despite outer appearances, I feel as though being Eurasian is like being any ethnicity, which is quite simply less of an issue than people make it out to be.

八歲以前，我一直在加拿大曼尼托巴省北部的草原小鎮成長。那裡人口不超過二千人，所有人幾乎都是德國移民及後裔，上相同的德國浸信會及去同一家雜貨店。我記得以後在大城市中踫到自動洗車機，就好像見到迪士尼的太空過山車一樣欣喜若狂，原因就只是這些東西對來我來自的地方而言，都是非常新奇的事物。我們鎮的電影院只有一個投射屏幕，播放過時的舊電影；唯一可以滿足我們這些小朋友對快餐的慾望，就只有位於可憐地小的所謂「大街」上那家 DQ 雪糕店。

在這個種族那麼統一，而近乎與世隔絕的地方長大，當一名半中半德的混血兒並不容易。那時，我常常感受到人們普遍對非白人的歧視。雖然被公然歧視的對象，主要是當地土著，我不能避免對於華人的母親及家中主要澱粉質食物是米飯這些事實，感到尷尬。我在成長的過程中，一向都是富冒險精神而又有男子氣概的女生，永遠不會害怕攀上最高的樹，又或者是在灌木叢生的森林中，找出最漂亮的樹莖當玩具槍來玩。然而，對於每天要爬上校巴，被那首專門嘲弄中國人的歌「中國人，多愚笨，拿雙筷子放肛門」所奚落，我不由得反胃想吐。

父親終於在全家人的勸說下，同意搬到英屬哥倫比亞省（卑詩省）那美麗的奧肯那根山谷去。基隆拿市對我帶來重大的改變，令我可與更多不同的人和媒介接觸，當地整體接受及歡迎多元文化，以及任何時候都可以吃麥當勞快餐這新事物。

在我12歲那年，我與母親及弟弟移居溫哥華。和我早前的生活相反，我在一個出名華人聚居的地方，與母親那邊的親戚一起居住。由於母親可以回到她所屬的世界和圈子裡，我對於自己中國人的那一面，亦漸漸處之泰然和為之驕傲。我的朋友圈子同時變得多元化，我也開始接受並傳承溫哥華人的心態，那種對於來自不同民族背景的人都總有正面的評價。

今天，我不能想到甚麼會比自己的混血兒身份更開心的事。在如此不同的文化環境下生活，令我對自己有更多的了解，並因此而更支持無分種族的世界觀。外在因素方面，我也因為自己與眾不同的外表而受益。在亞洲的時裝界客戶，均鍾情於長得像混血兒的模特兒，這偏愛在多年來已慢慢滲進主流時裝世界裡。我見過太多模特兒，本身是完全沒有亞裔血統，卻裝成是混血兒，以求有更佳的工作機會。

我在過去兩年，在加拿大就讀，及在亞洲地區當模特兒，至今仍然對於人家誤以為我不是中國人、是法國人、或是葡萄牙人等事覺得很有趣。對於混血兒，似乎人們總是不能遏止墜入那「種族猜謎遊戲」。我可以發誓，我被問是那個民族間的混血兒的次數，比問我的名字還多。然而，被問及種族這題目，對我來說已經是見慣不怪的舊聞，肯定對其他混血兒也是一樣。除了外表的不同，我覺得作為混血兒跟任何民族的人並沒有兩樣，簡單來說，就是沒有人們描述的那麼與眾不同的這回事。

To me, Eurasian means mixed… Chinese and something else.

I don't speak that much Cantonese but I talk to my classmates in English with bits of Cantonese thrown in. Although there are not many Eurasians in my school and most of the students are Chinese, I don't feel any different. I suppose I feel more English on the inside but I don't think about being Eurasian, it doesn't matter to me. It really hasn't affected my life.

對我來說，混血兒代表混合中國和其他民族的血統。

我並不太會說廣東話，但和同學交談中，我的英語會夾雜著廣東話的字詞。雖然在我就讀的學校裡沒有很多混血兒，大部分同學都是中國人，我並不覺得自己與眾不同。我想在內心深處，我會發現自己有英國人的一面，但我卻沒有把自己當成混血兒；民族身份對我來說並不重要，也對我的生活完全沒有影響。

I was born at a time when the mere sight of Eurasians could still provoke violence. During the disturbances in Hong Kong in 1967, my mother, who is Cantonese, was driving through Central with me in the passenger seat. We were surrounded by a jeering mob of leftists, calling her a foreigner's whore and me her bastard half-breed as they pounded the sides of the car. I was only two then. But I don't consider myself traumatized by race hatred. Ironically, I used to think of myself—in so far as a child thinks of these things, which is hardly ever—as Chinese. My cousins, who were both Eurasian and Chinese, were my frequent playmates and we spoke Cantonese among ourselves. I spoke Cantonese to my amahs. It's the first language I remember speaking.

My English can't have been great, because they had to test it before I was admitted to primary school, and I did badly. The headmaster asked me to tell him what was depicted in a series of flashcards that I suppose were designed for use in schools in England. One was of a thermos flask. I said—having had a keen awareness of suspect packages instilled in me by parents who had lived through leftist terror campaigns—that it was a bomb. Another flashcard showed a picnic rug. I identified it as a civil aid blanket—of the kind that famished refugees from China's Cultural Revolution huddled under when they made it to the streets of Hong Kong.

My father was Irish and an officer in what was then called the Royal Hong Kong Police. Our earliest homes were officers' quarters in police stations where my father was the resident inspector. I grew up literally surveying the seething ghetto from the tops of heavily fortified ramparts. What you saw in those days, on the other side of the barbed wire, was often unpleasant. I have memories of watching homeless families bed down beneath the colonnades of Sham Shui Po police station, sleeping on the discarded boxes that our groceries had been delivered in. That kind of inequality was everywhere—even within my extended family. I used to think it was an amazing adventure to leave the station and visit my uncle, aunt and four cousins, who were crammed into a single room in a Tsuen Wan housing estate.

In social terms, my childhood was a time when Chinese people and Westerners were having more contact than ever, and the racism of previous decades simply had to give. There was plenty of casual racism around. A whole section of my father's circle saw nothing wrong in calling a middle-aged Chinese mess servant "boy," or in decrying the admission of Chinese people to private members' clubs. But at the same time, there were others who took Chinese wives and whose veins practically ran with San Miguel, such was their love of Hong Kong. I don't doubt that if you were poor and Chinese in those days, Hong Kong was brutal, rotten and racist to the core. Eurasian police children were largely insulated from that.

When my parents married in 1962, neither of their families, nor my father's employer, approved, on the grounds that the union was interracial. Within ten years that had all changed: the world was changing. Obvious historical developments—the civil rights movement in the US, the growth of popular music that espoused love and peace—affected the way people thought about race, and when this trickled across to Hong Kong, you saw significant numbers of Chinese-Caucasian marriages for the first time. Around the poolside of the club, or at parties, you could tell that the older generation of colonials thought interracial marriages were still vaguely improper, but there was nothing they could

在我出生生的時代，混血兒的出現仍然會引起暴力糾紛。在1967年混亂的香港，有一天廣東籍母親駕車途經中環，車上載著年僅兩歲的我，被一群左派暴徒包圍，邊敲打車窗邊咒罵她是洋人的妓女，稱我為她的雜種孩子。然而，我並不覺得自己被種族仇恨傷害，諷刺地，我在小時候總是覺得自己是中國人，雖然作為孩子很少對民族有甚麼深刻的想法。我的表親中，有混血兒也有中國人，他們是我的玩伴，我們之間以廣東話溝通。我與保姆也是說廣東話，這是我印象中的第一語言。

我的英語很爛；從前入小學前是要考英文的，而我的表現強差人意。校長問我有關一系列抽認卡內畫的是甚麼，我想那是在英國學校上課時使用的抽認卡吧。其中一張是保溫瓶的圖畫，當時的我深受左翼恐怖活動的影響，父母總教導我小心可疑物品，所以我當時斷言圖中的是炸彈。另外一張卡上的是郊遊用的氈毯，我把它認成是人道援助的氈子──中國文化大革命期間蜂擁來香港的難民，在極度飢餓下用來包裹身體前來香港的那種氈子。

我的父親是愛爾蘭人，在當時的香港皇家警察工作。我們最早的家，是在警察局內的警察職員宿舍，父親為駐場督察。我在保安森嚴的堡壘上，眺望著外面沸騰的貧民窟長大。那時候從那些有刺的鐵絲網看到另外一面的世界，總是些令人不安的畫面。我記得曾經見過一些無家可歸的家庭，在深水埗警署外石柱廊下，睡在那些被雜貨店棄置的紙皮箱上。那樣的不平等，當時到處皆是，甚至在我的中國大家庭中也存在。我小時候常常在想，要離開警署去探望叔叔一家，是件很難以置信的冒險之旅；叔叔、嬸嬸及四名表兄弟姊妹，一家六口擠在荃灣屋邨的一房單位內。

我童年所身處的社會，中國人和西方人的接觸是前所未有的頻繁，種族歧視也是多個世紀以來最嚴重的，到處都可見不同民族間的歧視和偏見。父親的生活圈子中，大家都覺得稱一名中年的華人坎事兵作「小伙子」，或譴責一些私人會所接受了華人的會員申請，均沒有錯。但與此同時，也有些外國人娶中國人為妻，血液裡流著生力啤酒的味道，壓根兒很愛香港。如果你生活在這個年代，而且是名窮困的中國人的話，我不諱言當時的香港是個非常黑暗、腐朽和充滿種族歧視的地方；作為警察的混血兒孩子，則得以隔離於這個不平等的冷酷社會。

父母親在1962年結婚的時候，他們的家庭、父親的上司，無一同意，因為這屬於不同民族間的結合。明顯地歷史進程的演變，不斷影響著香港人對民族的看法──美國民權運動、鼓吹愛與和平的流行音樂的興起等──所以慢慢的，你會見到香港中國─白種人的婚姻變得越來越普遍。在俱樂部或派對中，你很容易發現上一代的殖民地宗主國的人民，還是覺得不應該存在異國婚姻，但對於他們朋友、下屬的混血兒孩子，在會場上到處奔玩耍，他們卻顯得無可奈何。同樣地，我的中國外祖父，也許對於白種人有很多愛國的偏見，一如很多中國人那樣；然而在面對我們這些半白人的孫子們時，他們除了甜在心裡的笑容，和給我們利是以外，還可以做甚麼呢？

我就讀的中學是英皇佐治五世學校，我的社交圈子和生活由那時起開始改變。當時在校內講廣東話是要受懲罰的，我的生活於是漸漸變成以英語為主。記得當時，我覺得在文化上像是去到錯的地方，我們要讀的，是有關英國憲章、Pennines 山脈的探礦等──這些和香港扯不上一點關係的東西。我們的數學教科書上，用的都是「牛奶仔」相關的例子出題──如布

do about it because their friends' and subordinates' Eurasian progeny were happily clambering all over the furniture. Similarly my Chinese grandparents probably held lots of patronizing notions about whites, as Chinese often do, but when their half-white grandchildren appeared, well, what could they do except smile sweetly and give us lai see?

I went to an English-speaking secondary school, King George Vth, and so the older I became the more my social world became an Anglophone one—especially because speaking Cantonese on the school grounds was actually punishable in those days. I remember feeling quite dislocated culturally, studying Magna Carta or coal mining in the Pennines—things that were hopelessly remote from Hong Kong. Our maths textbooks used to pose problems involving a "milkman"—how much change Mrs Brown got after buying three pints and so on—and for the longest time I thought this was a man made of milk, because we don't have them in Hong Kong and nobody ever explained to me what a milkman actually was.

In that sort of colonial environment, I might have had a very unsettled sense of identity. I know a lot of Eurasians at school did. But then I had Han Su-yin, whom I read obsessively from the age of 14. As a Eurasian writer championing Eurasianness, she was crucial to my adolescent notion of self. There's a passage in A Many Splendored Thing which reads: "Look at us, the Eurasians! Just look … The meeting of both cultures, the fusion of all that can become a world civilization. Look at us, and envy us, you poor one-world people, riveted to your limitations. We are the future of the world." That single quote sustained me through school, college and into young adulthood. For a long time, it struck me that the best way to be was not to be "half" anything but wholly Eurasian. Many of my contemporaries fretted over whether they were supposed to be Western or Asian. But I knew exactly what I was, which was neither—and both.

Because of Han Su-yin, being Eurasian mattered to me a great deal and informed a lot of my creative endeavors. I used to organize dance parties under the name "Eurasian Nation." (My brothers ended up using it as the name of their militant Eurasian hip-hop outfit, and the Van Kerckhove girls later used it to start a Eurasian website.) I credited to the "Eurasian Philharmonic" the string arrangements on an album of underground Hong Kong music that I produced. We once even tried to prank the South China Morning Post into believing that there was a shadowy Eurasian extremist group in Hong Kong agitating for Eurasian rights. We used to come out with stuff like "Two bloods, one love!" and "The white man has left us nowhere but Kowloon, and that is where we dance…" We arrogated the Black American Eastside hand sign—the fingers forming an E—as a Eurasian gang sign, and I would teach it to any little Eurasian kid I met.

I'm having what the cliché calls a "wry smile" as I remember this, because what I truly love about being Eurasian now is how unimportant it is in an era when every other person being born is of mixed race. In fact, the very terms "mixed race" and "Eurasian" are starting to sound weirdly old-fashioned to me—like they come from a time of pith helmets, segregated washrooms and Eugenics essays.

Since Reunification—or what some people still call "the Handover"—notions of Eurasian belonging and identity have changed in Hong Kong. Older generations passively waited to feel a sense of belonging here, and a lot of them never felt it. I often wonder if they were excluded from Hong Kong or if they ended up excluding themselves. Belonging is an active verb. You choose to belong somewhere, and behave accordingly. Culturally and historically, Hong Kong belongs just as much to us, and to its other established minorities, as it does the Chinese. We simply need to realize it and then get on with our lives. That is the attitude I see in Eurasians today, and I share it. I rejoice that what was once so life defining has become so irrelevant.

朗太太買了三品脫(pints)後，可以找回多少零錢等問題。很長的一段時間裡，我都以爲這是指一個用牛奶做的男人，因爲香港沒有這樣的送牛奶的人，也從來沒有人向我解釋過牛奶仔究竟是甚麼一回事。

在那樣的殖民地環境下，我很可能會有缺乏身份認同的問題，我知道在校內很多混血兒是這樣的。然而我有韓素音的作品，自14歲開始陪伴我成長。作爲名混血兒作家，她的思想和作品，對我青春期間發展的自我價値觀，起著攸關的作用。在《愛是偉大的事》一書中，她曾這樣寫道：「看著我們，混血兒們！就看著我們……當兩個文化相遇，融和所有文化，造就了世上的文明。你們這些單一世界的人，受著你們的限制，看看我們，嫉妒我們吧！我們將是世界的未來。」這句引言成爲了我的理念，帶領我走過中學、大學，也走進年輕的成年人世界。我從來都覺得，最好的不是當「半個」誰，而是「全個」混血兒。很多同代朋友，都在惘然自己究竟應該是西方人還是亞洲人。但我確準確知道自己是甚麼，我不屬於任何一個文化，或同時屬於兩個文化。

因爲韓素音，令混血兒這身份對我非常重要，也成爲了我創作的養分。我從前常常舉辦名爲「歐亞裔國度」的跳舞派對（我的兄弟最終用了這個名字，來命名他們激進的混血兒 Hip-hop 服飾，那些 Van Kerckhove 女孩後來也用了它來命名一個混血兒網站）。對於爲我創作的香港地下音樂出版唱片，得歸功於「歐亞裔交響樂團」一連串的努力。我們曾經胡鬧地騙《南華早報》，向他們宣稱有一幫混血兒極端分子，要在香港煽動爭取混血權益。那時候，我們常常用這些標語：「兩種血統，一樣的愛！」、「白人甚麼都沒有留給我們，只剩下九龍給我們跳舞……」我們冒充東岸美洲黑人的手勢——以手做出E字——作爲歐亞混血兒(Eurasian)幫的手勢代號，我更會教予每一名遇到的混血兒孩子。

記起這些事時令我有大家所謂的「歪笑容」，現在我更喜歡作爲混血兒，是因爲這個年代很多人都已經某程度上承傳自不同血統，大家都認爲不必要提起這個詞了。事實上，「混血兒」、「歐亞裔」等詞，已經開始變得老套——好像這詞是來自流行非洲的太陽帽、種族隔離的洗手間、優生學等的久遠年代。

自從回歸以後——或有些人仍然叫這作「政權移交」，混血兒在香港的歸屬感和身份認同，也開始變得不同了。老一輩被動地等候歸屬感的感受，很多卻一直等不到。我常常在想，他們是不是已經被香港摒棄了，或者是他們自己摒棄了自己。「尋找歸屬感」應該是主動的，你選擇自己屬於那裡，然後作出相應的表現。文化上和歷史上，香港屬於我們和其他少數族裔，和屬於中國人一樣的多。我們只需要明白這點，然後繼續我們的生活。那是我所見、所認同的混血兒們今天應有的態度；那曾經生死攸關的民族問題，已經變成了如此無關痛癢，我爲此而感到欣喜。

I was born in Bath, England. I stayed there for six weeks before returning to Hong Kong. Aside from a few years in England for university, I have always lived in Hong Kong – it is and always will be my home. I grew up here, and my family is here. If we must break it down into percentages, I'm ½ Chinese, ¼ Irish and ¼ Scottish. I speak English and Cantonese. English is my first language, though I speak Cantonese with my Chinese family, and sometimes at work. I speak English at home and with my friends. Notwithstanding my British passport, the easiest way to describe myself would be a "Hong Kong Eurasian."

I don't believe that Eurasian should be considered an ethnic group in its own right. Though there is some sense of solidarity and instant recognition and, dare I say, attraction to other Eurasians, at the end of the day we grew up with different experiences and different cultures shaping us into what we are. It's as crass and patronizing as lumping Chinese, Japanese and Korean together because they come under the umbrella of "Asian." What do I have in common with someone who is, say, Vietnamese/Dutch and grew up in Holland? Saying that, I'd be lying if I said I didn't feel a bond with other Eurasians. In fact, out of my main friendship group at school five of us were Eurasian.

I resent the idea of being "more" or "less" Western or Asian, or "more" or "less" of anything, especially when people try to impose their ideas of what they think I should be. It's something annoying and painful that people of just one ethnic group can't understand. People say: "You're not really Chinese because you don't look it and you went to an international school." But then, how could I possibly be Western? I've never lived there. Or when people say, "Your Irish/Scottish side doesn't mean anything because it's just a quarter." How dare people decide for me how I should categorize myself? What's that quarter then? A quarter of nothing?

I've had so many conflicting opinions on what I look like, I simply don't know any more. I guess you can detect some "foreignness" there. Some of the stranger nationalities I've been mistaken for are Russian, Italian and Spanish, although other Eurasians can always tell that I'm Eurasian, just as I can tell when other people are Eurasian… it's the Eurasian Nation! Most Chinese people think I'm simply a Westerner, until I bust out some Cantonese and explain that I'm from Hong Kong too. People are often much more friendly and curious about me once I do that.

People are always trying to guess what I am. Customs officials, shopkeepers, strangers on the MTR, waiters… they've all asked. But I don't mind. If my mixed-up appearance means I connect with more people, that can't altogether be a bad thing, can it? Besides, they normally follow it by saying that I'm "ho leng lui" and everyone needs an ego massage from time to time.

It rarely happens, but I have been seen as fully Chinese, too. Most memorably I remember being mistaken for a hawker in Temple Street. It was a strange experience to be talked down to by a tourist because of who he thought I was. I could naturally understand every word he said, and he was so condescending. I'll never forget that.

It doesn't bother me most of the time when people get it wrong, although sometimes I feel like an outsider in my own city. People never see you as being "from Hong Kong" if you don't look the part, which makes me feel a little stateless sometimes. Despite that, I wouldn't have it any other way. I'm very proud of my roots, and sometimes I feel like a chameleon because of it—able to blend in wherever I go.

Our historical legacy isn't exactly something to brag about—most Eurasians in Hong Kong 100 years ago were disliked by everyone, Western and Chinese, because they didn't "belong" to any one group. People are much more accepting now, of course, though I still occasionally get strange looks in the street when I'm out with my parents. I can't say I've suffered much discrimination on account of being Eurasian. I've had the occasional "Suzie Wong" comment, or people assuming I don't understand them and talking about me. But generally, not at all. On the plus side, I think it gives you a very unique perspective. You assimilate different cultural traits, and it gives you a more international outlook. You can blend in or stand out as much as you like.

In terms of how Eurasians are perceived by non-Eurasians, I would say that there's an element of—not jealousy, per se—but of Eurasians having the best of both worlds. Chinese people wish they had big eyes and double eyelids like mine, and Westerners like my dark hair and pale skin, and the fact that I don't burn easily in the sun. People say I'm lucky, being able to communicate in English and Cantonese, and having the best traits of both sides. Do I feel lucky? I must say that I do.

我在英國巴斯出生，六周大的時候，就回到香港。除了在大學那幾年待在英國，我都住在香港——這裡永遠是我的家。我在這兒長大，家人都在這邊。 如果一定要以百分比來區分我的民族，我是½中國人、¼愛爾蘭人及¼蘇格蘭人。我會說英文跟中文，雖然和中國那邊的家人以廣東話溝通，有時工作上也需要講中文，但我的第一語言卻是英語，在家和跟朋友都以英語交流。儘管我持有的是英籍護照，然而最簡單介紹自己的方法卻是「香港歐亞混血兒」。

我不相信混血兒應該成爲一個獨立的個別民族，雖然我們有某種團結的力量，相互間可以很容易辨認出對方，有時更會互相吸引，但是我們成長背景、經歷、文化是多麼的不同，塑造了今日的我們。如果說我們把中國人、日本人和韓國人歸納在一起考慮，認爲同屬「亞洲人」的大家庭，那麼我與一名譬如越南/荷蘭裔混血兒，怎麼可以找到任何相同之處呢？雖說如此，我不能撒謊說我與其他混血兒沒有感到一點點密切的聯繫，在學校我最熟識的主要朋友群中，就有五名是混血兒。

我非常痛恨有人說我「多少」像西方或亞洲人，或「多少」像甚麼，尤其是他人認爲我「應該」是如何的。有些來自單一種族的人，永遠不明白我們混血兒，這是很叫人討厭的事。人家會說：「你不太像中國人，因爲你既長得不像，而你又在國際學校讀書。」然而，我怎麼可能是名西方人？我從來沒有在那裡長住過。或者有人會說：「你的愛爾蘭/蘇格蘭血統只有四分之一，那並不代表甚麼。」他們怎麼可以決定我應該如何定位?那四分之一又是什麼?難道甚麼也不是嗎?

聽過太多不同意見指我像那國的人，我再也不知道該相信誰的了。我猜你也可以察覺到一些「異國性」。有些人誤把我當成是俄羅斯人、意大利人、西班牙人，真是莫名奇妙。雖然，其他混血兒總看出我是他們的一份子，如同我能夠分辨出其他混血兒一樣，活像個混血國度!大部份中國人只單純地把我當成西方人，直到我說幾句流利的廣東話，並解釋我也是來自香港；通常這樣之後，人們會對我友善得多，也好奇得多。

人們總想猜我是哪裡人，海關、店員、地鐵上的陌生人、侍應……全都問過。然而我並不介意。如果我的混血臉孔代表我可以因此更多人認識、交流，那並不是件壞事，不是嗎？此外，他們都常常跟著稱讚我「好靚女」，每人都總要有自我中心的時候吧。

雖然非常罕見，但我確曾被人以爲是一名完全的中國人，誤以爲我是廟街的一名本地小販。那是很奇怪的經歷，居然是一位外國遊客以爲我是名小販，我當然聽得懂他說的每一個字，他的語氣傲慢得很，我永遠忘不了。

一般來說，別人猜錯我來自那個民族，我都不會介意，有時這會叫我覺得自己雖然在土生土長的地方，也會像個外來者一樣。如果我長的不像他們，人們永遠不會視你爲「來自香港」，有時會讓我覺得自己是無國的。但除此之外，我非常自豪於自己的根源、民族，不會再作他選。我有時會感覺自己像條變色龍，可以到那裡都融合在當地的社會。

我們的歷史並不是一些可以讓我們自誇的東西——100年前在香港的混血兒，都是給別人看不起的人，不管是西方或中國人，因爲他們並不「屬於」任何一個民族。現在人們對混血兒普遍接受多了，雖然我與父母外出時，偶爾也會受到路人投射奇怪的目光。作爲混血兒，我不能說自己是被歧視的一個；有時或許有人對我有「蘇絲黃」的評價，或別人以爲我不明白他們的語言，而在面前談論我。然而在普遍情況下，則沒有甚麼別的。在積極的方面，我想作爲混血兒給予你很獨特的身份和想法。你可以透徹理解不同文化特徵，也有國際化的外表，可以隨意融入或脫離不同的文化圈子。

至於非混血兒是怎麼看我們這問題，我會說雖然本身並非出於妒忌，但是混血兒確實擁有兩種文化中最好的東西。中國人希望有像我那樣的大眼睛和雙眼皮，西方人則喜歡我的黑頭髮和白晳皮膚，而且在太陽下不容易被灼傷。人家說我運氣很好，能以英語及中文溝通，並遺傳了兩者文化特徵中最好的。那我覺得自己好運嗎？我只能說：是的，我運氣真的不俗。

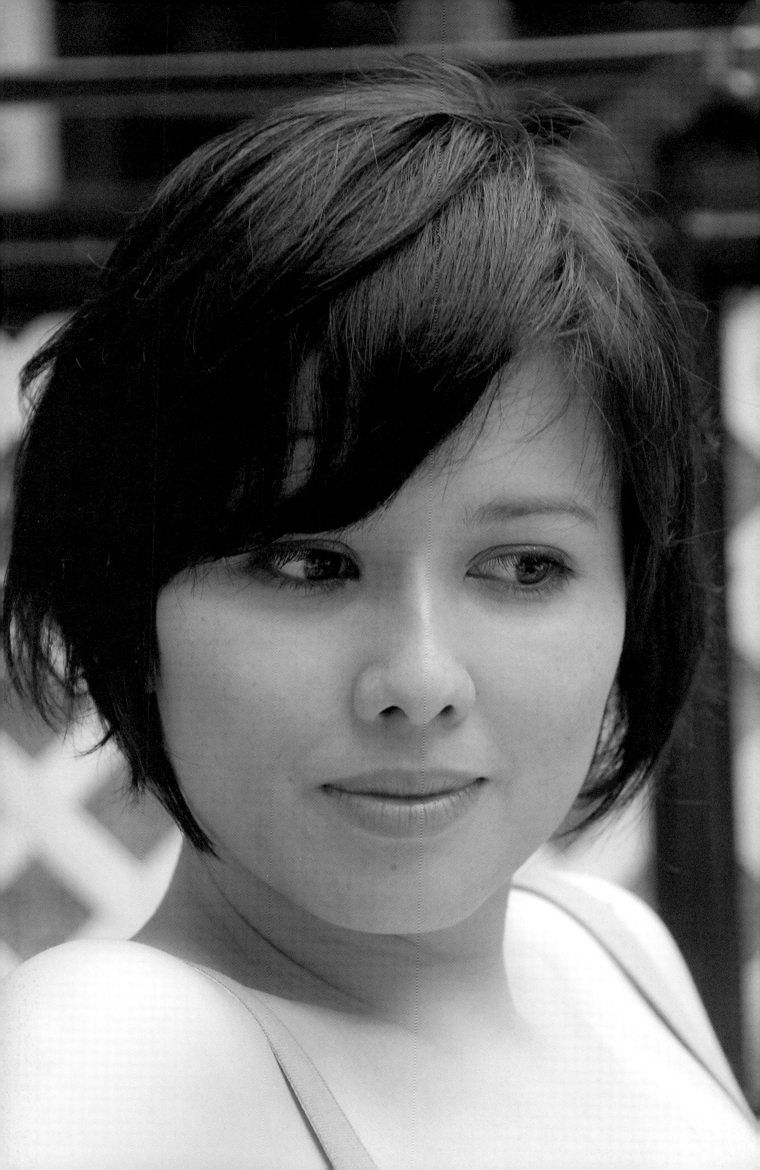

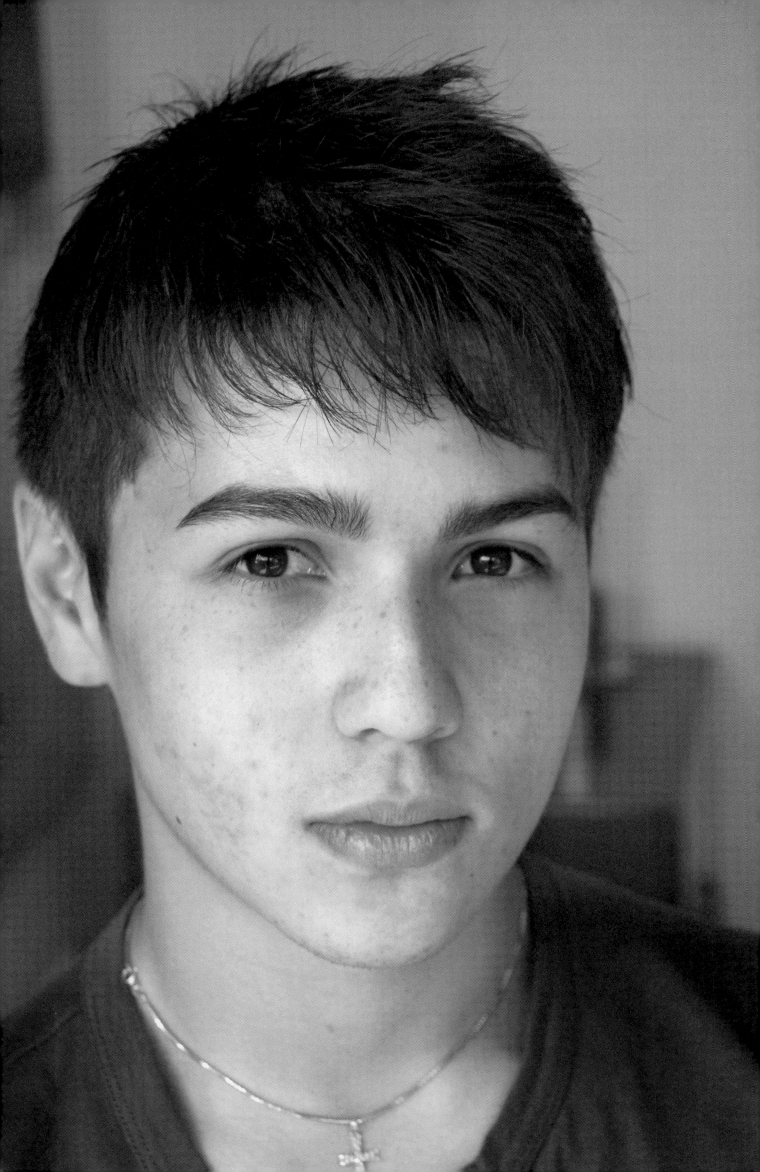

I was born in Bath and now live in Chippenham in the UK. I spent some time as a young child in Hong Kong but we moved to England in 1997 when my dad retired from the Royal Hong Kong Police Force and now I feel that Chippenham is home.

My mother is Filipino and my father is half Scottish and half Irish. I consider myself to be British by nationality but I would consider myself to be ethnically Eurasian if it were to be considered a distinct group in its own right. On the whole I feel that I'm equal parts Western and Asian.

Oddly enough, people seem to think that I'm from China or Japan. I find it slightly irritating as they're so far off the mark, but I've got quite used to it now. I do find that people are always trying to guess what I am. In my experience, non-Eurasians tend to put fully Asian people and Eurasian people in the same category. A lot of the time they don't see the difference.

Around where we live and where I go to school, you don't come across many Asian mixed people. I like the idea of being different, it's a positive thing – it's what I feel to be unique about me. I don't feel that there are any disadvantages when it comes to being Eurasian despite sometimes being singled out for minor teasing for my Asian background. It's never anything serious enough to anger me and is just something I accept.

I've never really felt the need to develop a radar for other Eurasians but it's definitely interesting when I meet someone of an Asian mix.

我在英國巴斯出生，現居於威爾特郡北部的Chippenham。我很小的時候曾在香港待過一段時間，但舉家在1997年父親於香港警隊退休時，遷回英國。我現在覺得Chippenham才是我的家。

母親是菲律賓人：而父親是半蘇格蘭、半愛爾蘭裔。我認為自己在國籍上是英國人，民族上卻是混血兒，如果說混血兒是一個獨立的民族的話。總體來說，我感覺自己擁有同等的西方和亞洲基因。

然而，很奇怪地別人都會覺得我是來自中國或日本。我覺得有點不高興，因為他們猜的差太遠了；不過現在漸漸習慣了。我發現別人總是喜歡猜我來自何方。在我的經驗裡，非混血兒傾向將亞洲人與混血兒納入同一組別內，很多時候他們看不出那個分別。

在我們住和我上學的地方，你不會見到很多亞裔的混血兒。我喜歡與別不同，那是正面的――那是為什麼我會覺得自己獨特。我不覺得作為混血兒有甚麼壞處，除了偶然會給少數人排斥，取笑我的亞洲人背景。然而都是些雞毛蒜皮的小事，根本不足以叫我動怒，我只會接受事實。

我從不認為有需要發展出雷達似的觸角，把別的混血兒認出來。然而遇到另一名亞裔混血兒時，絕對是個有趣的經歷。

My mother was Filipina and my father was German–American. They met in the Philippines when my father was stationed there during WWII. My parents married, and my mother went to the US as a war bride. Her parents were very concerned about racial discrimination in America. My mother's father wrote a beautiful letter to my father's parents, telling them how much they loved my mother and, no matter what happened, they would welcome her home at any time.

My parents were devoted to each other, and they were married for 56 years.

When I was very young we lived in Tennessee. I remember being conscious of looking different, and being surprised when a friend commented on my mother's accent! We then moved abroad: to Panama, to Thailand and to Nicaragua. In those expatriate communities, there were families of other races and other mixed-race children, and I felt welcomed.

The US has changed a great deal. Sometimes it seems odd to remember the "old" US, where there seemed to be little ethnic diversity, compared to the country that the US is today. I remember, during my teens and twenties, being often asked what my background was – when I'd just met someone, and even from a stranger on a bus. Once, although not in the US, but in a Latin American airport, a man approached me, saying he and his colleagues had spent some time trying to figure out where I was from, but couldn't decide, so he'd been volunteered to ask me…

People in Hong Kong seem used to seeing Eurasians – and this familiarity sometimes means they feel free to comment ("You're mixed, aren't you?" or "You must be half-Japanese?"). But I generally accept these comments as exhibiting interest, not judgment.

I feel American. Despite having lived outside the US for many years, I have never lived in the Philippines. My mother always spoke English to my three brothers and me. I do worry about the loss of understanding of our Filipino "roots", especially on the part of my daughter and my nephew and nieces. I've written down some of my mother's stories about her years in the Philippines, to preserve that knowledge for them.

我的母親是菲律賓人，父親是德國－美國人，當他在二次世界大戰時駐守菲律賓時，邂逅母親。父母在菲律賓結婚，母親以戰時新娘的身份到美國去。她的父母非常擔心在美國的種族歧視問題，外祖父曾寫過一封詞藻華麗的信給父親的父母，告訴他們很疼愛自己的女兒，無論發生甚麼事，任何時候都歡迎她回娘家去。

父母親深愛對方，婚後56年一直不減恩愛。

在我很小的時候，我們家住在田納西州。我記得自己很在意自己長得與別不同，而對一位朋友批評母親的口音時，也覺得很訝異！後來我們搬到巴拿馬、泰國和尼加拉瓜居住。在這些外來人的社區生活，他們有其他不同民族的家庭，和不同的混血兒孩子，我在那裡受到了別人的歡迎。

美國著實變了很多。有時記起以往那個「舊」美國，當時民族很單一，沒有現在那麼多樣化，會覺得有點奇怪。我記得在十來二十多歲時，常常被初次認識的人、或在巴士上被陌生人問及我的背景。有一次，在拉丁美洲一個非美國的機場內，一名陌生男士前來搭訕，說他和同事們猜了很久都猜不出我來自甚麼地方，於是他則請纓前來詢問……

香港人似乎很習慣見到混血兒——習慣到有時會很輕易便會去評價別人（如「你是名混血兒吧？」或「你肯定有一半日本人的血統？」等）。但一般來說，我會覺得那表示他們覺得好奇，而不是下判斷。

我覺得自己像美國人。雖然在美國以外的地方居住了很多年，我從來沒有在菲律賓住過。母親對我和三位兄弟都以英語溝通，我真的擔心有一天會失去了我們菲律賓的「根」，尤其是對於我的女兒和其他姨甥來說。我已經替母親寫下了她早年在菲律賓時的故事，為我們下一代保存這些知識。

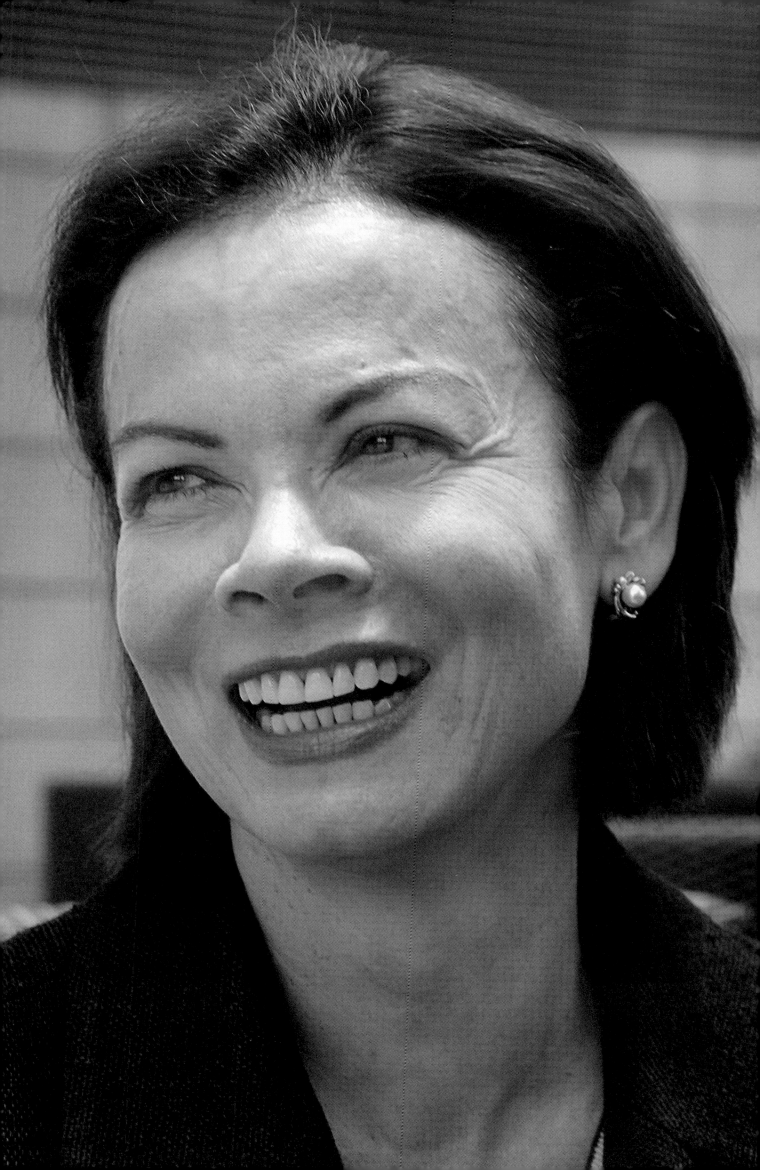

I was born in Singapore and my mother is Thai. Her father was an influential man in Bangkok and owned the land where the Mandarin Hotel now stands. Sadly, her mother died during childbirth. Prompted by the tension between my mother and her stepmother, my grandfather consulted a priest who suggested sending my mother to a boarding school in Penang. As she had already completed primary school, learning English was difficult but my mother worked hard, was promoted and began a career in nursing. She became a Catholic and was transferred first to Malacca and then to Singapore.

It was in Singapore that she met my father who is half Portuguese Eurasian and half Ceylonese Burgher (a fair-skinned Dutch Eurasian from what is now Sri Lanka). My father's mother was very much against the union – she asked 'How can you marry a Siamese?'. So my mother wrote to the nuns from her school who then contacted a priest in Singapore, a Frenchman, who gave my grandmother a glowing report on my mother. My grandmother could not ignore the priest and she finally accepted the marriage.

I have three elder sisters and two brothers. My mother was a very obedient wife and she adapted very well to Eurasian living. It was very important to my grandmother that she learned to cook all the Eurasian dishes.

We lived in a Eurasian enclave on St Francis' Road – you could throw a stone there and you would hit a Eurasian. My father passed away when I was seven years old. The area became a little hostile after that as my mother was not a Eurasian – she was even called a Siamese cat. I think a lot of it was about the family heirlooms though – my father was a wealthy man.

I can speak Thai and Hokkien as well as English. After St Francis' Road, we moved to Changyi Road where our neighbours were Chinese. My Chinese language skills became more polished when I joined the police. I was part of the Special Investigations Unit for Serious Crimes and had particular expertise with Chinese secret societies – the Cantonese and Hokkien sections.

Although I identify most strongly with other Eurasians, I find that I can blend in with other cultures – especially the Hokkien and Chiu Chow peoples. I have a good relationship with the Chinese community of those regions. My wife is Hokkien Chinese and I feel that my children have the best of both worlds. My mother-in-law used to work for a Eurasian family so, happily, she is conversant with Eurasian culture.

After Singapore became independent in 1965 and we broke away from Malaysia, many of the top army, police and intelligence guys were Eurasians (Boogars, Campbell, Le Cain, Theseira, Jambu, Stuart, Simon and Aeria to name a few). We were very much trusted to aid the transition. Historically, there have been many Eurasians in positions of importance in Singapore. The first Speaker of Parliament, Sir George Oehlers, was a Eurasian, as was Eddie Barker – he wrote our Constitution.

I do not think Eurasians have ever been marginalized in Singapore – if one wants to progress, one must show their abilities. It is not right to blame the government for one's lack of progress – it is up to you to better yourself, regardless of race.

Sometimes I feel as though young Eurasians are losing grip of their culture. They are more inclined to meeting up in Starbucks than hanging out at the Singapore Recreation Club, which is synonymous with Eurasians and our history. They are rejecting Eurasian food in favour of McDonalds.

Saying that, it is not too late, and all is not lost. Many Eurasians are making efforts to preserve our identity. Myself, I am trying to strengthen Eurasian culture at grassroots level by working with all sectors of the community on crime prevention. The Eurasian Association has been doing a wonderful job in working on our visibility. We are not a dead race. I tell young Eurasians to stand up and be counted. I feel so proud when I see another Eurasian excel.

我在新加坡出生：母親是泰國人。她的父親是曼谷一名很有影響力的人，擁有現在已改建文華東方酒店的那塊土地。然而很不幸地，她的母親在分娩的時候去世；因爲母親與她的後母關係緊張，外祖父就聽從牧師提議，把女兒送到檳城的寄宿學校。那時她已經完成小學課程，剛開始學英語時很困難，但她很努力，最後成爲了一名護士。她也篤信了天主教，最初被調派到馬六甲，然後再到新加坡。

就在那裡，她認識了我那半葡萄牙裔半錫蘭公民（白皙皮膚的荷蘭裔混血兒，來自現時的斯里蘭卡）的混血兒父親。我的祖母很反對他們的結合，問父親：「你怎麼可以娶一名泰國女人？」於是，母親去信她學校的修女，替她聯絡新加坡的一名法裔牧師，寫了一份非常出色的有關她的報告，交了給祖母。祖母不可以不理會該牧師，終於也同意了這椿婚姻。

我有三名姐姐和兩名兄弟。母親是位言聽計從的妻子，並很適應混血兒的生活。對於祖母來說，母親學會煮所有的混血兒菜餚，是非常重要的一環。

我們住在屬外來人領土的聖法蘭西路——要是你在那裡掉一塊石頭，恐怕也會掉到一名混血兒。父親在我七歲時過世，從此之後當地人對我們有些仇視，因爲母親不是混血兒——她甚至被稱爲暹羅貓。我相信主要原因是因爲家族繼承人的問題——父親是富裕人家。

我會說泰文、福建話和英語。繼聖法蘭西路後，我們又搬到樟宜路，鄰居都是中國人。加入警隊後，我的中文得以改進。我隸屬嚴重罪案組特別調查科，專門負責中國人的秘密組織——廣東話與福建話部。

雖然我和其他混血兒相處極度融洽，我發現自己也能融入其他文化——特別是福建和潮州人，和他們維持良好關係。我太太是中國福建人，我覺得我們的孩子擁有兩個世界最好的東西。我的丈母娘曾在一家混血兒家庭中工作，所以幸運地，她熟識我們的文化。

當新加坡在1965年獨立以後，從馬來西亞分裂出來，軍隊、警隊很多高層，和情報人員都是混血兒（枚舉數例，如 Boogars, Campbell, Le Cain, Theseira, Jambu, Stuart, Simon 和 Aeria 等幾位）。我們備受信任，協助過渡期間的安排。自古以來，很多混血兒在新加坡都位居要職。如首位國會議長 George Oehlers 爵士是歐亞裔，撰寫憲法的 Eddie Barker 也是。

我不認爲歐亞混血兒在新加坡有被邊緣化的現象——如果你要進步，你就必定要表現自己有這個能力。我們不應該怪責政府讓我們停滯不前——不管是來自那個民族，也須要自強不息，爭取更好表現。

有時我會覺得年青一代的混血兒，漸漸地失去了對自身文化的拿捏。他們寧可到星巴克咖啡店聚會，也不願意到象徵混血兒文化和歷史的新加坡休閒俱樂部。他們放棄混血兒食品，而選擇麥當奴快餐。

雖說如此，現在也並非太遲來保存這一切。很多混血兒很努力保存我們的文化與認同感，像我吧，我一直努力透過各社會各界提倡防罪意識，來加強草根階層間的混血兒文化。我們並非到了末路的民族，我常常告訴其他混血兒們，他們要站起來、要被接納和認可。每每見到有多一名成功與優秀的混血兒，我總會覺得非常自豪。

TARA JOSEPH HUI

JOURNALIST / MOTHER TO KATHERINE AND ALEXANDRA
記者 ／ KATHERINE 和 ALEXANDRA 的母親

Katherine has, in the past, asked 'Where am I from?' and there have been occasions where she has seemed to realize that she is a little different. But she does not seem overly concerned by the issue and mixes well with both Westerners and Asians.

Katherine actually understands and speaks a lot more Chinese than she lets on. I remember on one occasion when I was having difficulty asking the supermarket assistant where the lollipops were, Katherine finally got fed up and asked for directions in fluent Cantonese. It took me by surprise and to this day I do not really know how much she knows.

Katherine and Alexandra are exposed to their Chinese family regularly and they are very comfortable with their relatives here. Big dim sum lunches on Sundays and large family gatherings are normal for them.

Katherine 從前常常問「我從那裡來？」，有時候，她似乎明白到自己和別人有那麼的一點點不同。但她看來並不太在意這個問題，而與西方人或亞洲人均相處融洽。

Katherine 明白和會講的中文，其實比她假裝的厲害得多。我記得有一次在超級市場，當我很困難地在問超市職員棒棒糖的位置時，Katherine 終於忍不住以流利的廣東話發問。那時真的把我嚇一跳，就是到了今天，我也不知道她到底懂得多少。

Katherine 和 Alexandra 都定期地與她們的中國家人見面，她倆與本地的親戚們都相處融洽。對她們來說，星期日與一大群親友一起到茶樓、吃點心，都是很正常的家庭活動。

My mummy is British and my daddy is Chinese. I used to speak Chinese but then I didn't practise.

I feel more Chinese but I am also from London. I have classmates from London, India and lots of other countries. I know lots of people who are half English and half Chinese but it doesn't matter to me where people are from.

To me, Eurasian is like a country or something.

我的媽媽是英國人，而爸爸是中國人。以前我常說中文，後來卻疏於練習。

我覺得自己比較像中國人，然而也像倫敦人。我有來自倫敦、印度和其他不同地方來的同學，也認識很多半英半中的人，但我覺得來自甚麼地方並不重要。

在我來說，歐亞裔就像是一個國家甚麼的。

I was born in Hong Kong and have always lived here. My mother is Scottish and my father is Chinese. Although I unfortunately don't speak Cantonese and I carry a British passport, it would feel more accurate to describe my nationality as Hongkong...ish? Ethnically, I suppose I feel equal amounts Western and Eastern but I think I feel more patriotic about my Chinese side – it's cooler to be from China than from Scotland.

Although I would say I look more Caucasian than Asian, people can often tell that I'm mixed, or at least that I'm not purely British. I think they get the sense that there is something different about me. I guess I'm not your typical Eurasian – I have nearly black hair which has a lot of red in it, pale skin and freckles, quite Celtic really. My mum has Irish blood, perhaps that explains it?

I can tell that someone is Eurasian instantly and find it easy to bond with them. When I meet someone who is Eurasian we feel an immediate connection and accept each other straight away. I do have a group of Eurasian friends in school but it wasn't a conscious decision. We don't attract any special treatment in being Eurasian; we're treated just the same as everyone else.

I have had a couple of bad experiences with ignorant people who make comments about the 'purity' of my race but I would think people like that would be prejudiced against anyone different – black, Hispanic or whatever. I don't feel discriminated against at all. In fact, when people find out I'm Eurasian, they're interested and ask me loads of questions. It's quite flattering to attract so much interest really!

我在香港出生並長居於此，我的母親是蘇格蘭人，父親是中國人。縱使遺憾地我不會說廣東話，而且我持的是英國護照，我仍然覺得形容我的國籍爲「香港籍......？」會比較準確。倫理上我應該對東西方文化同樣重視，然而我對中國一方比較有愛國之情——畢竟來自中國比來自蘇格蘭來得酷一些。

雖然我長得像高加索人多於亞洲人，別人總曉得我是混血兒，至少知道我不是純英國人。他們大概在我身上看到一點點與別人不同的地方。我猜我不是大家認知的典型混血兒——我有近乎黑色的頭髮，裡面藏著很多暗紅色，白皙的膚色上長著雀斑，有點像克爾特人。可能這是因爲我母親也擁有部份愛爾蘭血統？

我很容易與混血兒相處，並總是看一眼就可以分辨出混血兒來。遇到混血兒時，我們會立時覺得大家有種特別的連繫，並順理成章的接受了對方。我在學校有一班混血兒朋友，但那並不是有意識部署與他們認識和結交。我們沒有因爲是混血兒而得到任何特別待遇，就和其他所有人一樣。

我曾經遇過一些無知的人，評論我是否有「純正血統」，但我想，他們這些人對任何與他們不同的民族都會存在偏見——黑人、拉丁美洲人等等。我完全不覺得被歧視，實際上，別人發現我是名混血兒時，他們總會對我感興趣和問很多問題。吸引那麼多目光，其實也蠻有給人奉承的感覺！

Though I have spent almost all of my adult life in the UK and the US, I moved to Asia four years ago. Returning to live in Hong Kong was a return to the place I left as a 14-year-old – with the associative adolescent's grasp of Cantonese.

Arriving in Hong Kong at the end of the Second World War with the RAF, my 20-year-old English father met and married my Chinese mother, and joined the Hong Kong Civil Service. They remained in Hong Kong until 1970, raising their half-English, half-Chinese family. My siblings and I were brought up in a more Western environment, with English as our native tongue; however, we attended predominantly Chinese schools, including St. Joseph's and St Paul's Convent, which at the time had an enrolment of perhaps five percent non-Chinese students.

A strong memory of my childhood is our Saturday afternoons at Tweed Bay Beach or at one or another sports club jumping in and out of swimming pools. But the highlight of all my memories is the trip we took on the vehicular ferry every Sunday morning to spend the day with my Chinese grandmother (plus a score or more of uncles, aunts, siblings, cousins and family friends) at her farm between Shatin and Tai Po. Listening to she and my mother chat in Cantonese and Hainanese, watching my uncles and aunties play mahjong, being familiar with my grandmother's fierce attachment to "unlucky" and "lucky" superstitions… all these experiences contributed to a childhood very much integrated with the Chinese way of life. Being half-English, half-Chinese meant growing up in two worlds – one dominated by a colonial influence and the English language, and one defined by distinctly Chinese customs and traditions.

My father's "home leave" every two and a half to four years was long enough for the entire family to travel by boat to see our English family for a few months. Stopping every few days along the coast of Asia, Africa, America and Europe, these trips taught me much of my geography through personal experience, leading to an expansion of my worldview and adaptive ability.

Our family's permanent move to England in 1970 was thus a move to a somewhat familiar country, governed by cultural rules which felt both familiar and comfortable. At 14, seeking to assimilate to my new home meant that leaving Hong Kong behind was more a necessary act of preferencing British culture than abandonment of my Chinese background.

Yet in those days, the Asian-Western mix was viewed not only as unusual, but "exotic." Once we moved to Surrey, England, I became more aware of this perceived exoticism; I remember walking down the street with my brothers and sisters, and though we all spoke with fluent British accents, our dark skin and equally dark eyes stood out as worlds away from our new school friends, most of whom had never left the UK, and very few had travelled beyond Europe.

By the age of 17, I was armed with an arsenal of school nicknames; everything from "Kung Fu" and "Little Grasshoppper" to "Bruce" (deriving, I suspect, from the popular actor Bruce Lee) was bestowed upon me by my Caucasian classmates in secondary school in England.

If my siblings and I hadn't been academic and interested in sport, I believe it would have been more difficult to assimilate to British schools, but I was never discriminated against for being Eurasian – despite the nicknames, which occur wherever a few hundred boys are thrown together!

Graduating university, all of my siblings and I considered ourselves more Western than Chinese. Outside of Hong Kong, people tend to think I am English. In Hong Kong, people who have had exposure to other Eurasians may realize that I am Eurasian. No one living in the UK, Europe or the US has much contact with Eurasians so they rarely get it right. Other than that, people tend to think that I may be part Hawaiian!

For me, being Eurasian has been a positive experience: coupled with the exposure to different cultures that allowed my parents – and, consequently, their children – to choose the best elements from each, moving "between worlds" at such a young age taught me to embrace change as opportunity. A perpetual minority (insofar as the very term "Eurasian" only became common outside Asia in the late 20th century) learns the significance of tolerance, of cultivating adaptability without losing tradition in the process. Growing up in 1960s Hong Kong as a half-English, half-Chinese individual was thus perhaps a different experience than a young Eurasian would encounter today; bustling with myriad races, the present-day Chinese city is one in which racial mixing has become increasingly common and – as exemplified by this very book – celebrated.

雖然我長大以後大牛的日子都在英國和美國渡過，我於四年前搬回亞洲去，帶著青少年程度的廣東話，回到我14歲時離開的香港。

我的英籍父親在20歲正值二次大戰結束的時候，隨皇家空軍來到香港，邂逅了我中國籍的母親並結婚，還加入了香港公務員行列。直到1970年，他們一直待在香港，供養他們牛英牛中的家庭。我與我的兄弟姊妹都在相對西化的環境下成長，並以英語爲母語；雖然我們多在本地中文學校就讀，包括聖若瑟書院和聖保祿學校，當時只約有5%非中國籍學生。

印象深刻的童年回憶，就是在白沙灣海灘度過周六下午，或在不同的體育會所的泳池嬉戲。其中最深刻的，卻是每個周日早上，我們坐渡海小輪，前往沙田與大埔之間的農場，探望中國籍外祖母（以及廿多個叔叔、姨姨、兄弟姊妹、表親和家人的朋友）。聽著外祖母與母親以廣東話及海南話交談，看著叔叔阿姨們在打麻將，祖母迷信於「幸運」和「不幸」的傳說等…這一切都令我的童年添上中式生活的色彩。作爲半英牛中的混血兒，表示你將在兩個世界中成長———個是充滿殖民地影響的英語世界，另一個是由中國傳統習俗所規範下的世界。

父親每2.5至4年間一次的「回家休假」，時間之長，足夠我們舉家乘船到英國探望親戚數月之久。沿途在亞洲、非洲、美洲、及歐洲海岸均停留數天，這些旅程及個人閱歷，教曉我不少地理知識，擴闊了我的世界觀，和加強適應環境的能力。

所以，我們在1970年時遷居到英國，其實是回到一個我們熟識的國度去，那裡有我們習慣的文化、制度。14歲那年到了英國融入當地的新環境，與其說當時離開香港是爲了要捨棄我的中國背景，不如說那是爲了要選擇英國文化。

然而在那個時代，中西混血不單只被認爲是異類，簡直是「異乎尋常」。當我們搬到英國薩里時，我越來越容易察覺到這「異常」的感覺；我記得那時與兄弟姊妹走在街上時，雖然我們都有一口流利的英國口音，我們黝黑的皮膚和同樣的黑眼睛非常突出，顯得與同輩的同學朋友們有天壤之別，他們有很多人從未離開過英國，很少人到過歐洲以外地方。

17歲那時，我的高加索中學同學已經替我起了無數的花名，由「功夫小子」，「草蜢仔」到「Bruce」（我懷疑那是來自著名中國演員李小龍Bruce Lee）等。

如我們幾個兄弟姊妹不喜歡學術與運動，相信我們很難適應英國的學校，然而我從來沒有因爲是混血兒而被歧視過——除了那些花名，那是任何少年群體相處時的都必然會出現的了。

在大學畢業時，我和所有兄弟姊妹都覺得我們像西方人多於中國人。在香港以外的地方，別人通常會以爲我是英國人；對於曾接觸過歐亞裔的香港人，他們或者會知道我是混血兒。在英國、歐洲或美國，沒有人經常接觸歐亞混血兒，所以他們很少會猜中，反而人們會傾向以爲我有夏威夷血統呢！

對我來說，作爲混血兒的經歷是相當正面的：滲入不同的文化中，讓我的父母——順理成章地讓他們的孩子——可以選擇每種文化中最好的，自小已經習慣在「兩個世界」中遊走，令我學懂了接受改變、把握機會。永遠都是弱勢社群（「歐亞混血兒」一字，直到21世紀末，才在亞洲以外地區普遍起來），我們學會互相包容的重要性，在培養適應不同文化的同時，卻又不失自己的傳統。在1960年代的香港成長的半英牛中混血兒，可能與今時今日的混血兒面對不同的際遇；在今日這個忙亂而融合了無數種族的中國城市，是其中一個地方，混合民族變得越來越普遍和值得慶賀，就如同此書的許多例證一樣。

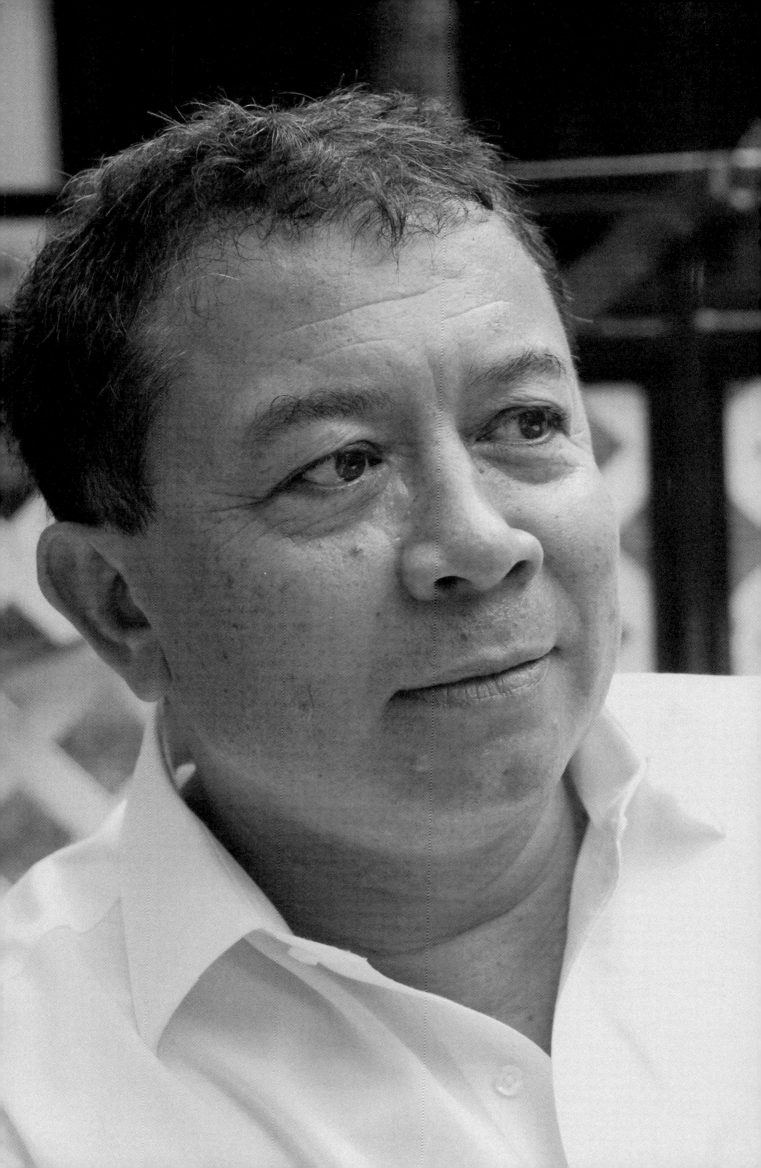

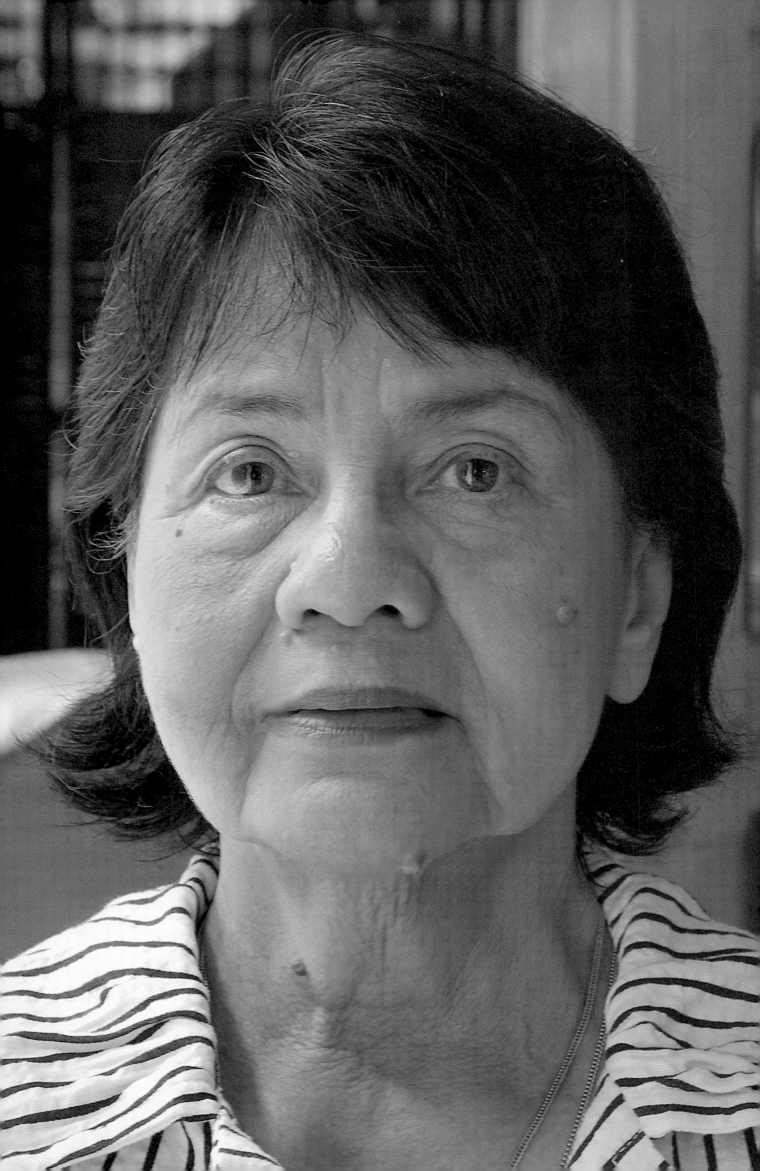

我是一名新加坡出生的荷德後裔（起源自阿姆斯特丹來的 Grosse 修帆工人，在1770年代來到馬六甲）。我相信在六至七代以前，這個 Grosse 工人於1780年與一名在馬六甲（姓 Da Costa）的歐亞混血兒女子結婚。姓氏對混血兒文化來說相當重要，它顯示了我們的祖籍，因此很多時候混血女士在婚後依然保留原來的娘家姓。我的歐裔血統與馬六甲及馬德拉斯的葡萄牙裔有所關連（在母親那邊姓 De Souza，這姓氏是從貿易公司 Jourdain, Sullivan and De Souza 而來，自1870年代來到海峽新加坡），對於我的亞裔祖先則所知的資料不詳。

在殖民地時代，混血兒傾向與混血兒群聚在一起。中國人似乎不知道怎樣看我們，而對英國人來說我們是次等公民，殖民地政府向來信任具誠信美譽的混血兒。戰時很多混血兒男士自願以英國國民身份從軍，整個混血兒部隊（D部隊）全成為了戰爭的階下囚，包括我父親與大哥。就是很多沒有參軍的混血兒，因為其英國姓氏如 Stuart Branson 等，而被當成平民戰俘扣押。我的父母有六個孩子，父親在樟宜當戰俘，母親於是決定遷到Bahau Catholic Colony（在 Negri Sembilan 的俘虜收容所）。這片是日本人安置混血兒天主教徒的地方，目的為紓緩新加坡糧食短缺問題。因為我們都並非農夫，所以也沒有作任何耕種，但我的哥哥們有份幫忙運棺材，而我當時只有五歲。最終日本人來了，用貨車把我們載回新加坡去，然後再拘留於Sime Road。差不多在同一時間，很多混血兒在暹羅建「死亡鐵路」時死去。

除了在戰時，混血兒大多作為白領工作人士。在我年青時，所有匯豐銀行的文員、大東電報局及Otech的電話接線生都是混血兒，我們的英語技能受到重視。在餘閒時，我們會到新加坡休閒娛樂部(SRC)，那是專為混血兒而設的俱樂部。我們喜歡跳舞是眾所周知的，在 SRC 的新年派對尤其有名，所有種族的人都會來參與，因為那是城中最好的派對。跳茶舞也是混血兒閒暇時喜歡的活動。

我並不覺得自己比較西化或中國化，我就在混血兒的文化下長大——我從來沒有想過其他。然而，可以說是是混血兒文化本身具備了中西方的影響。例如我們很重視家庭間的密切關係，以及隔代的溝通，那應該是來自亞洲人的影響。在另一方面，我們慶祝的那些節日則是我們很西化的表現。我很高興我所有孩子都與混血兒結婚，這樣就可以更容易保留我們獨有的文化。

I was born in Singapore of Dutch/German descent (Grosse was a sailmaker from Amsterdam who came to Malacca in the 1770s). I believe we go back six or seven generations, to when this first Grosse married a Eurasian (Da Costa) girl in Malacca in 1780. Surnames are very important in Eurasian culture as they show our ancestry and quite often women will retain their maiden names for this reason. I also have some connection to Portugal, Malacca and Madras, all through my maternal side, the De Souzas. This De Souza was part of the trading company Jourdain, Sullivan and De Souza, arriving in the Straits circa 1780s, but I am not entirely sure about the Asian side.

In the colonial days, Eurasians tended to mix with other Eurasians. The Chinese did not seem to know what to make of us and whilst we were "second class" to the British, the colonial government trusted the Eurasians who had a reputation for honesty and integrity. During the war, many Eurasian men volunteered for the army as British subjects. The whole Eurasian unit (D Company) were made prisoners of war, including my dad and my eldest brother. Many Eurasians who were not linked to the military were also interned as civilian internees only because they had British-sounding family names like Stuart and Branson. My parents had six children and with my dad in Changi as a POW, my mum decided to relocate to the Bahau Catholic Colony (an internment camp in Negri Sembilan). This plot of land was allocated to Catholic Eurasians by the Japanese to ease food shortages in Singapore. As we were not farmers, we did not do any farming there, but my brothers took work carrying coffins. I was only five years old at the time. Eventually, the Japanese came and put us on a truck back to Singapore and we were interned in Sime Road. A lot of Eurasians died building the 'Death Railway' in Siam around the same time.

The war aside, Eurasians tended to be white-collar workers. When I was young, all the clerks in the Hongkong & Shanghai Bank were Eurasians, as were all the telephone operators in Cable & Wireless and Otech. We were valued for our English language skills. During our leisure time we went to the Singapore Recreation Club (the SRC) which was a Eurasian club. It was well known that we loved to dance. The New Year party at the SRC was particularly popular and everybody would come regardless of race as it was best party in town. The tea dance was also a very popular Eurasian pastime.

I do not feel more Western or more Asian. I was simply brought up as a Eurasian – I never thought about anything else. However, it can be said that the Eurasian culture itself has Western and Asian influences. For example, we put a great emphasis on family closeness and communication between the generations in Eurasian culture – that is probably an Asian influence. On the other hand, the festivals we celebrate and our religion are very Western. I am glad that all my children are also married to Eurasians as we are more easily able to retain our distinctive culture.

I am half English, half Chinese and I was born in the UK. I graduated in the mid-90s when there wasn't much going on in the UK and decided to go backpacking. I had planned to come out to Hong Kong to teach English for just six months but have now been here for 12 years. I had been to Hong Kong twice to visit relatives: the first time when I was 12, which left me wanting more, and the second when I was 21. Hong Kong has always felt like it's booming, it has so much energy and things are always happening.

My father went to the UK in '68 to be a nurse and he met my mum who was also a student nurse. He is the only one of his family in the UK and apart from going for dim sum, I didn't have too much of a connection to my Chinese side growing up. I also never learned to speak Chinese – my father has more or less forgotten how to converse in Chinese himself, except for when he counts for some reason. Fortunately, nursing is very cosmopolitan and he has friends from all over the world. Although I looked quite Chinese, I felt more as though I was one-third Chinese as opposed to half. My father never really pushed me to take on any Chinese culture when I was growing up. However, there were subtle influences – I grew up with Bruce Lee and Mr Sulu as childhood heroes as well as the usual Star Wars characters.

I did make an effort when I was around 14 to learn to speak Cantonese and joined a Sunday class at Surrey University. Unfortunately, it was all in a primary school context and I only lasted the humiliation for about a month. I still regret not being able to speak Cantonese – it is such a big barrier.

When I did get to Hong Kong, I did not have too much of a culture shock – I had travelled widely before I arrived here. There are, however, things that I will probably never get used to. Rediscovering my Chinese side was definitely one of the motivations for coming to this part of the world. Unfortunately, my first experiences in mainland China were a little negative – it was a different place then. When I first arrived, I spent a lot of time with my father's family and celebrated all the Chinese festivals. I'm spending less time with them now as the language barrier can make things difficult, not to mention boring. Getting up at 5:00am for Ching Ming doesn't really appeal but I still love the lantern festival.

Being Eurasian has its advantages and disadvantages. For example, having a Chinese last name can be a bit of a disadvantage in being an editor for an English publication or for teaching English. It doesn't seem to matter that I was born and bred in the UK; people here want people with European names and appearances for that kind of work. It can also be a pain in terms of ethnic monitoring forms or in immigration matters.

On the positive side, I have found that being Eurasian and being able to blend in wherever I go has meant that I don't get ripped off as much when I'm travelling. In Ecuador or other places in Latin America, I just look local. There are many people in those areas called 'Mestizos' who look a lot like Eurasians. I do think that it also makes a person a lot more global. Having a twin heritage has made me more understanding and sympathetic to all cultures.

All in all, I think it is great being mixed. I was in my childhood quite a pioneer; there were very few mixed kids of any type, let alone Eurasian, but now it is pleasing to see a whole new generation of little mixed boys and girls growing up. I always smile when I see them and wonder what they might have in common with me, what advice I might be able to impart to them as they perhaps struggle with an identity crisis as they enter their teens. But I think there are so many of us now, especially here, that this no longer presents a problem – we are no longer anomalies – we are one big happy bunch! Ask Barack Obama! I just read Obama's book and I could really identify with some of his experiences in being a mix of black and white. The understanding engendered by being mixed is not just limited to Eurasians, it's an understanding between all mixes.

In terms of relationships, I think I would be more comfortable with someone who is Westernised in their outlook, with experiences I could share. Not being on the same wavelength or being able to communicate can be an additional stress on relationships. Race doesn't come into it – it's more about where someone grew up or how he or she was brought up.

I envisage returning to the UK eventually. I still think of England as my home, and love it to bits. I think I would want my children to have the same kind of childhood that I had. Besides, I have always felt that Hong Kong is a bit of a transient place, nothing ever feels that permanent. Saying that, I love Hong Kong for all the things it has that England does not, so I think my twin heritages compliment each other in a way.

我出生於英國，是名半英半中的混血兒。我在90年代中畢業，當時在英國無特別要做的事，於是決定當背包客旅遊去。我有計劃要到香港，打算教六個月的英語，結果在這裡一留就是12年。從前曾到訪香港探親兩遍，第一次在12歲的時候，令我想多留一會，第二次在21歲。香港總是給人正在急速發展的感覺，它充滿活力，總是有新事物出現和發生。

我的父親於1968年到了英國當護士，那時認識了同是學護的母親。全家只有父親一人到英國去，所以自小到大，我隨了吃點心以外，與我的中國人那邊的家庭沒有多少聯繫。我也從來沒有學會中文——就是我父親，他自己也多少忘了如何用中文交談，除了必需要用中文的時候。可幸的是醫護界非常國際現代化，所以父親擁有世界各地的朋友。雖然我看上去很像中國人，感覺上我只是三份一中國人，而不是半個中國人。我父親從來沒有迫我學習中國文化。然而，雙方文化也對我有些微妙的影響——如李小龍和蘇魯先生（電影《星空奇遇記》角色），以及《星球大戰》的角色，都是陪伴我長大的兒時英雄。

我在14歲時，確實曾經在薩里大學報讀了周日班，付出過努力去學習廣東話。無奈那是個小學程度的課程，我只忍受了一個月羞辱就沒有再讀下去。到今天，我仍然後悔自己沒有學會廣東話——那真是一個很大的障礙。

當我到香港去的時候，我並沒有太大的文化衝擊——我在來港以前曾到處遊歷。然而，這裡有些東西我想我大概永遠不會習慣。希望重新認識我中國人的一面，絕對是其中一個推動我來到東方的原因。很不幸地，我對中國大陸的第一印象是有點負面的，那裡是一個完全不同的世界。初回來時，我花很多時間和父親的家人在一起，並一同慶祝所有中國節日。我現在已經減少很多和他們見面的時間，一來是語言始終不通，二來真的很沉悶。為了清明節拜山而於早上五時起床，對我來說不是一件吸引的事，不過我仍然喜愛中秋節。

作為混血兒有利有弊，例如有個中國姓對作為英文刊物當編輯，或教授英語都不大有利。似乎在英國出生及成長都不重要，在這裡人們要的是一個歐洲名字以及外表，來做這一類工作。而在種族申報表，或與入境有關問題上，混血兒身份有時會令人很苦惱。

正面來說，作為混血兒可以讓我融入任何一個地方，而在旅遊各地時沒有那麼容易受騙。在厄瓜多爾或拉丁美洲等地，我看上去就是一個本地人。當地有被稱為「麥士蒂索人」（Mestizo）的印歐混血兒，長得跟歐亞混血兒非常相像。我也認為混血文化有助令人變得更國際化，承襲兩種文化使我更體諒其他文化及更和諧相處。

總的來說，我覺得作為混血兒很棒。我在孩童時代是個創新的人，當時的所有的混血兒小孩都相當少，不要說歐亞混血兒了。然而，現在喜見有全新世代的混血兒小孩在成長，我看見這些小男孩、小女孩時，都禁不住會對他們報以微笑，在想他們與我有甚麼相同之處，我可以給他們甚麼忠告，助他們可能在青少年期面對的文化身份危機與掙扎。但現在已經有很多混血兒，我們再不是異類，或存在甚麼問題了，我們是開心的一群！問奧巴馬吧！我剛看過巴拉克·奧巴馬的書，我真的理解到他作為黑人白人混血兒的一些經歷。作為混血兒而產生的諒解，不僅僅存在於歐亞混血兒，也是所有混血兒間的互諒理解。

在關係方面，我想我會與外表西化的人相處較舒服，因為可以與之分享我的經歷。在不同頻道或不能溝通，在一段關係中會添加壓力。種族並不成問題——重點只在於那人是在甚麼環境下成長和受教育。

我預期自己最終還是會回到英國去，我依然覺得英格蘭才是我的家，那是我至愛之地。我會希望我的孩子都可能擁有與我一樣的童年經歷。此外，我常常覺得香港只是暫時路過的地方，從來不會覺得長久。雖說如此，我也愛英國所缺的香港事物，所以我覺得所屬的兩種文化在某程度上可以互相補足。

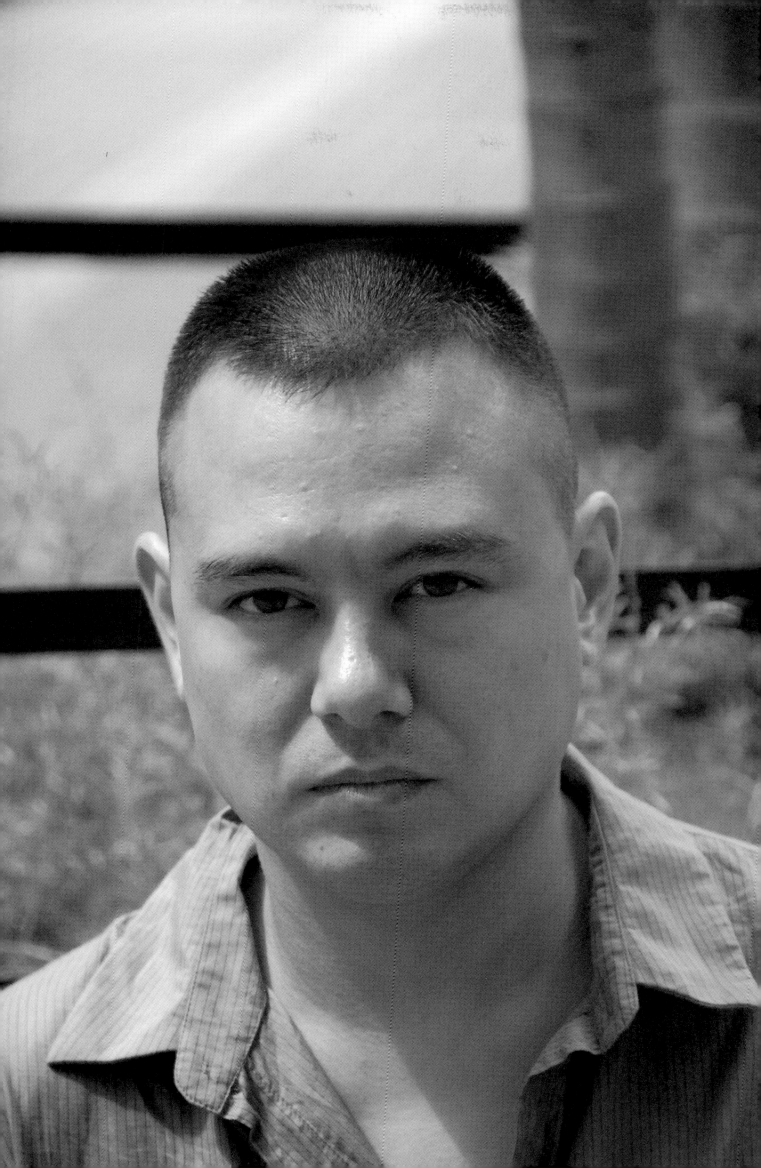

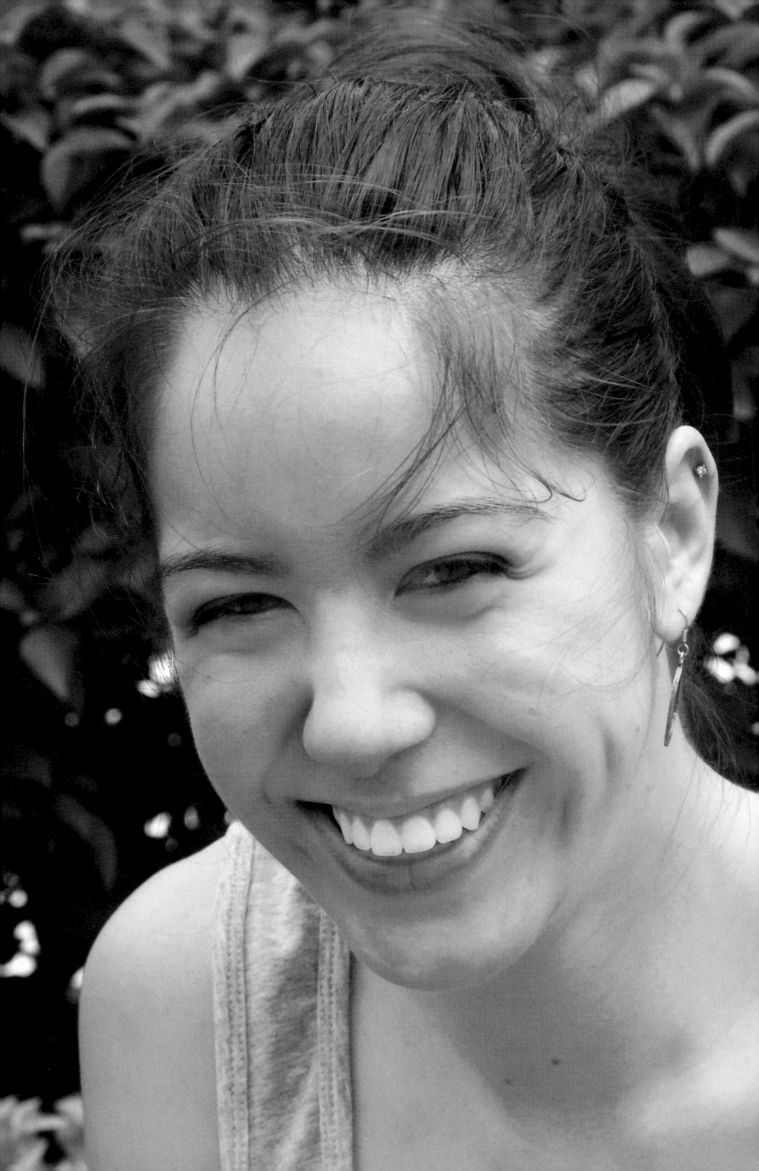

My father is Scottish and my mother is Chinese. I was born in London but moved to Hong Kong after a year and apart from some time spent in Edinburgh at university, I've lived here all my life.

There were only two or three other Eurasians in my primary school which was on the Peak and predominantly Western. I didn't feel as if I stuck out though, as I don't look particularly Chinese. There were far more Eurasians at my secondary school which was full of kids from all over the world. I always ended up with two groups of friends – the local group and the expat group and I found that I could move easily between them.

I have always been close to my maternal grandmother. I have an unusually small Chinese family and I would hang out with them for all the Chinese holidays. My Scottish family is huge but I don't see them very often, maybe once every few years.

My English is better than my Cantonese so sometimes I draw more towards my Western side for certain things but mentality-wise I feel pretty balanced between the two and generally feel as though I swing from one side to the other. I speak Cantonese to my mother and English to my father. It makes for some interesting dinnertime conversations – I enjoy it!

People in the UK would spend hours trying to guess where I was from. I think they could see straight away that I wasn't fully British. I got the usual stuff – South American, Spanish, Italian. I did feel homesick in Edinburgh, and somehow I felt more Chinese there than I do in Hong Kong. As well as missing Asian food, which I much prefer, I found that people in Edinburgh had weird ideas about Hong Kong and asked me strange questions such as whether I lived on a boat and wore a big hat or whether I had a television.

I've never experienced any discrimination on account of being Eurasian, most people tend to think it's pretty cool. Whenever I'm faced with an ethnic monitoring form I always tick two boxes -- when are they going to realize that we're pretty much a race in our own right?

我的父親是蘇格蘭人,而母親是中國人,我在倫敦出生,一歲時移居香港。除了待在愛丁堡上大學,我一輩子都在香港生活。

在小學時,我在山頂一家小學就讀,校內大多是西方人,僅有兩至三名混血兒同學。我不覺得自己被排斥,因爲我本來也長得不太像中國人。我就讀的中學則有更多的混血兒了,那裡的同學都來自世界各地。我總是擁有兩群不同的朋友——本地的和海外來的,我覺得在他們中間遊走並非難事。

我與外祖母向來親暱。在中國人家庭來說,我的家庭算異常細小,我們會一起過每一個中國傳統節日。反之我的蘇格蘭家庭很龐大,但我卻不會常常跟他們碰面,大概幾年才見一次吧。

我的英語比廣東話要說得好,所以在某些事情上,我有時會較爲傾向西方人的一面;然而在思維上我覺得中西的影響很平均,時而以中式思考,時而卻用西方思維。我和母親以廣東話溝通,和父親卻以英語交流,這樣子,有時令我們一起吃晚飯時的對話顯得很有趣——我覺得很好玩!

英國的人會花幾個小時都想不出我來自那裡,我相信他們一眼就看出我不是純英國人。和其他人一樣,我也有南美、西班牙和意大利人的特徵。在愛丁堡我會有思鄉的感覺,在那裡我會覺得自己比在香港時更像中國人。我會掛念我喜歡的亞洲食物。我覺得愛丁堡的人對香港有很多誤解,他們總愛問一些奇怪的問題,如我是不是住在艇上,是不是常戴大帽,或我家有沒有電視機。

作爲混血兒,我從來沒有給人歧視過,通常人家都覺得我很有型、很漂亮。在我需要在表格上填寫民族國籍時,我總是會選兩個種族——他們甚麼時候才會明白,我們混血兒其實也是一個獨特的民族?

I was born and raised in Hong Kong, and educated in England. Being Eurasian has given me a deep affinity with people from both the Chinese and English cultures. I feel just as at home in London as I do in Hong Kong (speaking Cantonese and Mandarin helps!). I believe people of both nations are more at ease with me and accept me more than they otherwise would precisely because of my heritage.

Crossing cultural divides has also aided me in my career. My background enables me to view China and Hong Kong with different eyes than those of my predominantly Western colleagues.

As my children (now six, three and one years old) spend their formative years in the United States, I know that we will frequently travel to Hong Kong and England as a family. Both places are a large part of my identity and I am determined to pass on as much of my heritage and experience to them as I can. I hope it will enrich their lives as much as it has enriched mine.

我在香港出生和長大，在英國接受教育。混血兒的身份，對來自中國或英國文化的人均有很深的關係。不管住在倫敦或香港，我都有家的感覺（會說廣東話和普通話對此有很大幫助！）。我相信兩個國家的人，都會因此而比起單憑我的文化背景更容易接受我。

跨文化的背景，在我的事業上也有所幫助。我的背景，令我能以不同眼光看中國與香港，跟我大部份的西方同事不一樣。

我的子女（分別為六歲、三歲、一歲）都在美國成長，我知道我們一家會經常到香港和英國去。這兩個地方都代表了我文化中的主要部份，我也決意要將自己的文化承傳和經歷，傳繼到我的孩子身上。希望他們也會像我一樣，讓不同文化豐富他們的人生。

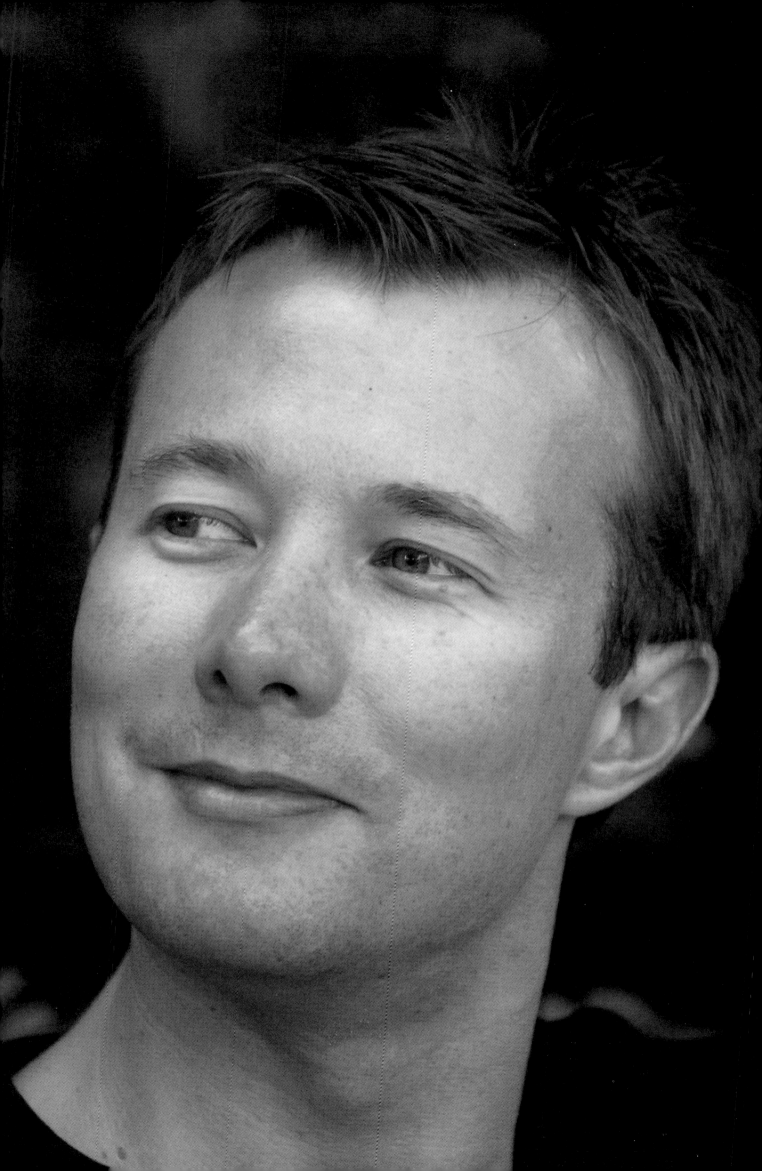

My mother is Chinese and my father is English, I was born in the UK and both my parents are still there. I came to live in Hong Kong in 1987 and feel divided fifty-fifty between the two places as I have homes in both.

I attended both primary and secondary school in the north of England and I thought I was English – just a rather dark English person... but others didn't see it that way. I was called things like "Chinky" by the other students, sometimes even the teachers. Although I felt English, I did often feel like an outsider in England and I suppose I must have identified with the Chinese as most of my friends were Chinese. By age fourteen or fifteen things improved for me as I had a stronger network of friends and by my twenties I began to look a lot more European.

Even now, I do feel more Western than Asian with the exception of when I'm with my Chinese relatives. In a Western environment, I just feel English.

I would say that about fifty percent of the time, Chinese people think I am pure Chinese. Whether people think I am Western or Asian does really seem to depend on what language I am speaking at the time. In the salon, I notice people looking at me curiously when I switch between the two languages – I don't think they can work it out. I can pass off as being local in European countries such as Spain or Italy as well as countries in South America.

I find the whole Eurasian phenomenon really interesting. Some of my Chinese aunts married American GI's and their children look a lot more Western than my siblings and myself who are all quite dark. Then there are my own children who are three quarters Chinese and my son looks more Western than I do, with lighter hair and a typically Eurasian appearance. I suppose it depends on the strength of one's genes.

Being Eurasian has not really had a positive or negative impact in my life although it is nice to be able to blend in with both cultures. I haven't suffered any discrimination as a Eurasian, only as an Asian in the UK. I did used to have some problems, for example, going through immigration in Hong Kong in the past when the queues were clearly divided between Chinese and Westerners but since 1997 it has become much easier.

I would say that ninety-nine percent of the time I can tell other Eurasians – we have a distinctive look.

我的母親是中國人,而父親是英國人,出生在英國,而父母現時還在那兒居住。我在1987年來到香港定居,我對兩地的感情都一樣,而且兩地均是我的家鄉。

我在英國北部就讀小學及中學,那時我自以爲是英國人——只是皮膚較黑而已⋯⋯然而,別人並不那麼認爲。同學都叫我作「中國佬」,有時連老師也是這樣說。雖然我覺得自己是英國人,我在英國常常覺得自己是外來人,可能人家都把我認作是中國人,因爲我大部份的朋友都是中國人。在14,15歲時,由於我有更大的社交圈子和朋友網,我的情況開始有所改善;而在20歲後,我長得越來越像歐洲人。

就是現在,除了和我的中國親戚在一起時,我也會覺得自己比較西化。在西方社會生活,我只覺得自己是英國人。

我會說中國人有一半的機會認爲我是純中國人。別人不會因爲我的語言而認爲我是亞洲人還是西方人。有一次,我在髮廊轉換兩種語言時,別人以好奇的眼光看著,我不認爲他們知道是怎麼一回事。在歐洲國家如西班牙或意大利等地,或在南美國家,我可以假裝成本地人。

我覺得整個混血兒界的現象很有趣。我的幾名中國籍姨媽,嫁了給美國軍人,他們的孩子長得比較像西方人,和我及我的兄弟姊妹不一樣,我們都長得比較黝黑。然後是我自己的孩子,他們是四份之三個中國人,然而我的兒子比我長得更像西方人,淺色毛髮及標準混血兒的外貌。我想,那是根據父母的基因,看誰的比較強吧。

作爲混血兒,對我的生活沒有帶來任何正面或負面的影響,然而能夠混合在兩種不同文化之中,總是件好事。我並沒有因爲混血兒的身份而受到任何歧視,只是在英國時,試過因爲是亞裔而被歧視過。我以往會試過在香港過入境處時遇上問題,那時很清晰劃分處理中國人和西方人的不同入境櫃台,但自從1997年以後,已經沒有這個問題存在了。

有99%的時間,我可以對其他混血兒說——我們都擁有出衆的外表。

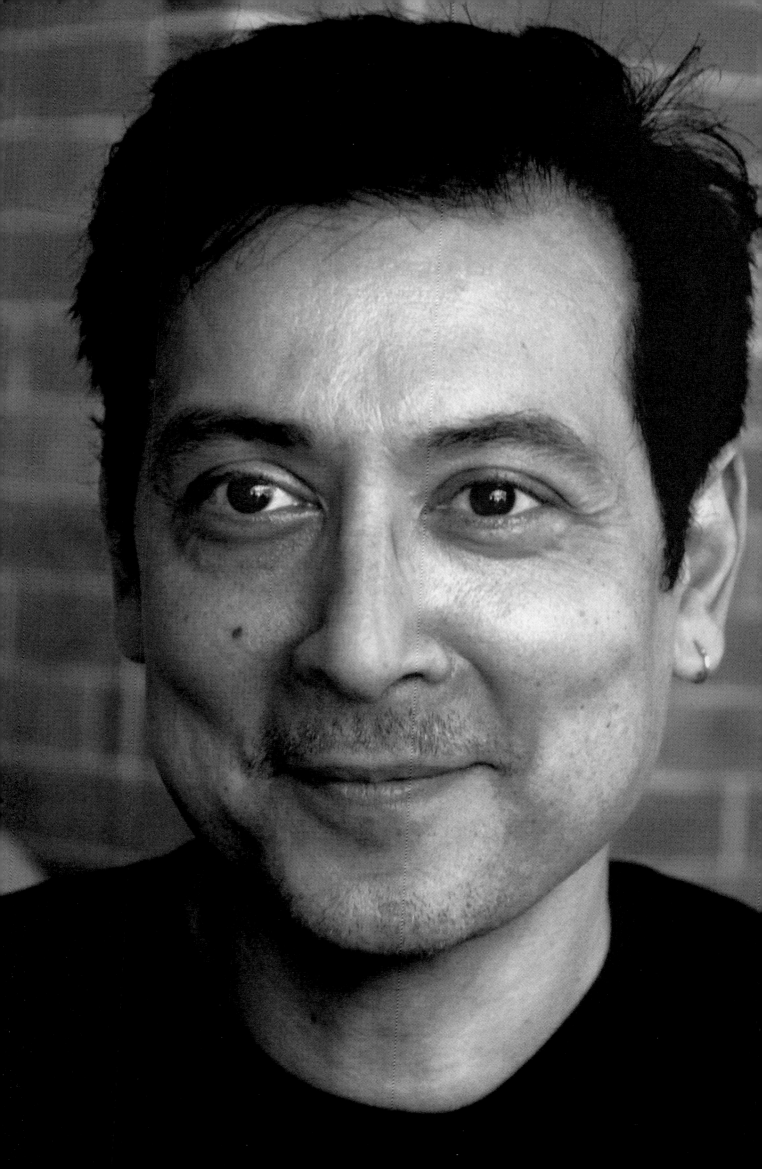

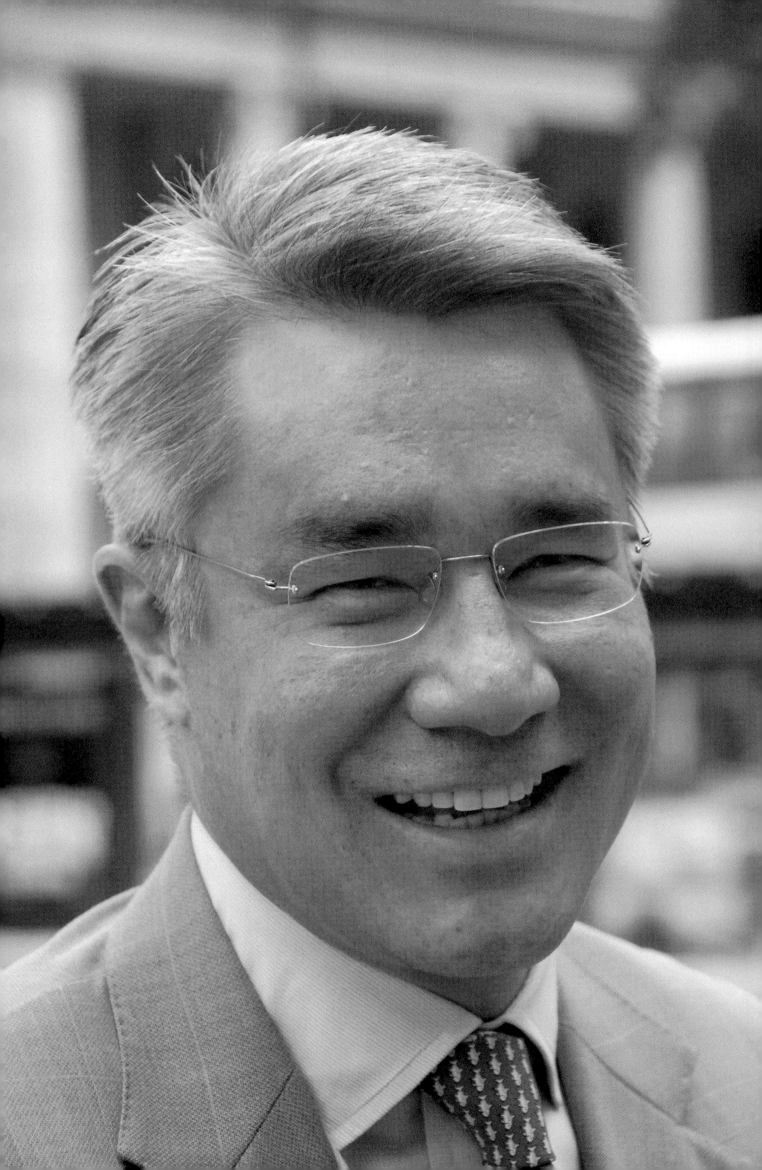

My father is Malaysian Chinese and my mother is Australian. My parents met at university in Brisbane. I was born in Kuala Lumpur. At the age of 12 I went to board in Brisbane. My sisters followed later and my parents eventually retired there. I stayed in Brisbane until 1991, then I came to Hong Kong and I have been here since.

English was the language of our home. I also speak limited Cantonese and Malay. I think language comes from your mother and my mother spoke to my sisters and me in English.

I think in large part you are a product of your surroundings. I increasingly think of myself as more Asian than Western. That's because I have been in Hong Kong for nearly 20 years. When I lived in Brisbane, I thought of myself as more Western than Asian. Then again, Brisbane was somewhat homogenous in those days.

Often a Eurasian kid will yearn to be either Asian or Western; it's the yearning to belong. Often the kid will be told that he is part of both groups and is therefore lucky. More and more, I think a Eurasian is neither. He is part of a third group. Often he is more comfortable among Westerners than an Asian kid would be, and vice versa. But his true cultural home is among other Eurasians.

At school I didn't feel disadvantaged, or even different, being Eurasian. A schoolboy tends to try to fit in. Neither did I feel different at university nor as a young graduate in Brisbane. I was aware I wasn't fully a part of one or other group, but then I didn't feel uncomfortable or awkward about it. That's just how it was.

If anything, I have become more aware of being Eurasian in Hong Kong. Being Eurasian has become a bigger part of my self-image as I have grown older. Also there are so many Eurasians here. I can't think of a better place to be Eurasian, as such, than in Hong Kong.

I guess some Eurasian kids will need guidance regarding their identity. Mostly though, I think a supportive family is the key. If your family is close-knit you can do anything, and you can deal with anything.

我的父親是馬來西亞華僑,母親是澳洲人,他們在布里斯本的大學認識。我在吉隆坡出生,12歲時到布里斯本讀書,妹妹稍後也跟著來,父母也在這裡退休。我在布里斯本一直留到1991年,然後才來香港,一待至今。

英語是我們家的主要語言,我會說有限的廣東話和馬拉話。我相信語言是由母親那邊承傳過來,我的母親對我和妹妹都以英語溝通,所以我們家都是用英語。

在很大程度上,人是其身邊環境下的產物。我越來越覺得自己更傾向是名亞洲人多於西方人,原因是我在香港快要20年了。當我在布里斯本居住的時候,我會覺得自己較像西方人;當時布里斯本相對是一個單一民族的社會。

混血兒孩子通常都會渴望成為真正的亞洲人或西方人,那是對民族歸屬感的渴望。別人卻常常告訴他,你是個幸運兒,屬於兩個不同民族。但我漸漸地看到,混血兒實際上兩個民族都不是,他們屬於第三個民族。他們通常會較亞洲的孩子更容易混在西方人的圈子內,反過來亦然;但他們真正在文化上的家,卻是屬於混血兒群的。

在校內,我不覺得混血兒的身份有甚麼不利的地方,或與別人有何不同。在校的孩子,總會努力融入同學群中。我在布里斯本讀大學時,以至畢業後,也不覺得自己和其他人有所不同。我覺得自己雖不完全屬於其中一個民族,但卻不覺得這有甚麼奇怪和不安,與生俱來就是這樣子的。

如果要說,我覺得在香港才令我更在意自己是名混血兒。隨著年紀漸長,混血兒的身份對我的自我形象起著越來越重要的作用;再者,這裡有那麼多的混血兒,我想不到一個比香港更適合混血兒居住的地方。

我猜想有些混血兒孩子需要別人的輔導,引領他們對自己的身份認同;在很多情況下,家人的支持是最重要的。有親密無間的家庭關係,才可以無懼風浪,做你想做的一切事情,處理任何問題。

My father is Scottish/Irish and my mother is Chinese. I was born in Hong Kong and went to boarding school in Scotland for a year when I was eleven. I then completed my secondary education in Hong Kong before attending university in England. I then spent a year in Beijing and have been back home in Hong Kong for about a year now.

I don't know whether I feel more Western or Asian. I find that a really difficult question. Admittedly, I've been going through some identity issues recently - which is odd as I've never been the type of person to ask themselves 'who am I?' I suppose I've always been quite sure of myself and I'm sick of people telling me who I am because I already know! For example, people will tell me 'but you can't be from Hong Kong' because I'm not pure Chinese or because I don't really speak Cantonese. Or they might, when I tell them that I'm from Hong Kong, follow with 'but where are you really from?' I've even been told 'to accept that you're British'. But why?

It's strange working in a local office where people refuse to acknowledge that I'm local. If I show any local knowledge whatsoever, they all act amazed. I also speak Mandarin which seems to throw them!

I never really identified with the culture in England. Likewise, I couldn't say that I identify with all Eurasians – if a Eurasian is half Japanese, half French for example, I would have nothing in common with them at all.

In England I was called 'Pocahontas' and people tended to guess that I was either some sort of Native Indian or South American. Curiously, in Beijing, people guessed that I was from Xinjiang, which is very close to Kazakhstan and the locals there look just like me.

I've never suffered discrimination for being Eurasian, but have had derogatory comments from both Chinese who think I am Western and Westerners who think I am Asian.

I don't feel privileged to be Eurasian, as at the end of the day we're no better than anyone else, but if the question is whether I am happy to be Eurasian then the answer is yes, I most definitely am happy to be a Eurasian.

我的父親是蘇格蘭／愛爾蘭人，而母親是中國人。我在香港出生，在11歲時，曾到蘇格蘭的寄宿學校留學了一年。之後我在香港完成了中學教育，再到英國升讀大學。後來我在北京待了一年，並再回到香港，現在已經回來快一年了。

我不知道自己是比較西化或中國化，我覺得這是個很難回答的問題。無可否認，我最近確實有想過想過自己的身份的問題——這是很奇怪的，因為我從來不是那種會問「我是誰」的人。我想我對自己是蠻有信心的，而且很討厭別人為我是誰下定論，因為我本來就很清楚自己是誰！例如，有人會告訴我「你不可能來自香港」因為我不會說廣東話。或當我向他們說「我來自香港」時，他們會回應「但你真正來自那個地方？」，更甚者是有人告訴我要「接受我是英國人」。為什麼要這樣？

在本地公司工作時，被人們拒絕承認我是本地人，是件很奇怪的事。他們會對我的本地知識感到很吃驚，而我說普通話的時候，更會將他們嚇倒。

我從來都沒有真正的認同過英國的文化。同樣地，我也不能說我與所有的混血兒相同——如果對於一名日法裔混血兒，我和他就沒有任何共通的地方了。

在英國，我被稱為「Pocahontas」（迪士尼《風中奇緣》內的印第安公主寶嘉康蒂），別人總猜我是印第安土著或來自南美。很奇怪地，在北京，人們卻覺得我是來自新疆——那裡鄰近哈薩克，當地居民長得和我差不多。

作為混血兒，我從來沒有遭到歧視對待，但卻曾在中國人以為我是西方人，或西方人以為我是中國人時，聽過貶抑的話。

我不認為作為混血兒有任何優越之處，畢竟我們和其他人也沒有兩樣。但如果問我是不是喜歡成為混血兒，那答案肯定是：當然！我非常慶幸自己是一名混血兒。

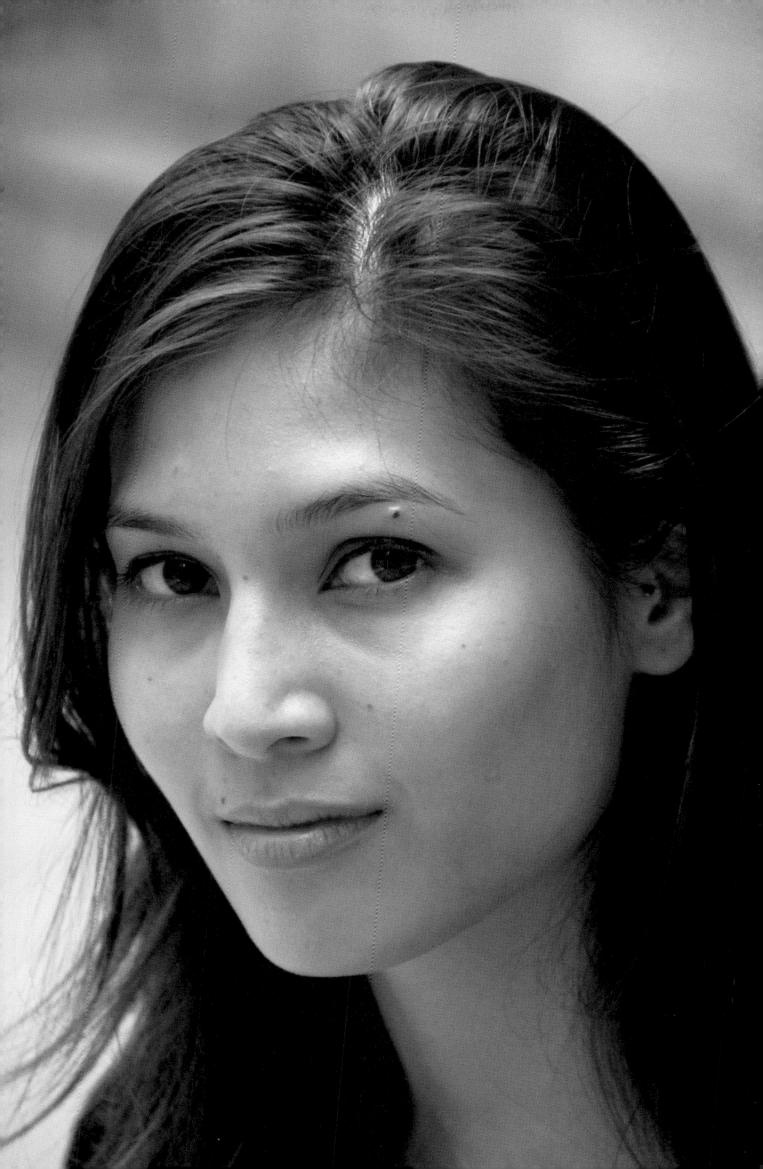

I was born in Bath, England and now live in Cardiff, Wales. I grew up in Hong Kong however, and still consider it to be my home. I am a mix of Irish, Scottish and Chinese and speak both English and Cantonese. As a Eurasian, I find questions of nationality and race difficult, and my answer depends on the context in which it is asked. I tend to say that I'm from Hong Kong, but I will sometimes throw in the fact that I'm half Irish, too.

I'm always proud to refer to myself as Eurasian, but the term is actually very diverse, and it means different things to different people. While I like the idea of belonging to a distinct ethnic group, and not having to tick "other" in the ethnicity sections of forms, I wonder whether such a distinction serves to unite Eurasians or separate them from everyone else.

I have found that people in Hong Kong are more likely to realize that I am mixed, while in the UK, people tend to assume I am 100% Chinese. I suppose it's due to exposure, as you obviously don't see as many Chinese or Eurasian people in the UK as you do in Hong Kong. Personally, I think look mixed, but I can understand how it might be difficult to tell. Although it can be tempting to put a person's inability to read my ethnicity down to ignorance, perhaps it's unfair to judge people when they get it wrong – I don't think that I could tell a Swedish person from a Norwegian!

Generally, I can tell when another person is Eurasian, although identifying the mix is more difficult. I also have a lot of people trying to guess which of my parents if European, and which is Asian. The assumption tends to be (incorrectly) that my father is European. One day, I went with my Chinese grandmother to the wet market. I was about eight years old at the time, and she stopped to have a chat with the local butcher. After enquiring about who I was and why I was a bit "funny looking", he asked which of my parents was Asian. When he was told that it was my dad who was Chinese, the butcher wiped his hands, came around the front of his stall and insisted on shaking my hand. He told me that it wasn't every day that one of us Chinese guys gets together with a white woman!

Personally, I think being Eurasian is fantastic, and I wouldn't want to be anything else. It gives you such a unique view of the world and it helps you understand how things may be viewed from different perspectives. Being bilingual is the most obvious benefit to being Eurasian, but the list is endless. I've never experienced any discrimination on account of being Eurasian – it's almost always been a positive thing. As I live in Wales, being able to draw on my Scottish or Irish heritage has been a real bonus when the rugby is on.

I think people view us with curiosity. People are naturally inquisitive about how we define ourselves, what our mix is, how our parents met and how we identify ourselves culturally. I believe that Eurasians can be some of the most beautiful people in the world, with unique looks and diverse backgrounds. Although it has to be said that being unique can produce some hilarious results. When I was born in the UK in 1983, Eurasian babies weren't all that common. It didn't occur to anyone at the hospital that my mum, who'd checked into the hospital under her maiden name, had a Chinese husband. So when I was finally brought into the world, a rather severe shade of yellow, the doctors told my mum that I was seriously jaundiced… until my dad wandered into the delivery room. Realizing that he was the father, the doctors decided that I was fine after all.

我生於英國的巴斯，現居於威爾斯的卡地夫。然而我在香港成長，並仍然以此爲家。我是愛爾蘭、蘇格蘭、中國的混血兒，會說英語及廣東話。作爲一名混血兒，我覺得有關國籍和民族的問題都很難解答，回答也會根據問題的整體背景而改變。我傾向說自己是來自香港的，但有時也會加上自己是半個愛爾蘭人。

我總是自豪地介紹自己是混血兒，但這個字的定義很廣泛，對不同人有不同意思。雖然我也希望混血兒分別出來，另屬一個獨特的民族，而在填表時再也不用在種族欄上選填「其他」，我懷疑此舉是會讓混血兒們團結起來，還是讓我們與其他人分隔出來。

我發現香港人較容易辨認出我是混血兒，而在英國，別人總假設我是100%中國人。我想那是因爲混血兒的曝光率問題，在英國明顯地比香港少得多混血兒。我自問自己長得像混血兒，但我明白到別人可能難於分辨。雖然我很容易可以說，那些不會辨別我的民族的人很無知，但或許這說法有點不公平——就正如我不會分辨瑞典人與挪威人一樣！

一般來說，我可以分辨出誰是混血兒，但要指出來自那些血統則比較困難。我也遇過很多人嘗試猜我的父母誰是歐洲人，誰是亞洲人；他們總是（錯誤地）假設我的父親是歐洲人。我記得在我8歲的一天，與華裔祖母到菜市場，她停下與一名本地屠夫聊天，在問了我是誰及爲什麼我長得有點奇怪後，他問及我的父母中誰是中國人；當他聽到原來我的父親才是中國人，他立即抹乾淨手，走出他的攤販與我握手，並說很少中國男子與白人女士在一起！

個人來說，我認爲作爲混血兒很棒，我並不想成爲其他民族。這身份給予你獨特的世界觀，幫助你明白到世上有很多事情可以從另一個角度去理解。有流利的雙語能力是作爲混血兒最明顯的好處，當然好處是數不盡的。我從沒有因混血兒而受歧視 —— 遇到的都是正面的經歷。我現在住在威爾斯，能在欖球賽期間利用我的蘇格蘭或愛爾蘭遺產，真的很有益處。

我覺得別人對我都充滿好奇，他們自然地會問及我們如何定義自己，我們來自那些不同血統，我們的父母是如何認識，以及在文化上我們如何將自己定位。我相信混血兒可以是世上最漂亮的人種，有著獨特的長相和不同的背景。雖說如此，作爲與眾不同的人，有時難免會出現滑稽情況。1983年我於英國出生時，混血兒嬰兒並不普遍。由於母親是以自己的娘家姓登記入院，醫院裡沒有人知道她有個中國人丈夫。所以當我出生時，醫生們看到我的黃皮膚時，告訴母親我得了嚴重的黃疸病...直到父親出現在接生室時，醫生們才知道我有個中國人父親，才斷定我沒有生病。

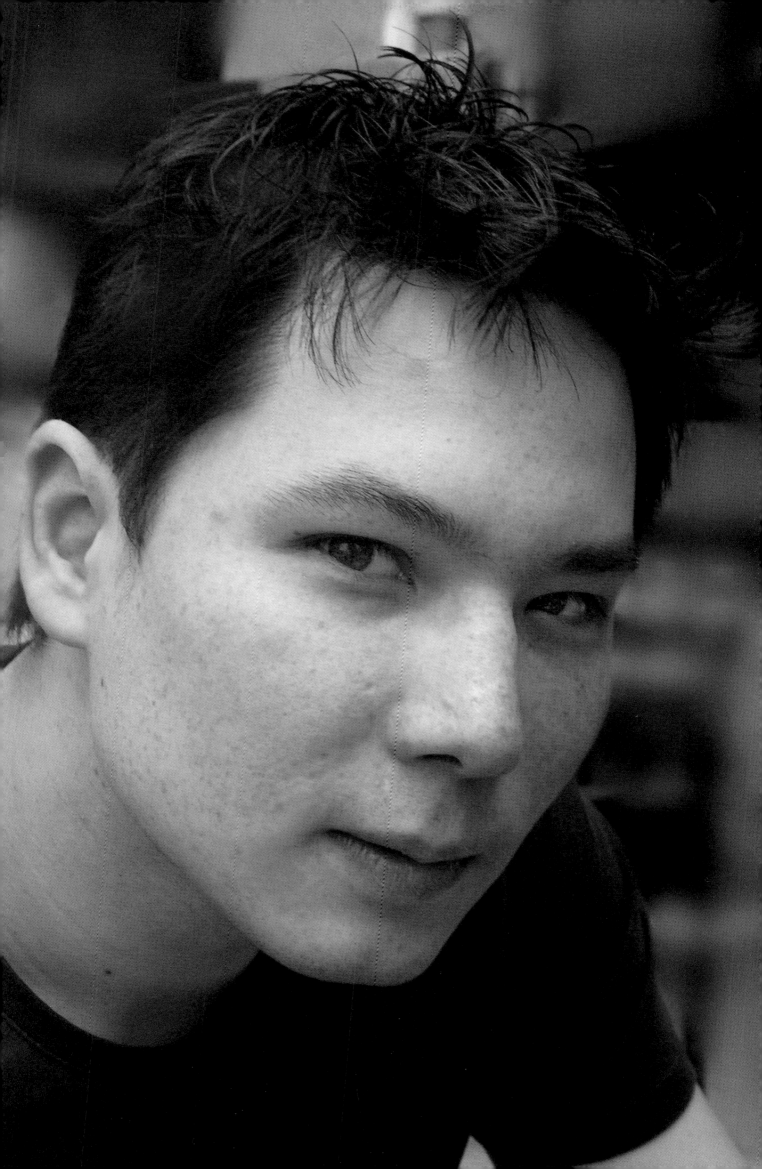

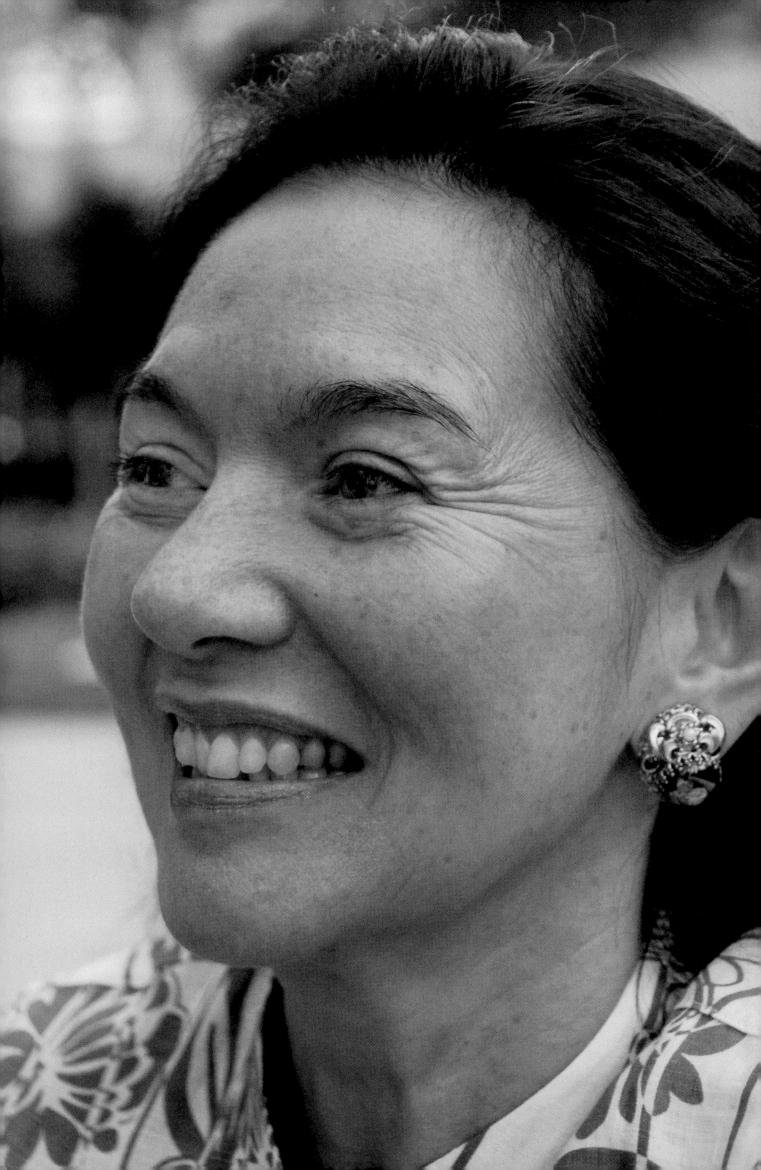

My mother is Hakka Chinese and my father is English. They met one another in Malaysia where my father was a tin mining engineer and my mother was a nurse. They later owned a rubber plantation in the Cameron Highlands.

My father was 24 years older than my mother and at the time mixed marriages were very rare. Most Eurasians were born out of wedlock. My mother's father was absolutely mortified but my father's family were fine about it.

My mother was not typically Chinese. She drank, smoked, gambled and was always very popular for being the life and soul of the party.

I was sent to boarding school in the UK at 13 as there were not many English-medium schooling options in Malaysia at the time. Being Eurasian was no big deal at boarding school; I was surrounded by diplomats' children from all over the world.

I fell pregnant at 15 and was forced to give my daughter up for adoption. When I was reunited with her a few years ago, I was delighted to see that she looks Eurasian too! I have been married a few times and have two children and two grandchildren.

I went back to Malaysia after boarding school. In Malaysia, identity cards of minorities are marked with a race, such as 'Chinese' or 'Indian'. Mine reads 'Other' which gives me the same privileges as Malaysians. I'm proud of that.

I have always been happy to be Eurasian. There have, in the past, been some off-colour comments such as "English men like you because you're so servile", or "You're so lucky that someone brought you from Thailand", but in my mind that is not discrimination against Eurasians but ignorance about Asians. I can't think of anything really negative about being Eurasian – my parents made me so proud and my mother especially made me feel like I could do anything.

I think Eurasians naturally have some resilience and are more prone to being open-minded. I have found it easy to make true friends because of these traits and feel privileged to be a Eurasian.

我的母親是中國客家人，而父親是英國人。他們在馬來西亞相識，當時父親是錫礦工程師，而母親則是一名護士。他們後來在金馬崙高原擁有一間橡膠廠。

父親比母親年長24歲，當時跨民族的婚姻是很少見的。大部份混血兒都是非婚生子女。外祖父對母親此舉感到無比羞辱，父親家庭那邊反而不覺得怎樣。

母親不是一般的典型中國人，她喝酒、吸煙、嗜賭，是派對中受歡迎的靈魂人物。

我在13歲的時候，被送往英國唸寄宿學校，因為當時在馬來西亞並沒有太多英語學校可供選擇。在寄宿學校裡，混血兒不是甚麼一回事，我身旁都是來自世界各地的領事館人員的子女。

我在15歲時懷孕，當時不得已放棄女兒給別人領養。幾年後當我與她重逢時，很開心見到她也長得像名混血兒！我結過幾次婚，有兩名孩子和兩名孫子。

在寄宿學校畢業後，我返回馬來西亞。馬來西亞的少數民族，是要身分證上登記其種族如「中國人」、「印度人」等。我的身分證上卻寫上「其他」，給予我和馬拉人一樣的特權。我對此很自豪。

我向來很慶幸自己是名混血兒。從前的確有些下流的評論如「英國人喜歡你，是因為你的奴性」，或「你真幸運，有人把你從泰國帶來」等。但我覺得這些言論並不是對混血兒的歧視，而是出於對亞洲人的無知和誤解。我想不到作為混血兒有甚麼不好——我的父母令我多麼自豪，尤其是我的母親，她令我覺得自己甚麼都可以做。

我想，混血兒擁有天生的適應力，思想也較為開放。我因此而易於結交真正的朋友，並為作為混血兒而榮幸。

I was born in Singapore and both my parents are Eurasians. My father was a 'Lesslar' which likely has origins from a small Swiss-German community in Penang in the early 1800s. My mother's maiden name was 'Foley' – I believe she was of Scottish descent as her mother was a 'Stewart'.

I consider myself to be Singaporean in terms of nationality and Eurasian when it comes to ethnicity. We used to be categorized as 'Others' on our Identity Cards but now the Eurasian ethnicity has been recognized and my Identity Card states 'Eurasian' as the Eurasian community is accepted as one of the domiciled communities of Singapore. Generally, we are Asians, with a European background or heritage. Our Asian side is more the fact that we have generations before us who were born and bred in this region.

I do not feel any pull between my Western and Asian sides because I am just Eurasian. We Eurasians in Singapore have a distinct lifestyle of our own. We tend to be Catholic so Christmas and Easter are very important to us. At Christmas, all the family get together and savour signature Eurasian dishes such as Sugee Cake, which is made of semolina and almonds, and Curry (Devil) Debal. The Sugee Cake is also served at Eurasian weddings. Although Eurasian households tend to be conservative, we are also seen as very social people – we enjoy a good party and love music and dancing.

Growing up, English was my mother tongue and I learned Malay as a second language. In the past, being Eurasian could be an advantage in getting a job as a secretary or clerk on account of our fluency and proficiency with the English language. Now, being Eurasian itself is neither an advantage nor a disadvantage – we are all Singaporeans and in order to get ahead, we have to prove ourselves like anyone else.

Within the Eurasian population in Singapore there are mainly three types of Eurasian, based on the colonial history in this region. Mostly, you can distinguish between the families by their family names. There are those of British descent with British family names; those that came with the Dutch East Indies, but not necessarily of Dutch stock. These families could be German, Danish or Flemish. Then there are those who have links to the Portuguese, who came in the 16th century through India and who made settlements in Ceylon, Burma, Indonesia (Ambon & the Spice Islands), Malacca and later Macao.

In previous generations, there used to be distinctions between Eurasians, and Eurasian families. There were also comparisons made to skin tones. The fair-skinned Eurasians, who tended to be the British or Dutch Eurasians, and who had a higher economic standing, were divided from the darker-skinned Eurasians who tended to be the descendants of the Portuguese Eurasians who have been in the region longer, and for many more generations. The fairer Eurasians were known as the 'Upper-tens' and the darker skin tone Eurasians were – for some reason unknown to everyone until this day – known as the 'Lower-sixes'.

In those days we were always reminded, in whatever we did, never to shame the family. So whatever grandma said was not acceptable, was NOT ACCEPTABLE. No one questioned this. These days, it is far more acceptable for Eurasians to marry non-Eurasians, but I think most of us are of the view that "marrying your own kind" – i.e. having the same faith, upbringing, traits and traditions – are all part and parcel of finding the right match. With all communities becoming more cosmopolitan, the boundaries between communities are becoming more grey and therefore equally acceptable.

I have always been and will always be very proud to be Eurasian. I have been a volunteer at the Singapore Recreation Club, which was a Eurasian Club in those days, for 40 years and I have been a volunteer at the Eurasian Association for almost 20 years. I feel that we as Eurasians have a lot to offer the other communities in Singapore. We are that in-between community. With Singapore and the world growing closer with the increased number of mixed marriages, the Eurasians have an important role as a study model. With several generations in this region we have become that perfect model to understand difference in ethnicity, cultural tolerance and acceptance at the family level.

我在新加坡出生,父母均是混血兒。父親姓"Lesslar",祖先很可能來自1800年代聚居於檳城的瑞士—德國小村。母親姓"Foley"——我相信她是來自蘇格蘭後裔,因為外祖母姓"Stewart"。

我覺得自己國籍上是名新加坡人,種族上是混血兒。我們習慣於在身份證上被列作「其他」民族,但現在混血兒已經被認同,所以身份證上已列「歐亞裔」,混血兒社區被接受成為新加坡定居民族之一。大體上我們是亞洲人,但擁有歐洲人的背景和文化。我們亞裔的一面,多半來自祖先多代均在這個地區出生及成長。

我並不覺得我身上的西方和東方血統有比重問題,因為我就是混血兒。我們在新加坡的混血兒有自己獨特的生活方式。我們多是天主教徒,所以聖誕節和復活節對我們很重要。在聖誕節時,所有家庭成員都會聚在一起,嘗特色混血兒食品如用意大利面粉和杏仁做的蘇芝蛋糕,及魔鬼咖哩。蘇芝蛋糕也是混血兒的婚宴食品。雖然混血兒家庭較為保守,我們也被認為是很愛社交活動——我們喜歡音樂和舞蹈,並享受好的派對。

成長的過程中,英語成了我的母語,我以學習第二外語形式,去學習馬拉話。從前混血兒因為擁有流利英語,所以有利於找尋秘書或文員等工作。現在混血兒的身份既沒有好處亦無壞處——我們都是新加坡人,和其他人一樣,我們要證明自己的能力以繼續進步。

根據殖民地歷史,新加坡的混血兒人口可以劃分為三類。在多數的情況下,可以由他們的姓氏分辨出他們來自甚麼家庭。那些英國姓氏代表他們是英籍後裔;那些有荷屬東印度姓氏的,不一定就是荷蘭裔,他們可以是德國裔、丹麥裔或芬蘭裔。也有一些與16世紀通過東印度前來新加坡的葡萄牙人有關係,這些葡裔移民,也聚居於錫蘭、緬甸、印尼(安汶及摩鹿加群島)、馬六甲,以及後來的澳門。

以往幾個世代,不同的混血兒及不同的家庭,曾經有過鮮明的分別。也有對混血兒的不同膚色作出比較:皮膚白皙的混血兒,多擁有英或荷裔血統,經濟較為優越;相對地膚色較深的混血兒,則為經濟較差的葡萄牙後裔,但他們遷居來此的時間較早,已經有多代人土生土長於新加坡。膚色淺的混血兒被稱為「社會最上層的貴族階級」(Upper-tens),膚色深的人因為某些不明原因,至今為止一直被視為「社會低下階層」(Lower-sixes)。

那個年代,我們常常被告誡,做甚麼都不要緊,就是永遠不要做一些令家族蒙羞的事。所以,祖母說甚麼事情是不可接受的,就是不可接受,沒有人會去提出質疑。現在,混血兒與非混血兒婚姻的接受程度大大提高,但是我覺得我們大部份人的看法,還是認為找到合適的另一半,不可缺少要「與同族類結婚」的條件——指擁有相同信仰、成長環境、特質、傳統的混血兒。然而隨著社區越來越都市化,社區的界限也變得模糊,於是不同地區背景都同樣被接受。

我從來都為自己的混血兒身份而自豪,並曾於為混血兒而設的新加坡休閒俱樂部當了40年義工,及於歐亞裔協會當了差不多20年義工。我覺得我們混血兒對新加坡的其他種族社區可以有很多貢獻,我們是社區種族間的橋樑。當新加坡與世界變得更接軌,而跨種族婚姻數目越來越多,混血兒們成了一個很好的研究學習模式。我們已經有數代人生活在這個地區了,自然而然成了最佳的現存社區模式,去了解不同民族在家庭層面上對文化的寬容性與接受度。

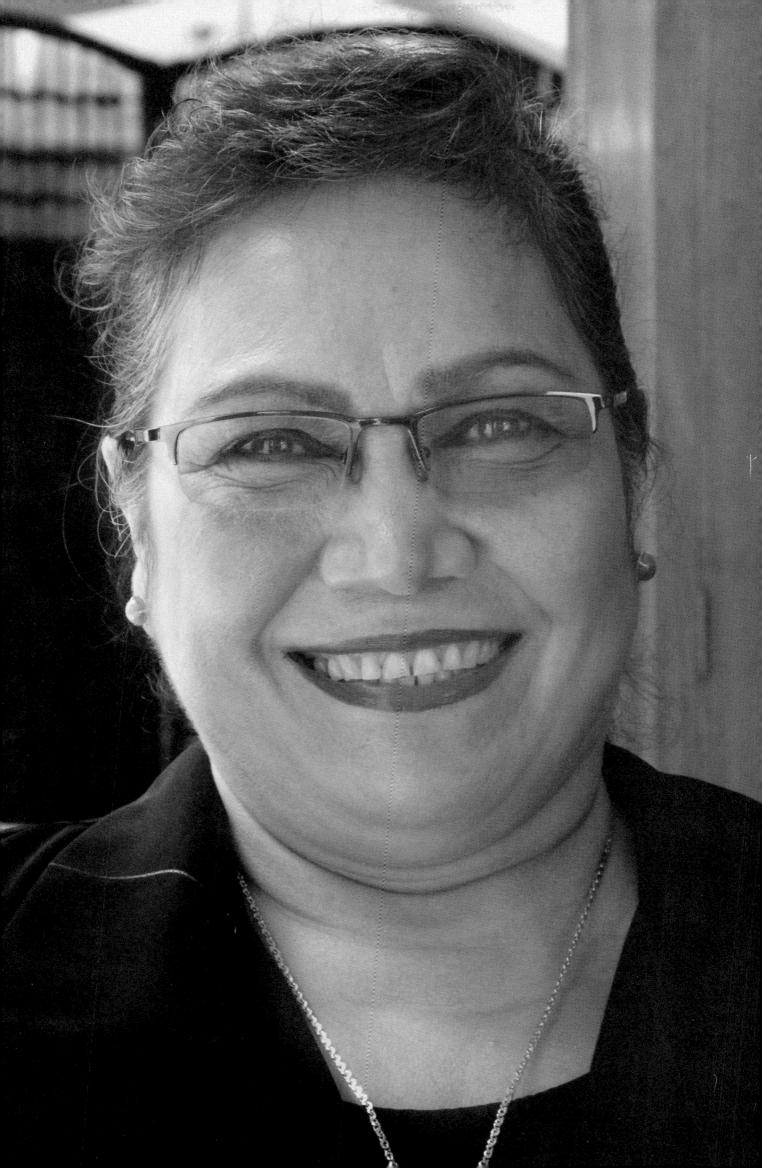

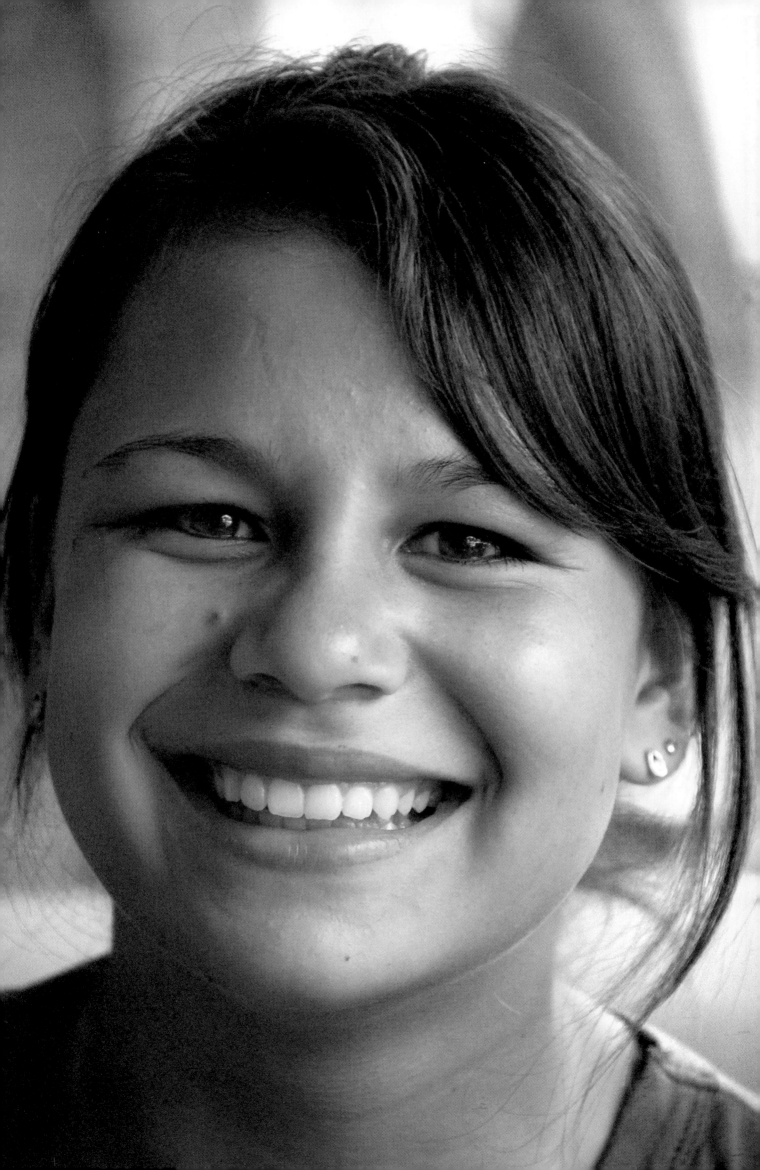

我的母親是英國／威爾斯人，而父親是中國人，但他們兩個均在紐西蘭出生及長大，我也是，然而在兩歲時移居到香港去。

我很難決定那裡才是我的家——香港抑或紐西蘭。我常常會回到紐西蘭，而且除了直系親屬在香港以外，其他所有親人都在那裡。我真的覺得兩地都難以割捨。

雖然種族基因上，我是一名混血兒，在生活上我覺得自己是完全的一名西方人，可能因為我的父親本身也並不太像中國人——他也不大會說中文。我們會慶祝中國節日，但我認為那是因為我們住在香港，跟我們有中國文化無關。

雖然這樣說，作為混血兒可以鶴立雞群是件好事——尤其在歐洲地區。在紐西蘭，偶爾人們會問我是不是有毛里人的血統，但並不常發生，因為那裡有那麼多不同的種族及文化的融合。在香港，本地中國人會以為我是西方人——他們不知道我是混血兒，對我來說一點都不重要。

很多時候，我都可以認得出其他混血兒；當然，如果那些混血兒長得像亞裔人，會比較容易分辨，如長得像西方人那麼淺的膚色，剛比較難辨別了。

如果我們有自己的種族，那當然是很棒的事情，因為現在已經有那麼多的混血兒了。

My mother is English/Welsh and my father is Chinese but they were both born and raised in New Zealand. I was also born in New Zealand but moved to Hong Kong when I was two years old.

I can't decide where I feel to be home – Hong Kong or New Zealand. I go back to New Zealand so often and apart from my immediate family, all the rest of my family are there. I feel really split between the two places.

Although I am genetically Eurasian, I just feel Western. I guess it's because my dad isn't very Chinese – he doesn't even speak Chinese that well. We do celebrate Chinese holidays and festivals but I think that's more because we live in Hong Kong, not because of any affinity with Chinese culture.

Saying that, I do find being Eurasian a positive experience in that it's nice to stand out – especially in European places. In New Zealand, people do sometimes ask if I'm part Maori but not that often as there is such a mix of races and cultures there. In Hong Kong, local Chinese just assume that I am Western – it doesn't bother me that they don't realize that I am mixed.

I can tell other Eurasians most of the time but it helps when they are the more Asian looking ones. Eurasians with very pale skin are harder to identify.

It would be really cool to have our own group as there are so many of us now.

I was born in Hong Kong, am half Filipino, half French and I currently live in France for my studies. I am fluent in English and French, learning Chinese and Japanese, and I tend to believe that my Spanish is not too bad.

I am French, officially. But I feel partially French, partially Filipino, with a bit of Chinese. I feel at home wherever I have stayed for a while – however, growing up in a big city has made me feel more comfortable in Hong Kong or Shanghai rather than where I live now.

Ethnicity plays a big role in one's nationality along with the usual stereotypes. Even though I have nothing Chinese about me, I know a lot about their culture and a part of their history, their way of thinking and ways of living. I lived in Shanghai for quite a while and what I liked most about it was that although there weren't many non-Chinese on the streets, and I feared standing out on account of that, when I did actually go out for a walk it just didn't matter. I was well accepted and I felt comfortable amongst the Chinese.

Having lived in China and France, and visited both Western and Asian countries, I find I am more prone to my Asian side. On the contrary, my sister is drawn more towards her Western side. She doesn't look Asian at all in my opinion. If we walked down the street together, I don't think many could see that we were siblings; I've already had this experience with my friends in school. When one of my very good friends saw my sister for the first time, he couldn't believe who she really was and I'm guessing it's mostly because she is pure, pale white and I've got that pale milk chocolate skin colour.

I don't find that people try to guess my ethnicity very often. Hong Kong is a very international territory, and France welcomes foreigners from the four corners of the world. Wherever I am between these two places, I'm surrounded by countless ethnic groups, so I don't believe they would really try to guess where I'm from. If people do have a go, they tend to think I'm from somewhere around Southeast Asia. It doesn't bother me at all if people get it wrong. I make mistakes too, and guessing is somewhat a gamble, you win or you lose, some take it well and others not so. Nobody can really guess where I'm from since I don't have much Filipino culture, and you just have to sleep under the sun for a day to get my skin colour.

I think most Eurasians have some kind of 'touch' which makes them unique. I have both Asian and European features, but my bronzed skin and 'potato nose' give me that Filipino touch. It's just like mixing colours. If you add a little red to yellow, just a little, it turns slightly orange, but is still considered yellow.

To be honest, being Eurasian is an amazing experience because we share two or more developed cultures. I've had the chance to live in Hong Kong, Shanghai and France and travel quite a lot. Being Eurasian can mean having family scattered across the globe and the opportunity to visit. I have travelled frequently to visit aunts and uncles in the US, Canada and the Philippines amongst other places. The people around me changed, their way of thinking, lodging, studying, everyday life, almost everything was different depending on where I was. Being half French, when I moved to France in 2001 I was astonished to discover the real French 'baguette'. It was so good. That's also when I found out they eat frogs' legs and snails (I'm pretty sure I must have known this before, but I guess I was too young to care about it and forgot).

The only disadvantage of being Eurasian is the possibility of racist acts or discrimination. Saying that, I have never suffered any discrimination myself on account of being Eurasian and I believe that Eurasians are generally very well accepted in the world. I can understand some may feel uncomfortable in the presence of someone so different, but as long as there is no provocation or misleading verbal exchange, there shouldn't be any problem.

I don't think there should be a distinct and recognised 'Eurasian' group. All Eurasians can easily recognize each other, which is pretty good already. Creating more groups would possibly create more problems. For my part, it's always nice to meet others just like me, people who share the same background. I also seem to bond with other mixes very well: one of my good friends has one side from Madagascar, the other from France, and other friends are half Latino.

We're all humans, so the way I see it, we're just another type of person.

我在香港出生,半個菲律賓人、半個法國人,現時在法國讀書。我會說流利的英語及法語,正在學習中文及日文,我相信自己的西班牙文應該會不錯。

我的官方籍貫是法國,但我覺得自己有法國人的部份,也有菲律賓人的部份,同時還有一點點中國人的部份。只要我在一個地方待過一段時間,我就會覺得那裡有家的感覺——然而長大於大城市,令我覺得在香港或上海生活,會較我現在身處的地方來得自在舒適。

一個人的種族淵源,對他的國籍和其他一貫特徵有著很大的影響。雖然我沒有流著中國人的血,我知道很多關於他們的文化、歷史、思想和生活習慣。我曾在上海住過一陣子,最喜歡這個城市的地方,就是它的包容性。雖然這裡沒有很多外國人,我也害怕會因此而鶴立雞群;然而當我真的走在街上,卻發現我並沒有讓人看成異類,在中國人群中就像其他人一樣被接受。

曾在中國和法國居住過,也曾到訪過不同的西方和亞洲國家,我覺得自己較傾向於亞洲的一面。相反我的姊姊則較傾向她的西方的一面。依我來說,她沒有半點亞洲人的模樣;如果我們一起走在街上,相信沒有多少人會看得出我們是胞姊妹,我們在學校時就有這樣的經歷:我的一位好朋友第一次看見我姊姊時,他不相信眼前人真的是我的親生姊姊。我想,那是因為她擁有純白的皮膚,而我的膚色則是淺牛奶巧克力的顏色。

我不覺得別人常常猜我來自甚麼種族。香港是個非常國際化的都市,而法國歡迎來自世界四面八方的外來人。我在兩地遊走時,均被無數的不同民族包圍,所以我不相信他們真的想猜我來自何方。真的要猜的話,多數人會說我來自東南亞。就是估錯了,我一點都不會介意,我也常常弄錯,這就跟賭博差不多,不是輸就是贏,有些人比較幸運,有些人不然。沒有人真的可以猜出我來自的地方,因為我沒有多少菲律賓人的文化,而你可能需要在烈日下躺一天才看得出我的正確膚色。

大部份混血兒都有些「特徵」讓他們看起來很獨特。我同時擁有亞洲人和歐洲人的輪廓,但我的古銅式皮膚和「酒渣鼻」,給予我菲律賓人的特徵。如你在黃色中放一點紅色,只是一點點,雖然會稍稍變成橙色,但總的仍算是黃色。

老實說,作為混血兒是很奇妙的,居然可以分享及承傳兩個或以上的文化。我有機會在香港、上海和法國居住,以及到處遊歷。作為混血兒,即代表你的家人遍佈全球不同地方,你都可以去探訪。我常常有機會到美國、加拿大、菲律賓及其他地方,探望我的姨姨和叔叔。隨著我到不同的地方,我身邊的人不斷改變,他們的思維模式、居所、學習、日常生活,所有東西都不相同。雖然算是半個法國人,當我在2001年移居法國時,才赫然發現真正的「法國麵包」有多好吃,也發現他們是會吃青蛙腳和蝸牛的(我幾乎肯定之前應該已經知道了,但那時可能年紀太小,已經對此沒有印象了)。

做混血兒唯一的弊端就是可能成為種族歧視行動的對象。雖說如此,我自己不會受過任何歧視,也相信普遍來說,混血兒在世界各地也是受歡迎的。我可以理解為何有些人在面對著跟自己人極不相同的人,會覺得奇怪和不安,但是只要大家沒有故意挑釁對方,或有言語間的誤會,相處應該沒有很大問題。

我不認為應該明確分辨出一個叫「混血兒」的民族。所有混血兒可以輕易地認出對方,這已經是夠好的了。創造更多種族只會製造更多麻煩。在我來說,遇到和我類似背景的人,永遠是件快樂的事。我也似乎與其他昆血兒相處得很好,有一名很好的朋友是馬達加斯加和法國的混血兒,有些朋友則有一半拉丁美洲人血統。

依我看來,大家都是人類,我們只不過是有點不同罷了。

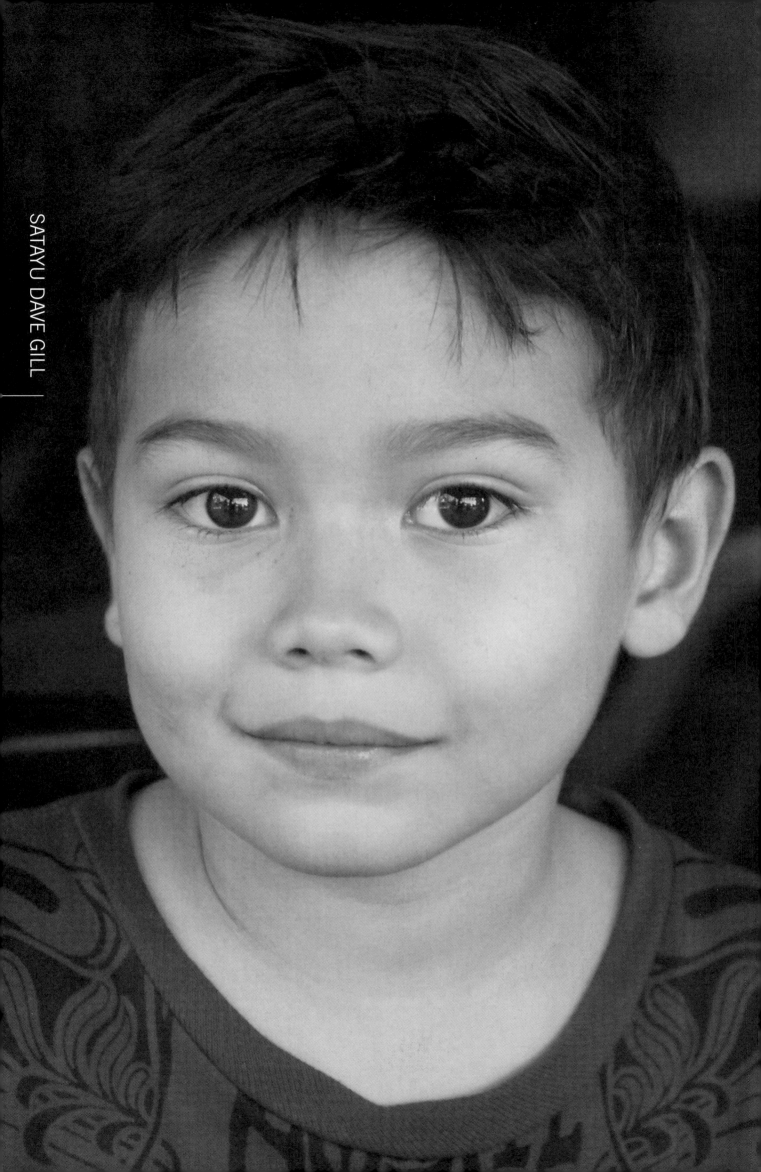

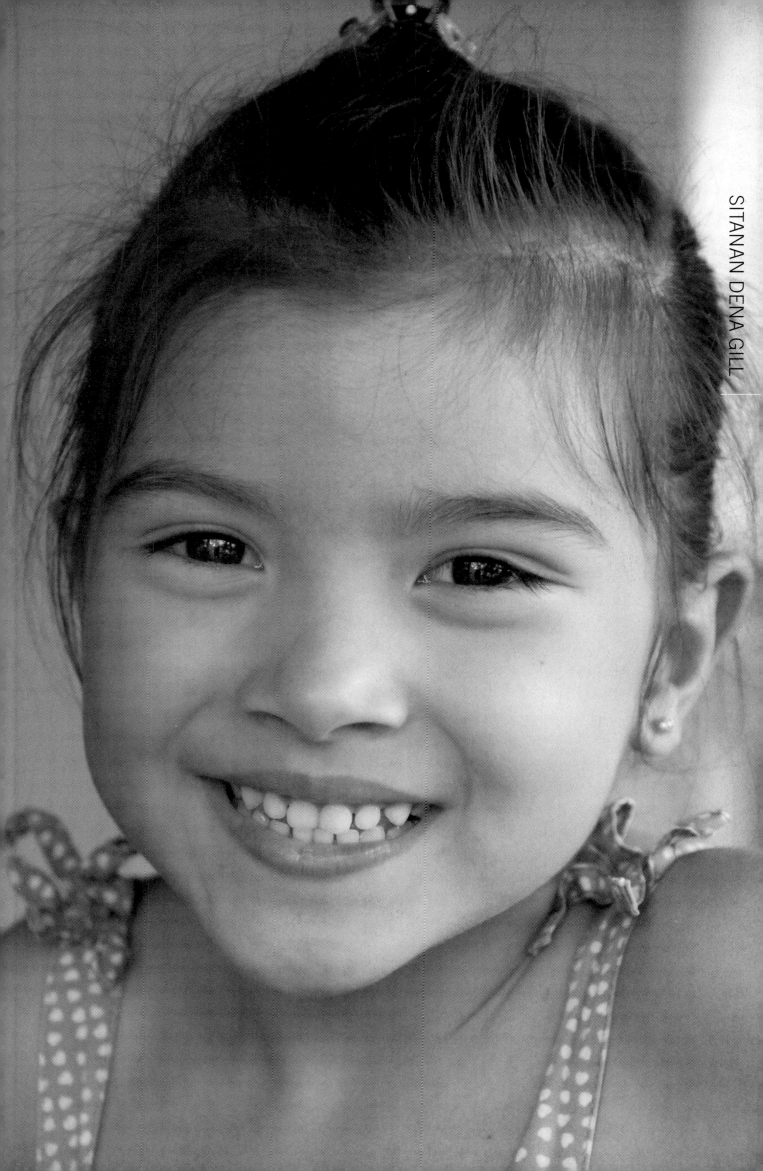

I returned to live in Hong Kong two years ago with my husband who is English, having spent a great deal of my life in the UK. Hong Kong is such a culturally diverse and cosmopolitan city, I feel totally at home living and working here. Being half-English (my mother's side) and half-Chinese (my father's side), it is wonderful to be back. My husband's business is here and we have just bought a house, so I envisage being here for a long time. With the world getting smaller because of globalization, my mixed background gives me the added advantage of understanding Asian and Western cultures and being at ease with both.

I was born in London; my parents were living in Thailand at the time but we returned to Hong Kong when I was two. My early years were spent in Hong Kong. We lived in a lovely colonial house, and life was great as a child growing up here. At the age of nine, I went to boarding school in the UK and stayed there through and beyond university. People in the UK often did not see the Asian in me because of my English accent, but in Hong Kong, most people recognise my mixed background.

At boarding school, I had many friends from Hong Kong – Chinese, Eurasians and Western. We were together not only at school, we travelled together back and forth to and from Hong Kong and saw each other during holidays. I am lucky as I have family in both Hong Kong and the UK. In Hong Kong, it was great to be home with my parents; in the UK, my mother's twin sister became my surrogate mother.

My one regret is that I do not speak Cantonese. This is partly because I was never in Hong Kong long enough, and partly because my father, being such a Francophile, encouraged us to learn and speak French. We spent our long summer holidays in our house in France, so speaking French came more naturally. I studied Mandarin as part of my university degree in the UK because I felt it was such a shame that I was half Chinese and did not speak the language.

My parents met in London when my father was working in the City. My mother came from a traditional English family and she settled easily into my father's family which was also very traditional. My sister and I were brought up to observe and respect family values and traditions, both Chinese and English. We observed all the major festivals, at which time the family would gather together to celebrate, so a lot of the values have been ingrained in me.

My parents have been a real inspiration. They have been together for over 40 years, overcoming some prejudices in the early days. I value my heritage and feel very blessed to be a part of two wonderful cultures. I have two children and hope to pass this heritage onto them.

我的大半輩子都在英國生活，在兩年前隨英籍丈夫回到香港，這個多元文化的大都會，我在這裡生活及工作都覺得好像在家一樣。作為半英（母親）半中（父親），我很高興回歸香港。我丈夫的生意都在這邊，而我們剛買了房子，所以我預期我們會在這留一段長時間。世界因為全球化而變得越來越小，我的混血背景令我增值不少，不但使我更能理解中西文化，也可以在兩種文化中都相處自若。

我在倫敦出生，那時我的父母均在泰國居住，但在我兩歲時我們舉家回到香港。我早年在香港生活，住在可愛的殖民地色彩的房子內，成長的生活優哉悠哉。九歲時，我到了英國就讀寄宿學校，就一直待到大學畢業。由於我的英語口音，在英國別人都看不出我亞洲人的一面，但在香港，大部份人則認出我是名混血兒。

在寄宿學校時，我有很多來自香港的朋友——有中國人、混血兒和西方人。我們不僅在校內交往，也一起來回香港，在假期也依然見面聚會。很幸運地我在香港及英國均有家庭，在香港我很開心可以回家與父母相聚，而在英國，母親的孿生姊姊則成了我的代母。

我最大的遺憾，就是我不會廣東話。部份因為我從來沒有在香港住上很長的時間，另外也因為我的崇法的父親，老是鼓勵我們學習及說法語。漫長的暑假間我們都住在位於法國的房子，令我們習慣自然地說法文。我在英國大學時，選修了普通話，因為我覺得身為半個中國人，不會說中文實在是太羞愧了。

我的父母在倫敦認識，當時父親在西堤區工作。我的母親來自傳統的英式家庭，而她很容易融入父親同樣傳統的中式家庭中。我和妹妹在成長期間都在奉行和尊重中西方的家庭價值及傳統。我們慶祝所有重要節日，每次都聚集了整個家族的成員，所以很多價值觀都會在那個時候開始根深柢固影響著我。

父母對我的啟發及影響至深，他們已經在一起40年了，並克服了早年的偏見。我很重視中西文化遺產，而且很自豪可以同時作為兩個偉大文化的一部份。我現在已有兩名孩子，希望以後都可以將兩種文化薪火相傳下去。

My mother is Chinese and my father is English. I was born in Hong Kong but moved all over the world during the early years of my life – I lived in Australia, Cairo, Fiji, the UK and Washington before moving back to Hong Kong at the age of eight.

I attended Hong Lok Yuen primary school in Tai Po and although we studied Chinese, it was only about an hour a week. I don't speak Chinese now.

I generally feel 'international' but have a definite connection to Hong Kong. I don't feel all that Chinese but can appreciate Chinese culture and my mother's mentality. Saying that, my mother herself doesn't have the strongest ties to her Chinese family so this may have had an effect on how Chinese I really feel. I do feel a connection to other Eurasians, but at the same time I feel a little different sometimes on account of not being able to speak Chinese.

I went to the UK for college and then university. I felt a bit different to the English students but for having been brought up in Hong Kong, not for being Eurasian. Admittedly, I fly half the flag for Britain – especially in sports and suchlike. Perhaps I have an affinity to the UK through the colonial rule in Hong Kong! That being said, with the world being increasingly homogenized I feel we're all global citizens.

I can't really recall any examples of discrimination on account of being Eurasian but I remember getting funny looks when I was with my mother when I was young.

People do always try to guess where I'm from – they mostly guess Spanish or Latino. From my accent, they tend to come up with South African or Australian.

I see being Eurasian as a very positive experience. Being caught between two different cultures can be a bit of a whirlwind but I feel enriched by having both perspectives. I also feel fortunate for having lived in so many countries. People from one place can be so narrow-minded.

我的母親是中國人，而父親是英國人。我在香港出生，很幸運地我早年已在世界不同的地方居住過——包括澳洲、斐濟、埃及、英國、華盛頓，在八歲時才搬回香港。

我在大埔康樂園小學就讀，雖然我們會學中文，但只限於每星期幾個小時的課，而我也要不斷趕進度。可惜我不會說流利的廣東話。

我覺得自己很「國際化」，但和香港卻有很深的淵源。我覺得自己像中國人，欣賞中國文化、母親的價值觀和態度……等一下，我是不是漏了中國食物呢？雖然這樣說，母親在移居海外這些年頭，已經斷了一些她和家庭的聯繫。我會覺得和其他混血兒有種特殊的聯繫，不過就是因爲我不會說中文，總覺得和他們不太一樣。

我到了英國上大學，覺得英國學生有點不一樣，不過這想法不是因爲我的混血兒身份，而是因爲我在香港長大的背景而產生。不得不承認我確是半個英國人——尤其在運動方面，可能因爲我在香港的英殖民地管治下，對英國有種親切的聯繫吧！但是現在世界越來越同化的環境下，我覺得大家都成了世界公民。

我不記得任何因爲混血兒而受到歧視的例子，但在我小時候，跟母親在一起時，曾吸引過別人異樣的目光。

人家總嘗試猜想我來自何方，大部分會猜我是西班牙人或拉丁人；從我的口音，他們傾倒估計我是南非或澳洲人。

我把混血兒看成是很正面的事。落在兩種文化中間，有時可能會覺得頭暈轉向、不知所以，但我卻認爲能夠擁有兩種不同的文化觀點，可以豐富自己的人生和價值觀。我也覺得自己很幸運，有機會在那麼多不同的國家居住過，接觸不同的文化。光是來自一個地方，而缺乏異地的經歷，會讓人的眼光變得狹隘。

I was born in Singapore and am of Portuguese, American-Irish, Thai-Chinese and Dutch descent.

In Singapore we tend to define a Eurasian as any person who has a mix of European and Asian blood (i.e. ancestry). As long as at least one ancestor is one of each, then their descendants are considered first-generation Eurasian. In spite of this, however, my children are not considered Eurasian because their father is Chinese and, according to the National Registration in Singapore, these days the ethnicity of the child as stated on their birth certificate follows their father's race or ethnicity; although within the community he is part of the community, and hence is considered a Eurasian. I guess being Eurasian is not about ancestral lines and following the paternal family name. It is more about being part of a Eurasian community, that sense of belonging to this domiciled community of Singapore. So it is not just having a European family name that makes one Eurasian. Being Eurasian is more the sharing and handing down of family traditions and customs, and this is often more an influence from the maternal side.

The other thing about being Eurasian is our distinct features, physique and poise. I think people tend to think my appearance is more 'Western' to our fellow Chinese, Indians or Malays. I am often referred to as 'Ang Moh' which means 'European' in Chinese. When I was a child, I had blonde hair and the colour turned reddish as I grew older. My mother told me I was the only one of her eight children who was born with blue eyes. (My eldest daughter was born with grey eyes).

I was brought up in a typical Eurasian household with all the traditions, home-cooked foods and meals, customs and nostalgia. My parents were Catholics and very strict and staunch ones, like all typical Eurasian parents of those days. Eurasian boys would come to the house wanting to date me but we were not allowed to go out unchaperoned, one of the typical family rules. Our parents wanted us to marry Eurasians, as did all Eurasian parents in those days. Having said that, my elder sister married a Chinese man my uncle introduced her to, and I ended up marrying his brother. It can be difficult marrying into another culture and I have on occasions found it so even though I myself come from a mix of family traditions and customs.

I grew up speaking English at home as my first language and took Mandarin and then Malay as my second language at school. There were a number of Eurasians at school, but I had a mix of friends and still do. Before I got married, family celebrations were centred around the Western traditions such as Easter and Christmas. But after marriage, I began to celebrate the Chinese ones too. Saying that, I have maintained and continued to practice my strict upbringing and have brought up my children the same way too. One habit that has stuck since I was young is that I still do not turn on the radio or television on Good Friday. In this day and time that's a real challenge for the young and I am glad my parents brought me up the way they did.

I do not think there is any difference in how Eurasians were perceived when I was young and how we are seen now. I have always been proud to be a Eurasian, and still am.

我在新加坡出生：是葡萄牙裔、美籍愛爾蘭裔、泰籍華裔、以及荷蘭裔的後代。

在新加坡，我們傾向定義歐亞混血兒爲擁有歐洲和亞洲血統（即：祖先）的人。只要祖先中至少一人是如此，那他們的後代都是歐亞混血兒了。雖然如此，我的孩子卻算不上是歐亞混血兒，因爲他們的父親是中國人，而根據新加坡國家登記條例，孩子出世紙上申報的種族，將跟隨其父親的種族而填寫。不過，由於他是混血兒社區的一份子，所以也算是名混血兒。我猜作爲混血兒不光是要看父親那邊的姓氏及祖先血統，更多在於是不是在混血兒的社區內，即是不是隸屬新加坡定居群體之中。所以，不只是擁有一個歐洲姓氏或代表一個人是混血兒，他們需要更廣義地可以承傳家族傳統及風俗，那更多是來自母親那邊的影響。

另外一個作爲混血兒的特色是我們分明的輪廓、外貌和自信。我想別人覺得我相對中國人、印度人或馬拉人來說，長得較爲「西化」。我常常被指是「紅毛」，即福建話中的「西方人」。孩童時代我擁有金髮，而長大後則慢慢變成紅髮。母親告知我是她八個孩子之中，唯一一個擁有藍色眼睛（我的長女出生時擁有灰眼睛）。

我在典型的混血兒家庭長大，習慣他們的傳統、住家菜、習俗、懷舊之情。我的父母都是天主教徒，非常嚴格、忠誠，一如當時所有典型混血兒父母一樣。有時可能會有混血兒男生來我家追求，但我們不可以獨自在沒有大人陪伴下外出，那是典型的家規。父母希望我們都與混血兒結婚，那是所有混血兒父母的期望。縱然如此，我的姊姊最後嫁了她叔叔介紹她的一名中國男子，而我則嫁了他的弟弟。與不同文化的人結婚可以是件很困難的事，雖然我本身在混雜的家庭傳統及習慣中長大，也會這樣覺得。

我在家都是說英語，並以此爲母語，後來在學時，先學習普通話，然後是馬拉話，作爲第二外語。在學校中有一些混血兒，但我的朋友不只是他們，也有其他的同學，現在朋友群也來自不同種族。在結婚以前，我的家庭慶祝活動圍繞在復活節、聖誕節等西方節日；但在結婚以後，我也開始慶祝中國節日。然而，我不僅保留及延續自小養成的嚴謹傳統習慣，也將這一套帶到孩子的身上，如在耶穌受難節不開收音機及電視。對這個時代的年青人來說或許是個莫大的挑戰，我很慶幸父母如斯嚴格地教導我們成長。

我不認爲在我年輕時和現在相比，別人對混血兒的看法存在任何不同。我從來都對混血兒身份感到自豪，以前和現在依然一樣。

As this was never meant to be an exhaustive or definitive study but rather a fleeting glimpse into the lives and faces of a number of Eurasians, I was surprised to find that I was able to make some observations during the making of this book.

Apart from establishing ethnic mix, nationality and place of birth, I gave the subjects free rein to discuss being Eurasian and tried to vary my prompts. Despite my different approaches, I found that many held similar views and beliefs especially with regards to having 'Chinese' morals and 'Western' social habits. Most subjects were keen to enforce the idea that they felt equal amounts of each and it was also striking that many subjects employed the same terms – such as 'best of both worlds' – despite not having conferred with each other. There was an overwhelming desire to portray being Eurasian as a positive and enviable state of being and many accounts contain a definite note of pride.

If this book had been written even thirty years ago, the responses might well have been very different. As it happens, differences can be seen between the interviews of those below the age of twenty, those now in their thirties to forties and those who are a bit older. The youngest subjects seemed almost baffled as to why I was attributing such weight to the idea of being Eurasian. The middle group was most likely to be militantly proud of their heritage and in the elder subjects there was often a defensive edge to their answers.

As I have said, this was never meant to be a scientific or even academic process but I do hope that value will be found in years to come in the contemporaneous accounts of some seventy Eurasians. I also hope that people will enjoy studying the images of these Eurasians and take the time to find and explore the genetic legacy etched upon their faces.

本書並非全面或完整的研究著作，而僅爲讓我們瞥見一些歐亞混血兒的生活面貌的作品。然而在訪問及製作過程中，我很訝異竟可從中得到不同的觀察和啓示。

除了要列出融合自那些民族、國籍和出生地，我給予受訪者最大的自由度探討作爲混血兒的種種，以及嘗試不同的提示問題。儘管我使用了不同的方式發問，我發現他們很多位均對「中式」價值觀和「西式」生活習慣，持相似的觀點和信念。大部分被訪者熱切表達他們平衡地接受中西文化，其中最突出的，莫過於很多被訪者都不約而同地使用了相同的字眼，如「兩個文化中最好的部分」等。他們一致地渴望將混血兒描繪爲正面和深受羨慕的一群，很多位對自己混血兒的身份感到絕對自豪。

如果本書在30年前寫出來，受訪者的回應該有很大差異。書中的訪問偶然揭示了不同年齡層，如20歲以下、30至40歲、以及年紀更大一點的受訪者，均持不同意見。最年輕的一群被訪者，幾近困惑地奇怪我爲什麼要將混血兒看得這樣沉重。中年的一群，普遍表達他們對混血兒的文化承傳強烈地感到自豪；老一輩的回應，則相對有較強防禦性。

如我所說，此書從來無意成爲一本科研著作，我只希望透過記錄70名出現在相同時代的混血兒故事，令本書在往後的歲月裡能夠彰顯其價值。我也希望讀者會有興趣研究這些受訪者的相片，並花些時間，去探索刻在一張張臉孔上不同的遺傳下來的傳奇故事。